Art, Dialogue,
Action, Activism

Art, Dialogue, Action, Activism

::: **CASE STUDIES FROM ANIMATING DEMOCRACY**

Editors

Pam Korza and

Barbara Schaffer Bacon

AMERICANS
for the ARTS

WASHINGTON, DC

Americans for the Arts, Washington, DC 20005

© 2005 Americans for the Arts

All rights reserved. Published 2005

13 12 11 10 09 08 07 06 05 1 2 3 4 5

The photograph on the cover is a photo collage from the play
An Altar for Emma (2001), part of The Esperanza Peace and
Justice Center's ongoing program, *Arte es Vida*. Photo courtesy
of The Esperanza Peace and Justice Center.

Book design by studio e$_2$.

Library of Congress Cataloging-in-Publication Data

Art, dialogue, action, activism : case studies from Animating Democracy
/ editors, Pam Korza and Barbara Schaffer Bacon.— 1st ed.

 p. cm.

 ISBN-13: 978-1-879903-38-8 (alk. paper)

 1. Community arts projects—United States—Case studies. 2. Artists
and community—United States—Case studies. 3. Arts and society—United
States. I. Korza, Pam. II. Bacon, Barbara Schaffer. III. Animating
Democracy (Initiative)

 NX180.A77A74 2007

 701'.03'0973—dc22

 2005021013

ISBN–13: 978-1-879903-38-8
ISBN–10: 1-879903-38-5

The paper used in this publication meets the minimum requirements of
the American National Standard for Information Sciences—Permanence
of Paper for Printed Library Materials, ANSI Z39.48-1992.

Additional copies available at www.AmericansForTheArts.org/bookstore

Art, Dialogue, Action, Activism: Case Studies from Animating Democracy
is a publication of Animating Democracy.

Animating Democracy, supported by the Ford Foundation,
is a program of Americans for the Arts.

Table of Contents

Preface

ART, DIALOGUE, ACTION, ACTIVISM examines the role of dialogue in the work of cultural organizations oriented toward civic action and activism. In art that seeks to engage pressing civic issues, the question often arises, is dialogue enough? Four very different activist endeavors offer insights into dialogue that is integrated within cultural activity as a means of educating and organizing, dialogue as a means to explore different perspectives among people who hold a common goal or position, and dialogue as a necessary precursor to decision making or action.

From 2000 to 2004, with support from the Ford Foundation, Animating Democracy—an ambitious initiative of Americans for the Arts—provided the cultural organizations leading these and other such experiments in arts and humanities-based civic dialogue with funding, opportunities for peer exchange, and other technical support. Animating Democracy set out to demonstrate that civic dialogue and art can be mutually enhanced when the two are thoughtfully brought together. With focus and intention, artists and cultural organization leaders can use the inherent power of art and the humanities to stimulate civic dialogue and engagement and, in the case of the projects featured in this book, dialogue that leads to action.

The cultural organization leaders, artists, dialogue practitioners, and community partners involved in these projects were encouraged to reflect openly and critically about their efforts. In the spirit of experimentation and learning that could be shared with the field, what *didn't* work was welcomed as much as what did. As a result, the case studies provide portraits and practical analyses of the projects that are candid in revealing challenges as well as successes. They detail civic issues addressed, arts and humanities components, and artistic and dialogue methodologies. Whether written by project organizers themselves or by "project liaisons" who shadowed each project, asking questions and helping to draw out what artists, cultural organizers, and partners were experiencing, the case studies reflect a diversity of voices from within the projects and varied styles of presentation.

Art, Dialogue, Action, Activism opens with an essay by Detroit-based activist, cultural worker, and octogenarian Grace Lee Boggs. She describes a United States in which a host of issues beg for "a new paradigm of our selfhood and our nationhood." Stressing the need for tremendous philosophical and spiritual transformation to effect social justice and change, she advocates a shift from politics and protest as usual to positive and holistic change-making. Boggs recounts several movements of the last half-century and promising contemporary ones that demonstrate an expanding desire to "grow our souls," and recognizes artists as key paradigm shifters to aid in the transformation needed toward a more just society and world. As one artist taking on that challenge, artist and activist Rha Goddess provides an

introduction to the case studies. She weaves reflections on her own work linking hip hop aesthetics, dialogue, empowerment, and action with concepts and learning shared within the case studies. She offers a useful framework for thinking about the continuum of arts-based civic dialogue, engagement, and transformation.

Projects featured in *Art, Dialogue, Action, Activism* are:

Allen County Common Threads Theater Project. Through a long-term residency by Sojourn Theatre combining theater and dialogue, the Council for the Arts of Greater Lima (Ohio) moved a community toward action on longstanding issues of race and trust among city and county leaders. The case study explores how a thoughtfully constructed partnership among artists, a dialogue practitioner, and capable community leaders began to effect change through dialogue *and* action.

Agents & Assets. The Los Angeles Poverty Department's play and residency investigating the advent of the United States crack epidemic was mounted in Detroit to coincide with an election deciding policy related to treatment vs. incarceration of nonviolent drug offenders. The project engaged drug policy activists, residents impacted by drug policy, students, and the local arts community in dialogue. This case study shares the challenges of cultural activist work linked to influencing legislation and the promise of such a project to support longer term activism goals.

Arte es Vida. Through The Esperanza Peace and Justice Center's ongoing *Arte es Vida* program, cultural activity is a forum for "plática" or dialogue and serves to raise consciousness, recover history, inform people of current issues, and mobilize community members toward action. The case study articulates cultural, theoretical, and practical elements unique to the Esperanza's dialogue practice.

Understanding Neighbors. This project spearheaded by Out North Contemporary Art Center sought to change the contentious tenor of debate about rights of same-sex couples in Anchorage, Alaska. The case study explores what happened when a cultural organization with strong political views on the issue shared leadership with partners in an effort to create a welcoming environment for dialogue across the widest spectrum of conservative and progressive participants.

Animating Democracy set out with a serious goal to document the philosophical, aesthetic, and practical dimensions of this work for the benefit of the field and participating artists and organizations. *Art, Dialogue, Action, Activism* is one of five case study volumes in Animating Democracy's Art & Civic Engagement series. These and three other Animating Democracy publications are listed in the back of this book. Together they offer a deep and holistic look at the work of arts and humanities-based civic dialogue from many perspectives. They offer new as well as affirmed knowledge drawn from rich practical experience. We hope they will prove to be timely resources, as well as enduring ones, that inform continued vital work in civically engaged art in communities across the United States.

Acknowledgments

WE EXTEND OUR GRATITUDE to the many Animating Democracy participants whose work is the basis for these case studies. It has been a privilege to support and learn from the artists, cultural organization leaders, and community and dialogue partners who made these arts-based civic dialogue endeavors possible. With intelligence and candor they have shared insights and learning in deep and generous ways, demonstrating their commitment to the educational value of the work as well as its impact in their own communities. The artistic and programmatic innovations that have resulted from their arts-based civic dialogue projects have been rewarding to support and experience.

Our special thanks go to the writers: Grace Lee Boggs, whose life experience and fresh ideas challenge and inspire and whose essay we are honored to have commissioned and now share; Rha Goddess for capturing in her introduction the importance of this work in this time; John Malpede, whose arts activist work spans decades and whose documentation of Los Angeles Poverty Department's *Agents & Assets* project will continue to contribute to field understanding; Graciela Sánchez, who delves deeply into the Esperanza's long commitment to cultural activism work to bring critical understanding and invaluable lessons by which others can learn; Sue Wood, who captures well the spirit, integrity, voices, and results of the *Allen County Common Threads Theater Project*; and Lynn Stern, who brings clarity and sensitivity to the complexities, successes, and challenges of the *Understanding Neighbors* project.

We have valued the editorial contributions of a great team of editors. Gayle Stamler and John Fiscella's skillful and intelligent content editing have served to draw out important ideas and sharpen the material in valuable ways. We are grateful to Kirsten Hilgeford and Susan Gillespie, editors with Americans for the Arts, for their expert proofreading, additional editorial work, and for overseeing the production process. We thank Anne Canzonetti for her proofreading and editorial contribution on the Art & Civic Engagement series. Our special thanks are extended to studio e_2 for book design that captures so beautifully and functionally the intent and spirit of the publication. The creativity, professional expertise, and hard work of each one has paid off in a resource for the field of which we are very proud.

Thanks to all our colleagues at Americans for the Arts who have offered their ideas and support to Animating Democracy's efforts and to this book in particular, and to the Ford Foundation, without whose vision and support Animating Democracy would not have been possible.

Barbara Schaffer Bacon and Pam Korza
Co-directors, Animating Democracy

Introduction

AT A TIME WHEN OUR BODY OF CIVIL LIBERTIES is lying face down on the ground with its arm twisted behind its back, it's pretty hard not to cry "uncle." As the global culture seems to be sorting humanity into the "terrified" or the "terrorists," our ability as people to creatively and authentically express ourselves is seriously at risk. The leadership of this nation would have you believe that their actions are about democracy and freedom. However, I believe that the greatest "patriot act" any of us can undertake in this moment is to know, honor, and give voice to who we really are. This is the struggle: to be real. And in being real, each of us has the opportunity to be free.

The case studies you are about to read represent a movement within the continuum of arts and civic participation, each uniquely pushing the envelope of art's ability to effect social and political change.

For the Esperanza's *Arte es Vida* program, this movement is about the reclamation of history and culture, about challenging the politics of land and space, and about healing the wounds of mental, physical, and spiritual colonization. For the Arts Council of Greater Lima's *Common Threads Theater Project*, it's bridging the great divides between urban and rural, between black and white, between "leaders" and "followers"—and understanding the social-political impact of limited natural resources and industrial decline on all of the above. For Out North's *Understanding Neighbors,* the commitment is to genuinely engage conflicting points of view on what could be America's next "civil right," i.e., respect for the rights of same-sex couples, in the hopes of encouraging deeper exploration and understanding of self and others. For the Los Angeles Poverty Department's *Agents & Assets*, it's leveraging the power of collaboration to unify multiple cross sections of a larger community, and encouraging a poly-angled approach to understanding the impact of drugs and drug-induced policy on one of the toughest neighborhoods in the nation.

And for Grace Lee Boggs, her personal manifesto, *These Are the Times That Grow Our Souls*, gives us a spiritual blueprint for the way our participation in this new terrain can, will, and must create a more loving, just, and compassionate world.

If you are new to this field, I have the distinct honor and privilege of providing an introduction to this work. If you are already passionately engaged, my hope is that these stories will continue to invigorate you as you undertake your mission.

I have always been intrigued about the notion of liberation. I was a child born into the tail end of the civil rights era, and my parents ingrained in my siblings and me, early on,

the importance of education, community, and voice. As a change-of-life baby, I have the advantage of being able to connect my passion for Hip Hop and humanity to the long legacy of arts-based resistance in this country. Nina Simone, Paul Robeson, James Baldwin—these were the muses who inspired my parents to march for their civil rights, and I inherited this legacy. I have often been asked, "What is the role of the artist in times like these, in movements like these?" And more specifically, though not surprisingly, I have been asked: "What is the role of a Hip Hop artist?"

When Hip Hop became the new rock 'n roll, America's conscience never questioned the power of music to negatively influence the impressionable minds of a new generation. The "moral conscience" of this nation leapt into action with parental advisory stickers and congressional lobbying efforts.

But what about inspiration? Does? Can? Will Hip Hop or any other form of art get us there? And what is the value associated with being inspired? Can art inspire us into action? Can art actually transform individuals, communities, politics, social constructs, and/or culture? Is art alone enough? If not, with what must it be partnered to maximize its effectiveness? These are the questions I have been engaged in for the last five years.

My work as an artist-activist is about empowerment through the marriage of high art, high spirit, and high action. I am deeply invested in how we make the leap from arts-based civic dialogue to arts-based civic transformation. As I think about the stages of arts-based civic participation, I see them in the following way:

> **Arts-based civic dialogue:** utilizing the creation and presentation of art to spark critical DIALOGUE around issues that deeply impact individuals and communities;

> **Arts-based civic engagement:** utilizing the creation and presentation of art to spark critical ACTION around issues that deeply impact individuals and communities;

> **Arts-based civic transformation:** utilizing the creation and presentation of art to leverage new ways of BEING and THINKING about self, community, and the world at large, to transform the issues that deeply impact individuals and communities to a place of resolution or empowered manageability.

In 2003, I launched two very distinct and yet very related projects; *Meditations With The Goddess* and *We Got Issues!*

Meditations With The Goddess is a multidisciplinary theatrical trilogy that explores the belief that the new revolution is to be WELL—mentally, emotionally, spiritually, physically, and financially. In these journeys, three Goddesses manifest as a Psychotic Rapper, a Bible Thumpin' Stripper, and a Shiite Muslim Soccer Mom to explore the questions of insanity, sin, and tragedy.

In developing Part I, we did the customary theatrical readings and people did not want to leave the room when we were done. They wanted to talk; somehow the art was

creating a safe space to explore the epidemic of mental illness and the notions of personal and universal insanity. On that first night we committed to incorporating a community dialogue into every workshop, reading, and excerpt performance as an integral part of developing the work.

The unbelievable courage that people have shown through these dialogues has compelled us to incorporate the dialogue-in-action series as part of the tour. We are creating links with national and local mental health agencies to examine how the piece can be used to forward their work. We believe we can make the most impact in breaking down social stigma and creating awareness about the need for cultural competency within the professional mental health field.

We Got Issues! (WGI) is performance-based movement built from a national dialogue among women between the ages of 18 and 35. In the first phase of the project, we traveled the country and, through an intense "ranting" process, came face to face with almost 1,000 young women. We asked them, "Do you vote? Why or why not? What are the issues that are most important to you?" We commissioned a diverse team of writers and activists who turned these rants into a collection of fierce monologues. On September 13, 2004, 10 incredible performers, activists, and everyday young women took the stage of the Apollo Theater and mounted the world premiere of the *WGI Performance Piece* for a sold-out audience of more than 1,100 people.

Can art inspire us into action? Can art actually transform individuals, communities, politics, social constructs, and/or culture? Is art alone enough?

What we learned in the development of this work was that:

1. Young women want to raise their voices in an authentic way, and they need permission and affirmation to do so, especially when it comes to articulating their politics.
2. Young women crave tribe and community, and their ability to thrive and be empowered is directly proportional to the extent to which they are able to create a healthy tribe.
3. Even though many young women fear power, particularly young women of color, they hold great aspirations for themselves and their communities.

As we move into the next phase of our work we are asking, how do young women in this country begin to see themselves as true citizens who are able and willing to shift the social-political landscape in this society? How do young women in this country begin to think about their power and leadership in a more holistic way?

Our intention is to create a model curriculum for arts-based transformative leadership that can be implemented in virtually any community where there is a desire to strengthen young women's capacity to lead. Through this project we hope to create an arts-based, transformative young women's movement that encourages a new paradigm of civic leadership and social-political activism in America.

As I reflect on the case studies in this book through the lens of my own experiences, what I find encouragingly similar in each are the strategies for developing and sharing the art. Each project provided its respective communities with visceral access to the issues.

I believe that when we are able to employ our specific issues to create more universal themes for dialogue, we create the possibility of unpredictable allies.

I believe our greatest chance at impacting the circumstances that negatively affect our society begins with our ability to activate the hearts, minds, and spirits of the people. Whether they are writing Calaveras—stylized satirical poems dedicated to living people addressed as if they were dead—in the Esperanza's celebration of *Dia de los Muertos*, or experiencing the courageous voices of a community divided through the "Passing Glances" performance piece in *Common Threads*, incorporating community in the creative process builds their investment in the future of the art and the issues.

These projects also shared a deep consideration of who their communities were, and who they most wanted to engage. There was incredible attention paid to environment, location, quality of facilitation, and the overall tone of the dialogue. The *Agents & Assets* project brilliantly expanded its audience by creating a forum that examined the "rhetoric of war" commonly adopted by drug enforcement and other official efforts. Not only were the project's organizers able to engage drug reform activists, artists, recovery professionals, and scholars, but they were also able to expand the relevance of their work to include the interests of peace and anti-war activists. I believe that when we are able to employ our specific issues to create more universal themes for dialogue, we create the possibility of unpredictable allies.

Finally, the commitment to having members from the community convene and facilitate these projects not only built local investment, but encouraged leadership in ways that will impact these regions long after the "project activities" have been completed. In the *Understanding Neighbors* project, 25 community-based volunteers were trained to facilitate the project's dialogue sessions. These individuals also became ambassadors who carried the vision of the project and the constructive dialogue methodology into the community. I believe that ownership on the ground creates social diffusion, which is the most critical ingredient for social/political change.

Just as these projects shared common strengths, they also shared common questions and challenges.

The team. How do artists, community organizers, and dialogue facilitators become ONE, i.e., fully integrated into all aspects of the project's vision, design, development, and implementation? What are the kinds of skills that artists, organizers, and dialogue facilitators need to bring to the table in order to be effective? How is common ground reached when there are divergent perspectives and visions?

What seems paramount to the survival of each of these projects was the team's courage and integrity, which manifested itself in their ability to practice the external vision within the interior walls of the project. As shared by *Common Threads* organizers regarding ownership issues around the artistic work, "Again, the team's ability to directly probe issues and concerns emerged as its strongest asset. Project leaders were consistently courageous about persevering through these periods of confusion and discomfort."

Outreach, language, and transparency. How do diverse community voices become engaged in a dialogue project? What are the most effective strategies for encouraging genuine, open, and enthusiastic community participation? When seeking to engage people

around controversial issues, how much of the project agenda should be revealed? Can art be neutral? Can project goals be neutral? What is the relationship between neutrality and activism?

One of the key elements in engaging diverse voices in a dialogue is being willing to meet people where they are, both literally and figuratively. Sometimes this means creating special collaborations with organizations that involve those you are less likely to reach. Sometimes it means being willing to suspend the belief or position that one view is "right" and another is "wrong." *Understanding Neighbors* project founder Jay Brause talks about his shift in approach to working on the issues associated with same-sex couples prompted by contentious past discourse. "In the entire time those issues were being discussed, no one was listening to each other. It was far too easy to see the other as the enemy... I know from my work in arts and culture, unless people have a chance to experience each other firsthand there is no hope for understanding."

This project took meticulous care to create a neutral dialogue space. From the kinds of collaborations organizers engaged in to the dialogue process they chose, there was a huge investment in building trust across opinions. However, despite painstaking efforts, it was still very difficult to engage more conservative views in the dialogue. Out North observed, "...In light of the weak response from the community's conservative sectors... the project's 'neutrality' was of lesser consequence to fostering meaningful community dialogue than active participation from all sides of [the] issue..." Out North consequently questioned the efficacy of civic dialogue as a means to achieve its vision for social change in its community: "how can a dialogue foster understanding among 'neighbors' when key segments of the community haven't asked to sit down and talk?"

Sustainability and the long haul. How does this work become sustainable once the initial funding and resources run out? How does a community make the leap from "project participation" to "way of life?" What kinds of critical partnerships must be established for long-term viability?

I believe strategies for sustainability need to be considered almost from the very beginning. Assessing the level of project ownership and the long-term viability of community-based collaborations is critical. The Esperanza's work within its own community provides real insight. As the Esperanza's leaders say, "In order to engage in civic life, one must trust one's community and allies... Without long-term support it doesn't make sense to 'dialogue'... Without committed help, it doesn't make sense to organize, to create, to work for alternatives, to 'vote' when your efforts are blocked by those with the power to silence, refuse, or ignore you."

When I think about civic transformation, I think about individuals and communities living inside of their passions, their purposes, and their dreams. I see inspired leadership and full accountability on the part of all citizens. I see abundant resources, organic collaboration, and mutual generosity.

I believe that the new frontier is about cultivating a vibrant interior world, one that is rooted in vision and is integral to any external strategy for effecting social/political change.

Art encourages this cultivation, whether through the process of creation or presentation, and all of us have access to this creative energy. Intuitively, I feel that we as a society are working to heal the crisis of inspiration and the breakdown of community. The role of the artist is to create, and the work of creation is about being inspired, in every moment, not just as an artist but as a human being.

The stakes have never been higher for us in our evolution as humanity. As Grace Lee Boggs so eloquently puts it, "…each of us needs to undergo a tremendous philosophical and spiritual transformation. Each of us needs to be awakened to the personal and compassionate recognition of the inseparable interconnection…between ourselves and all the other selves in our country and in the world."

As you read about these incredible projects, with all of their triumphs and challenges, I hope you will be inspired into action, I hope you will work to add your drop to the well of this movement, and I hope you will encourage others to do the same.

Rha Goddess
artist/activist

These Are the Times
That Grow Our Souls

GRACE LEE BOGGS

In October 2003, Detroit-based activist, cultural worker, and octogenarian Grace Lee Boggs energized and inspired a national gathering of artists, arts organization and community leaders, and activists with her speech at Animating Democracy's National Exchange on Art & Civic Dialogue. In this essay commissioned by Animating Democracy she expands on ideas seeded at that gathering.

MORE QUESTIONS THAN ANSWERS

In the last 60 years, I have had the privilege of participating in most of the great humanizing movements of the second half of the last century—labor, civil rights, black power, women's, Asian American, environmental justice, antiwar. Each was a tremendously transformative experience for me, expanding my understanding of what it means to be an American and a human being, and challenging me to keep deepening my thinking about how to bring about radical social change.

However, I cannot recall any previous period when the issues were so basic, so interconnected, and so demanding of everyone living in this country, regardless of race, ethnicity, class, gender, age, or national origin. At this point in the continuing evolution of our country and of the human race, we urgently need to stop thinking of ourselves as victims and to recognize that we must each become a part of the solution because we are each a part of the problem.

How are we going to make our livings in an age when hi-tech and the export of jobs overseas have brought us to the point where the number of workers needed to produce goods and services is constantly diminishing? Where will we get the imagination, the courage, and the determination to reconceptualize the meaning and purpose of work in a society that is becoming increasingly jobless?

What is going to happen to cities like Detroit that were once the arsenal of democracy? Now that they've been abandoned by industry, are we just going to throw them away? Or can we rebuild, redefine, and respirit them as models of 21st-century self-reliant, sustainable, multicultural communities? Who is going to begin this new story?

How are we going to redefine education so that 30 to 50 percent of inner-city children do not drop out of school, thus ensuring that large numbers will end up in prison? Is it enough to call for "Education, not Incarceration"? Or does our top-down educational system, created a hundred years ago to prepare an immigrant population for factory work, bear a large part of the responsibility for the escalation in incarceration? In the last three years

the issues in education have been made more acute by Bush's "No Child Left Behind" act. A climate of fear and intimidation has been created in our schools by penalizing "under-performing" schools, forcing teachers to teach to the test, showing "zero tolerance" to students, and encouraging military recruitment.

How are we going to build a 21st-century America in which people of all races and ethnicities live together in harmony, and Euro-Americans in particular embrace their new role as one among many minorities constituting the new multiethnic majority?

Our lives, the lives of our children and future generations, and even the survival of the planet depend on our willingness to transform ourselves into active planetary and global citizens...

What is going to motivate us to start caring for our biosphere instead of using our mastery of technology to increase the volume and speed at which we are making our planet uninhabitable for other species and eventually for ourselves?

And, especially since 9/11, how are we to achieve reconciliation with the two-thirds of the world that increasingly resent our economic, military, and cultural domination? Can we accept their anger as a challenge rather than a threat? Out of our new vulnerability can we recognize that our safety now depends on our loving and caring for the peoples of the world as we love and care for our own families? Or can we conceive of security only in terms of the Patriot Act and exercising our formidable military power?

When the chickens come home to roost for our invasion of Iraq, as they are already doing, where will we get the courage and the imagination to win by losing? What will help us recognize that we have brought on our defeats by our own arrogance; our own irresponsibility; and our own unwillingness, as individuals and as a nation, to engage in seeking radical solutions to the growing inequality between the nations of the North and those of the South? Can we create a new paradigm of our selfhood and our nationhood? Or are we so locked into nationalism, racism, and determinism that we will be driven to seek scapegoats for our frustrations and failures—as the Germans did after World War I, thus aiding and abetting the onset of Hitler and the Holocaust?

We live at a very dangerous time because these questions are no longer abstractions. Our lives, the lives of our children and future generations, and even the survival of the planet depend on our willingness to transform ourselves into active planetary and global citizens who, as Martin Luther King, Jr., put it, "develop an overriding loyalty to mankind as a whole in order to preserve the best in their individual society."

The time is already very late and we have a long way to go to meet these challenges. Over the decades of economic expansion that began with the so-called American Century after World War II, tens of millions of Americans have become increasingly self-centered and materialistic, more concerned with our possessions and individual careers than with the state of our neighborhoods, cities, country, and planet, closing our eyes and hearts to the many forms of violence that have been exploding in our inner cities and in powder kegs all over the rest of the world—both because the problems have seemed so insurmountable and because just struggling for our own survival has consumed so much of our time and energy.

At the same time, the various identity struggles, while remediating to some degree the great wrongs that have been done to workers—African Americans, Native Americans,

and other people of color; women; gays and lesbians; and the disabled—and while help-ing to humanize our society overall, have also had a shadow side in the sense that they have encouraged us to think of ourselves more as determined than as self-determining, more as victims of "isms" (racism, sexism, capitalism) than as human beings who have the power of choice and who for our own survival must assume individual and collective responsibility for creating a new nation that is loved rather than feared and that does not have to bribe and bully other nations to win support.

These are the times that try our souls. Each of us needs to undergo a tremendous philosophical and spiritual transformation. Each of us needs to be awakened to a per-sonal and compassionate recognition of the inseparable interconnection between our minds, hearts, and bodies; between our physical and psychical well-being; and between our selves and all the other selves in our country and in the world. Each of us needs to stop being a passive observer of the suffering that we know is going on in the world and start identifying with the sufferers. Each of us needs to make a leap that is both practi-cal and philosophical, beyond determinism to self-determination. Each of us has to be true to and enhance our own humanity by embracing and practicing the conviction that as human beings we have free will; that despite the powers and principalities that are bent on objectifying and commodifying us and all our human relationships, the interlock-ing crises of our time require that we exercise the power within us to make principled choices in our ongoing daily and political lives, choices that will eventually, although not inevitably—there are no guarantees—make a difference.

How are we going to bring about these transformations? Politics as usual—debate and argument, even voting—are no longer sufficient. Our system of representative democ-racy, which was created by a great revolution, no longer engages the hearts and minds of the great majority of Americans. Vast numbers of people no longer bother to go to the polls, either because they don't care what happens to the country or the world, or because they don't believe that voting will make a difference on the profound and inter-connected issues that really matter. Even organizing or joining massive protests against disastrous policies and demands for new policies fall short. They may demonstrate that we are on the right side politically but they are not transformative enough. They do not change the cultural images, the symbols, that play such a pivotal role in molding us into who we are.

As the labor movement was developing in the pre–World War II years, John Steinbeck's *The Grapes of Wrath* transformed the way that Americans viewed themselves in rela-tionship to faceless bankers and heartless landowners. In the 1970s and 1980s, Judy Chicago's *The Dinner Party* and *Birth Project* reimagined the vagina, transforming it from a private space and site of oppression into a public space of beauty and spiritual as well as physical creation and liberation. In this period we need artists to create new images that will liberate us from our preoccupation with constantly expanding production and consumption and open up space in our hearts and minds to imagine and create another America that will be viewed by the world as a beacon rather than as a danger.

This need has become more urgent since 9/11. In the words of activist, organizer, and writer Starhawk, "9/11 threw us as collectively into a deep well of grief... The movement

In this period we need artists to create new images that will liberate us from our preoccupation with constantly expanding production and consumption and open up space in our hearts and minds to imagine and create another America that will be viewed by the world as a beacon rather than as a danger.

we need to build now, the potential for transformation that might arise out of this tragedy, must speak to the heart of the pain we share across political lines. A great hole has been torn out of the heart of the world... With the grief also comes a fear more profound than even the terror caused by the attack itself. For those towers represented human triumph over nature. Larger than life, built to be unburnable, they were the Titanic of our day... Faced with the profundity of loss, with the stark reality of death, we find words inadequate. The language of abstraction doesn't work. Ideology doesn't work. Judgment and hectoring and shaming and blaming cannot truly touch the depth of that loss. Only poetry can address grief. Only words that convey what we can see and smell and taste and touch of life, can move us. To do that we need to forge a new language of both the word and the deed."[1]

[1] Starhawk is a veteran of progressive movements committed to bringing the techniques and creative power of spirituality to political activism. *Webs of Power: Notes from the Global Uprising,* a collection of her recent political writings with new commentary, was published in late 2002. www.starhawk.org.

GROWING OUR SOULS

The America that is best known and most resented around the world pursues unlimited economic growth, technological revolutions, and consumption, with little or no regard for their destructive impact on communities, on the environment, and on the billions of people who live in what used to be called the "Third World."

On the other hand, there is little or no national or international recognition of the movement to "grow our souls," which began emerging organically in the United States after the dropping of the atom bomb on Hiroshima and Nagasaki at the end of World War II demonstrated both the enormous power and the enormous limitations of viewing human beings mainly as producers and as rational beings in the scientific sense.

...songs of the civil rights movement, like "We Shall Overcome" and "Ain't Going to Let Nobody Turn Me Around"...helped grow the souls of their supporters all over the country and the world.

At the time, Einstein summed up most succinctly the urgent need for this redefinition of what it means to be a human being. "Technological progress," he warned, "is like an axe in the hands of a pathological criminal. The release of atom power has changed everything but the human mind and thus we drift towards catastrophe. The solution to the problem lies in the heart of mankind. Imagination is more important than knowledge."

"A human being" he said, "experiences himself, his thoughts, and feelings as something separated from the rest...a kind of optical delusion of his consciousness. This delusion is a kind of prison for us, restricting us to our personal desires and to affection for a few persons nearest to us. Our task must be to free ourselves from this prison by widening our circle of compassion to embrace all living creatures and the whole of nature in its beauty."

The nuclear bomb created a great divide in theories and strategies for social change. Henceforth, human beings could no longer pretend that everything that happened to us was determined by external or economic circumstances. Freedom now included the responsibility for making choices. Radical social change could no longer be viewed simply in terms of us vs. them, of victims vs. villains, of good vs. evil, or of transferring power from the top to the bottom. We could no longer afford a separation between politics and ethics. Consciousness and self-consciousness, ideas and values, mere "superstructure" in the Marxist-Leninist paradigm, had to become integral, both as end and as means, to social struggle. Radical social change had to be viewed as a two-sided transformational process,

of ourselves and of our institutions, a process requiring protracted struggle and not just a D-Day replacement of one set of rulers with another.

The 1955–56 Montgomery Bus Boycott was the first struggle by an oppressed people in Western society from this new philosophical/political perspective. Before the eyes of the whole world, a people who had been treated as less than human struggled against their dehumanization not as angry victims or rebels but as new men and women, representative of a new, more human society. Practicing methods of nonviolence that transformed themselves and increased the good rather than the evil in the world, always bearing in mind that their goal was not only desegregating the buses but creating the beloved community, they inspired the human identity and ecological movements which over the last 40 years have been creating a new civil society in the United States.

The sermons of Martin Luther King, Jr., and other religious leaders, produced in the heat of struggle, played a critical role in the success of the Montgomery boycott and ensuing civil rights struggles. But as Rosemarie Freedom Harding, who worked closely with the Student Nonviolent Coordinating Committee (SNCC) activists in the 60s, has pointed out, "Another vital source of support was music, particularly the sacred music of the black experience, which has long been an alchemical resource for struggle: a conjured strength... The songs changed the atmosphere, becoming an almost palpable barrier between demonstrators and police, giving the marchers an internal girding that allowed them to move without fear."[2]

Grace Lee Boggs at the National Exchange on Art & Civic Dialogue, October 2003. Photo © Tony Caldwell.

Prior to the civil rights movement, songs like "Joe Hill" and "Solidarity Forever" had demonstrated the link between music and social action. But the songs of the civil rights movement, like "We Shall Overcome" and "Ain't Going to Let Nobody Turn Me Around" not only energized those on the frontlines. They helped grow the souls of their supporters all over the country and the world.

The publication of Rachel Carson's *Silent Spring* in 1962 added another dimension to the evolving movement towards inner and outer transformation initiated by the civil rights movement. By helping us to see how the widespread use of chemicals and hazardous technologies in post-World War II America was silencing "robins, catbirds, doves, jays, wrens, and scores of other bird voices," Carson awakened millions of Americans to the sacredness of nature and to the need, expressed by Einstein, for "widening our circle of compassion to embrace all living creatures and the whole of nature in its beauty."

The next year Betty Friedan's *The Feminine Mystique* brought small groups of women together in consciousness-raising groups all over the country. Laughing and crying over stories of growing up female in a patriarchal society, women transformed anger into hope

[2] Rosemarie Freeney Harding and Rachel E. Harding, "Radical Hospitality: How Kitchen-table Lessons in Welcome and Respect Helped Sustain the Black Freedom Movement," *Sojourners Magazine* (July–August 2003).

and created a social and political movement much more participatory and closer to daily life than just going to the polls and voting for someone else to represent you. Some three decades later, the transformative power of women's story telling has been captured by playwright Eve Ensler in *The Vagina Monologues,* a dramatic compilation of women's soliloquies. Every year, in order to raise both funds and consciousness, thousands of women's groups all over the country and the world reproduce or produce their own version of these monologues, turning the monologue art form itself into a movement.

As the civil rights movement, the environmental movement, and the women's movement were gaining momentum, small groups of individuals, especially on the West Coast, were coming together in workshops to open themselves up to new, more spiritual ways of knowing, consciously replacing the scientific rationalism that had laid the philosophic foundation for the modern age. To become truly human and to really know truth, people were discovering the value of summoning up all our mental and spiritual resources, constantly expanding our imaginations, sensitivities, and capacity for wonder and love, for hope rather than despair, for compassion and cooperation rather than cynicism and competition, for spiritual aspiration and moral effort. Instead of either/or, reductive, dualistic, and divisive or "blaming the other" thinking, this movement affirmed the unity of mind and body and of the spiritual with the material. It advocated a consciousness that rejects determinism or the belief that we are limited by the past that repudiates all absolutes, that finds joy in crossing boundaries, that is naturalistic instead of supernatural, and that strives for empowerment rather than power and control.

[3] New York: Harmony Books, 2000. Since spring 1999, the Positive Futures Network, publishers of *YES Magazine,* with the support of the Fetzer Institute, has been hosting two State of the Possible retreats a year to acquaint cultural creatives with one another.

Today millions of Americans are part of this organically evolving cultural revolution. According to Paul Ray and Sherry Anderson in their carefully researched book, *The Cultural Creatives*, these Americans total about 50 million, or 20 percent of the population, and include people from all walks of life and from all ethnic groups and, not unexpectedly, more women (60 percent) than men.[3]

These Americans are not political in the conventional sense. Although most cultural creatives are progressives, having participated in or supported the human identity and antiwar movements of the second half of the twentieth century, they have not organized into a national movement to struggle for state power or "more" for themselves. They have no known leaders or national spokespeople. Yet because they believe in combining spiritual growth and awakening with practical actions in their daily lives, they are having a profound effect on American culture.

For example, most reject the getting and spending that not only lay waste our own powers but put intolerable pressures on the environment. They try to eat home-grown rather than processed foods, maintain physical well-being through healthy habits rather than by dependence on prescription drugs, and try to make livings in ways that are in harmony with their convictions.

Depending on skills, interests, and where they live, most carry on this cultural revolution in their own way. For example, a doctor may decide to practice alternative medicine, a teacher will try to create a more democratic classroom, a businessman will try to replace

competition with cooperation in his firm or may quit his business altogether in order to act as consultant to community organizations. Whatever their line of work, they participate in a lot of workshops because they view themselves and the culture as works in progress.

The social activists among us struggle to create actions that go beyond protest and negativity and build community, because community is the most important thing that has been destroyed by the dominant culture. For example, at mass demonstrations against NAFTA [North American Free Trade Agreement] or FTAA [Free Trade Area of the Americas], Starhawk organizes small affinity groups for democratic decision-making and to combine community-building with protest.

4 See *Another World Is Possible* (Seattle, WA: Moving Images, 2002), 24-minute video of the 2002 World Social Forum, www.movingimages.org.

What unites us is not an organization or leaders but the sense that we are in the middle of what Buddhist writer Joanna Macy calls a "Great Turning."

Whether or not it is recognized by the corporate-controlled media, the Great Turning is a reality. Although we cannot know yet if it will take hold in time for humans and other complex life forms to survive, we can know that it is under way. And it is gaining momentum, through the actions of countless individuals and groups around the world. To see this as the larger context of our lives clears our vision and summons our courage.

This "Great Turning" is not only taking place in the United States. The "Battle of Seattle" in November 1999 announced the birth of a new movement of millions all over the world who are determined to honor and protect local places, communities, and resources from destruction by global corporations. The first World Social Forum in January 2001 attracted 20,000 activists to Porte Allegre, Brazil, to proclaim that "Another World Is Possible." Since then many more thousands have gathered at successive annual forums, the fourth and latest bringing 80,000 to Mumbai, India, in January 2004. Since the second World Social Forum, held after 9/11, dancing, poetry, puppets, chanting, and drumming have been as much a part of this "another world" as seminars and workshops.[4]

...it would be easy to abandon all hope for Detroit's future or to be satisfied with pseudo-solutions like casinos and luxury sports stadia. Yet precisely because physical devastation on such a huge scale boggles the mind, it also frees the imagination to perceive reality anew.

REBUILDING, REDEFINING, AND RESPIRITING DETROIT

It is within the context of this "Great Turning" that we are currently struggling to rebuild, redefine, and respirit Detroit. Nationally and internationally, Detroit has become a symbol of the end of industrial society. Physically it is almost as devastated as Dresden, Berlin, and Tokyo after the massive bombings of World War II. Buildings that were once architectural marvels, like the Book Cadillac hotel and Union Station, lie in ruins. Many of the institutional structures that remain are fenced in or gated and in most neighborhoods people live behind triple-locked doors and barred windows.

Under these circumstances, it would be easy to abandon all hope for Detroit's future or to be satisfied with pseudo-solutions like casinos and luxury sports stadia. Yet precisely because physical devastation on such a huge scale boggles the mind, it also frees the imagination to perceive reality anew; to see vacant lots not as eyesores but as empty spaces inviting the viewer to fill them in with other forms, other structures that presage a new kind

of city embodying and nurturing new life-affirming values in sharp contrast to the values of materialism, individualism, and competition that have brought us to this denouement.

That is what my late husband James Boggs, Sharon Howell, and I have been trying to project ever since 1988 when, in the course of our struggle with Detroit Mayor Coleman Young over casino gambling, he called us naysayers and demanded to know "What is your alternative?"

From the very beginning Detroit Summer has emphasized the pivotal role that art plays in transforming how we imagine ourselves and the places where we live.

Thanks to that challenge and drawing on our movement experiences, we began to understand that restoring Detroit means much more than looking at buildings, businesses, and economic relationships. It means creating ways and means to help Detroiters re-imagine our city in order to rebuild it. To achieve that goal we knew we had to start with young people because, in our rapidly changing and increasingly chaotic world, they are the ones most involved, consciously or unconsciously, in trying to discover who they are and what to do with their lives.

In that spirit, in 1992 we founded Detroit Summer, a Multicultural, Intergenerational Youth Program/Movement to rebuild, redefine, and respirit Detroit from the ground up.

Our inspiration for Detroit Summer came from two sources: (1) the Freedom Schools that SNCC activists organized during Mississippi Freedom Summer, in which children and adults were motivated to learn because they were empowered to view themselves as change agents and first-class citizens; and (2) MLK's call for programs that would involve young people in "self-transforming and structure-transforming," "direct actions in our dying cities," and for "new forms of work for those for whom traditional jobs are not available."

Detroit Summer started out by engaging youth volunteers in three main activities: painting public murals to reclaim public space; planting community gardens to re-connect young people with the Earth and with the community; and intergenerational and peer dialogues to share our fears, hopes, and dreams.

From the very beginning Detroit Summer has emphasized the pivotal role that art plays in transforming how we imagine ourselves and the places where we live.

Since the first year of Detroit Summer, we have created some 20 murals all over the city, each designed by youth volunteers and a master artist in consultation with the community. At first, we had a very difficult time finding any one to give us the public space for a mural. People said that gangs would deface the murals so there was no point in doing them. Finally we found a principal at Maybury School in southwest Detroit who agreed to give us a wall on the outer edge of the school property. We were also fortunate to have as our master artist Ray Jimenez, a Chicano and former gang member from Fresno who was using art as a way of spreading a message of peace in the community.

One day, as Ray was working on the mural with about 20 neighborhood kids, he saw a figure walking down the street that reminded him of his mother. The similarity was so striking he followed her to talk. When the woman turned around, she looked so much like his mother that Ray was speechless. It turned out that the woman was his mother's

sister, separated for nearly 25 years, who lived down the block from the mural. Her son, Dave, became part of the mural project. If his cousin could come 2,000 miles to a city he didn't know to make a difference, Dave said, the least he could do was "get off my ass and walk to the end of the block." That year Dave joined his neighbors to form the Clark Park Coalition, a group of citizens who restored the neighborhood park through their volunteer energies.

This story is an example of the capacity of art to reconnect people both literally and metaphorically. Public art—created within a community context, bringing together gifted artists with community members of all generations—provides a means of recreating community bonds. From those bonds, new energies emerge, creating new connections, instigating new changes.

Our community gardening activities immediately attracted former auto worker Gerald Hairston, passionate environmentalist and father of the community gardening movement in Detroit. Gerald introduced us to the Gardening Angels, a loose network of community elders, many of whom had come from the South and who were already growing food for themselves and the community on vacant lots. He also led us to Paul Weertz, a science teacher at Catherine Ferguson Academy (CFA), a public high school for teenage mothers, who was helping his students learn respect for life and for the earth along with math and science by raising farm animals, planting a community garden and fruit orchard, and building a barn. As a result, instead of dropping out in large numbers, 70 to 80 percent of the young ladies stay in school and go on to college.

Across the street from CFA were a couple of abandoned houses that Deborah Grotefeldt, an artist from Project Row Houses in Houston, suggested that we buy and rehab for emergency use by CFA mothers. On the corner between the two houses Detroit Summer youth, under the mentorship of Grotefeldt, landscape architect Ashley Kyber, and Trisha Ward of Art Corps/LA, then created an art park as a meeting and story-telling place for neighborhood residents. As a result, the neighborhood is coming back to life. A CFA teacher has bought and renovated the abandoned house next to one of the Detroit Summer houses. A family down the street has fixed up its own house and bought two neighboring houses to rehab for other family members. CFA students are using an EPA grant to do soil testing in the neighborhood and have reported their results and proposals back to the community at a community festival.

The success of the *Art Park/Soil Testing and Remediation* project in revitalizing the CFA neighborhood inspired us to embark on a similar effort in the neighborhood near the Detroit's Cultural Center, which once housed Detroit's Chinatown but has now been largely abandoned. To bring diversity to a city that has been too narrowly viewed as black and white, Asian-American university students embarked on a project with local Asian Americans to revive Chinatown. To launch the project, they created a mural linking the struggle for justice for Vincent Chin, an Asian-American Detroiter murdered by two auto-workers on the eve of his wedding in 1982, to African-American struggles for civil rights. The mural, at ground level, has transformed the space facing it into a courtyard where Asian-American, African-American, and Euro-American residents of the neighborhood are beginning to interact with one another.

Out of their own need to articulate and communicate in the dynamic, pulsating rhythms of hip hop and rap, they have created weekly Poetry Workshops for Social Change and an independent media center which they call "Loud and Clear."

Meanwhile, to help expand the mural message movement, the Boggs Center, in collaboration with the Department of Transformation of the Detroit Public Schools and the College of Creative Studies, co-sponsors *Artists and Children Creating Community Together* (AC3T), a program which involves elementary school children mentored by College of Creative Studies students, in producing drawings that are then transformed into giant murals to hang on the outside walls of the school. AC3T murals now hang on the walls of four Detroit schools: Cooper School on the east side, King School in northwest Detroit, Webster School in southwest Detroit, and Thirkell School in the neighborhood known as Northwest Goldberg. With the energy generated in the community by the Thirkell School murals, Northwest Goldberg residents have been able to mobilize weekly clean-ups and other restorative activities like community gardening.

Grace Lee Boggs at the National Exchange on Art & Civic Dialogue, October 2003. Photo © Tony Caldwell.

Inspired by the community gardening movement, students in the School of Architecture of the University of Detroit Mercy, under the leadership of visiting architect Kyong Park and department head Steve Vogel, created Adamah, a vision for rebuilding a devastated two-and-a-half square mile area on the east side not far from downtown Detroit. The Adamah vision, based on urban agriculture (Adamah is Hebrew for "of the earth") includes unearthing Bloody Run Creek, which had been covered over and absorbed into the city's sewer system, and turning it into a canal for both recreation and irrigation. The vision includes community gardens, greenhouses, grazing land, a shrimp farm and dairy, a tree farm, lumber mill, windmills to generate electricity, and living and work spaces in the former Packard auto plant.

As people watch the 20-minute Adamah video you can almost feel their minds and imaginations expanding. Community residents draw from Adamah ideas for rebuilding their own neighborhoods. Out-of-towners start wondering how they can spend time in Detroit to help build the movement.

In 2001, Gerald Hairston passed away unexpectedly and Los Angeles community artist Nobuko Miyamoto who, like so many others, had been inspired by his passion for community gardening, wrote the song "I Dream a Garden" in his memory. To accompany the song she choreographed an Obon folk dance, a Japanese-American circle dance, Detroit-style, incorporating Japanese, African, Latin, and Native-American rhythms and dance steps. She also worked with landscape architect Ashley Kyber to create a sculpture garden called "Gerald's Griot Garden." The project culminated in a Harvest Celebration, which began with elders and young people telling stories about Gerald in the Griot Garden and ended with over 200 people dancing the multicultural folkdance created by Nobuko to honor the earth that meant so much to Gerald.

As one thing has led to another, Detroit Summer, which began as a three-week program in 1992, has become year-round with new programs that have come out of the creativity of the young people who now provide the core of its leadership. Out of their own need to articulate and communicate in the dynamic, pulsating rhythms of hip hop and rap, they have created weekly Poetry Workshops for Social Change and an independent media center which they call "Loud and Clear."

Out of complaints about their lack of mobility has come Back Alley Bikes. They acquired some used bikes from supporters, found a skilled mechanic to train them in bike repair, and then invited neighborhood youth to select, repair, and take home their own bikes. The result is an alternative method of transportation with which young people are putting the neighbor back into the 'hood.

Over the years Detroit Summer has demonstrated that the capacity of young people to make social and political judgments is directly linked to the growth in self-confidence that they gain from working with one another and making practical judgments and choices in concrete, mundane activities like gardening, rehabbing houses, painting community murals, and repairing bikes.

It is because our school systems deprive children and young people of opportunities to engage in activities like these as a natural and normal part of the curriculum that they are now in such crisis. All too many classrooms have become war zones where teachers can't teach and children can't learn because we are still following the "command and control" model created 100 years ago to prepare young people for factory work.

To address this situation, teachers, students, parents, and community activists have been meeting at the Boggs Center with the goal of discovering a form that would inspire all those involved in the educational process to begin reimagining education. After much sharing of personal stories, we have decided to follow the examples of the women's movement and the Mississippi Freedom Schools and to create the "Freedom School Monologues," a dramatic compilation of testimonials by students, teachers, and parents about their school experiences. Forty years ago Freedom Schools were created because the existing school systems (like ours today) had been organized to produce subjects, not citizens. To bring about a "mental revolution," reading, writing, and speaking skills were taught through the discussion of black history, the power structure, and the need to build a movement to struggle against it. We hope that the "Freedom School Monologues" will stimulate ideas for a new participatory democratic model whose aim is to develop young people into critical thinkers, decision-makers, and responsible citizens.

1

Arts Council of Greater Lima

::: **ALLEN COUNTY COMMON THREADS THEATER PROJECT**

SUE WOOD

PREFACE

A scene from Passing Glances.
*Photo © Todd Campbell/
The Lima News.*

[1] Unless otherwise noted, all
excerpts from the play *Passing
Glances: Mirrors and Windows
in Allen County*, written by
Michael Rohd, are drawn from
the voices of community members
who were interviewed by
Rohd and Sojourn Theatre.

*What helps us make sense of history, of things we can't touch? When we're not stand-
ing, or floating, in the middle of it? Faith. Faith is about what you can't see. Memory.
The image of that which is past, or gone. And maybe, just maybe as important—poetry.
Art. Meaning that someone, or someones, conjure up—construct—to bring the chaos
of memory, and the invisible threads of faith, into a room.*

*There is a poetry in the stories of everyday life that can escape the eye at first glance.
We all have stories. Whether we're a person, a family—a community. How they con-
nect, what they mean, what they say about who we are and how we live together…
It's easy to pass by the poetry. Just like a memory fades, or is re-remembered different
as time goes by. Just like faith can be tested in quiet moments of reflection and loud
moments of tragedy. There are, if the eye watches, and the ear listens, moments worth
not missing. Voices worth not ignoring.[1]*

—Excerpt from Passing Glances

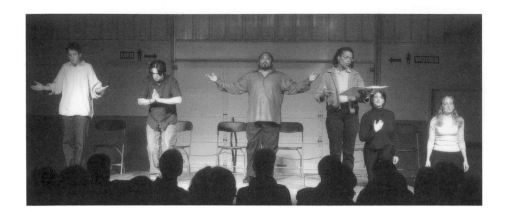

A script reading of scenes from Passing Glances. *Photo © Dean Brown/ The Lima News.*

In recent years, in Ohio's Allen County, issues of race, leadership, and water resources have divided city and county officials and residents. Lima, the county's largest city, suffered from loss of industrial jobs and declining tax base, shrinking population, and downtown and neighborhood decay. In the suburbs and rural farmlands, county residents mistrust city officials who control needed water resources and have made moves toward annexing the county in order to revitalize the city. Issues of race have persisted over many years between the largely white rural and suburban population and the significant African-American population in the city of Lima.

The *Allen County Common Threads Theater Project* sought to address these issues. Building upon a successful 2000 event called Common Threads (based on a European community arts model), the Arts Council of Greater Lima, Bluffton College, and a steering committee of interested citizens set out to develop a second *Common Threads* endeavor. The goal was to engage a large crossection of both city and county residents and leaders in dialogue about issues of "trust among leaders" and "respecting differences." With the support of Animating Democracy, the project revolved around an extended residency by Sojourn Theatre and its artistic director, Michael Rohd. Over 14 months, company members met and interviewed 400 residents. Their words and perspectives fueled Rohd's script for the "poetic documentary" play, *Passing Glances: Mirrors and Windows in Allen County.* Meanwhile, dialogue consultant Patricia Romney trained 40 local people in dialogue facilitation skills. Together they designed and facilitated community dialogues in relation to script readings of the in-progress play and later after public performances of it. They designed a culminating *Common Threads* conference involving over 200 citizens in seeing the play, discussing the issues, and forming action teams to address them.

Over 7,000 people from 15 of the 16 villages, townships, and towns of Allen County were involved in some way in the *Common Threads* project. Although African-American individuals were identified as new leaders through the project and many white residents expressed new understanding of issues of race, on the whole the impact was seen as limited with continued hard work to be done. But the project took important and productive steps "along a continuum of action toward a more democratic community." *Common Threads* action teams are at work to improve relationships among city and county elected officials and have linked with the Chamber of Commerce to propose a citizen's long range community plan. The *Common Threads* dialogue process continues to be used in school

and community settings supported by the cadre of trained dialogue facilitators. And, the arts are perceived as a way to address community issues.

This case study by Sue Wood, Animating Democracy project liaison to the *Common Threads* project, provides an in-depth view of Sojourn Theatre's intensive community-based theater process. The company's dialogic research and creative development approach afforded an opportunity for diverse voices to be heard and built a foundation of trust and honesty for the project. The case describes the project's broad-based community leadership—a core team of organizers and "sector leaders" who effectively linked to various constituents—as well as innovative media partnerships. The case also analyzes tensions that were constructively addressed throughout the project including: naming and framing the issue; negotiating insider/outsider concerns; as well as the collaboration between artist and dialogue consultant. Finally, the case study looks at the challenges faced by the arts council and other community leaders to sustain the important forward steps made by the *Common Threads* project.

BACKGROUND

The complexities and scope of the Common Threads project are emblematic of the tangle of civic issues from which it developed. Lima, Ohio—a city of 40,000 people in a county of 108,500—has lost 10,000 industrial jobs since 1960 and 29 percent of its population since 1970, largely due to the flight from the city of middle class white and black residents. The resulting lost tax base, decay of city neighborhoods, and declining infrastructure have exacerbated tensions between urban and suburban/rural citizens. This tension is largely apparent in the complete mistrust between city and county officials. The mayor of Lima, Dave Berger, running unopposed for a fourth term when this project began, attempted to revitalize the city through annexation and new business development, but was unable to engage in productive dialogue with his rural counterparts, leading to inaction and further mistrust. Water became a prevailing metaphor for this estrangement, as the city had treated water, which the townships needed. When the Lima mayor made water a leverage point, county residents, believing the city was holding them hostage, further declined to cooperate. As city residents receive fewer services and county residents' water supply dwindles, each side views the other as insensitive and intractable.

Racial prejudice and mistrust simmer just under the surface, and frequently bubble to the top. Lima is now 26 percent African American and city residents, particularly African Americans, view county residents as racist and insular. County residents are increasingly reluctant to enter the city, which they perceive as unsafe. Following the Rodney King incident in California in 1993, which raised national issues about law enforcement and race, civic leaders initiated a Study Circles project focused on race and race relations. Organized through churches, the program engaged 8,000 youth and adults over a 10-year period and resulted in the training of numerous local facilitators. The Lima Study Circles program became a national model, and set the stage for the *Common Threads* initiative.

In spite of the success of the Study Circles, race relations and city/county tensions continued to fester throughout the 90s. As noted in an early document sent to Animating Democracy by the Arts Council of Greater Lima:

Allen County workers were losing more and more good paying jobs, County and city elected officials were stalemated because of the conflicting interests of their constituencies, the City of Lima's population and tax base were decreasing with city services barely maintained, the farm community faced new problems of diminishing resources, and the community of color continued to have little access to the networks it needed to find employment opportunities.

In 2000–2001, some civic leaders convened to examine the impediments to economic development in the county. They identified racial differences and distrust of leaders, thus laying the groundwork for framing the issue for *Common Threads*.

Cultural Context

During this economically and civically challenging period, the Council for the Arts of Greater Lima (CFA) continued to administer artist residencies in schools and multidisciplinary arts festivals and to promote historic preservation and the role of arts in everyday life. Increasingly, CFA began to view its role as that of a broker—an intermediary between artists and artistic expression and the civic realm. Certainly community engagement and issue-based artistic work was a priority for CFA when Martie MacDonell, its leader from the mid 1960s to 1985, was at the helm. From 1986 to 2000, MacDonell led another nonprofit organization, American House, which explored Allen County's industrial, cultural, and ethnic history through oral history programs, exhibits, documentaries, drama, and other artistic means. After several other CFA executive directors came and went, CFA leadership passed to Bart Mills in the late 90s and MacDonell agreed to become an advisor to the board. MacDonell was the architect of the *Common Threads* project, and she would serve as its unpaid project director. Her investment of personal and professional resources in this project had significant impact on its overall direction and success.

Also part of the cultural landscape at this time was the large Veterans Memorial Civic and Convention Center of Lima and Allen County, located in downtown Lima. Because the Civic Center was built to offer programs of interest to all area citizens, its board and staff grappled with the issues of how and by whom it would be used, and how to sustain it financially. A small but vibrant nonprofessional theater community also struggled with insufficient visibility and shrinking resources.

***Common Threads:* Phases One and Two**

Against this backdrop, Bluffton College developed the *Common Threads* project in 2000. Originating in Europe and brought to local attention by MacDonell, Common Threads is a process that stimulates community art-making to address area issues. In Allen County, this initial *Common Threads* endeavor claimed the key civic issues recently identified by local leaders, restating them slightly as *respecting differences* and *trust among leaders*. With Bluffton College—a small, private college about 20 miles from Lima—as the sponsor and Judy Gilbert, assistant to the president of Bluffton College, as project coordinator, *Common Threads, Phase One* identified and exhibited the work of six Lima area organizations already engaged in community art-making that addressed issues of peace and diversity.

As an outgrowth of Phase One, MacDonell and Gilbert recruited a steering committee of diverse arts and social service practitioners to develop *Common Threads* and plan a

conference for the fall of 2001 to introduce the *Common Threads* approach to the larger Allen County community. Meanwhile, MacDonell learned of Animating Democracy, and, seeing the first *Common Threads* project as a launch pad, applied for and received Animating Democracy funding for *Common Threads, Phase Two*, to be sponsored by the Council for the Arts of Greater Lima. Continuing to work with the themes of respecting differences and trust among leaders, MacDonell, Gilbert, and Mills recruited theater artist Michael Rohd and dialogue specialist Patricia Romney for their Animating Democracy project, which would feature an original theater production created by Rohd and his company. Building on the Study Circle experience, the project would utilize Romney's skills to train local dialogue facilitators in arts-based civic dialogue. Rohd, founder and artistic director of Sojourn Theatre of Portland, Oregon, and Romney, CEO of Romney Associates of Amherst, Massachusetts, would visit Allen County multiple times over the duration of the project, and would be involved in the culminating performances and dialogues at the Civic Center and throughout the community in October 2002.

In addition to Bluffton College and the Civic Center, the *Common Threads* leadership team recruited other partners for *Common Threads, Phase Two*. Both the City of Lima and the Board of Commissioners of Allen County came on board, a hopeful signal that productive interaction across the city/county boundaries might indeed occur through this project. Lima's daily newspaper, *The Lima News*, was also a partner.

Project Goals
In a list of goals, articulated at the outset of the project or emerging during early months of planning, project leaders proposed that:

- Citizens of Allen County would view civic issues from multiple perspectives and increase their understanding of the two key issues: trust among leaders (rural, urban) and respecting differences (blacks, whites).
- Citizens not previously involved in urban or countywide issues would have access to opportunities and events.
- City and county elected officials would engage in dialogue and discover common ground.
- Emerging civic leaders in Allen County would be identified and nurtured.
- Local residents would receive training in arts-based civic dialogue facilitation skills.
- The Council for the Arts would build its capacity to raise funds for and implement issue-based arts projects among local and regional arts and cultural providers, artists, and community development groups.
- Public awareness about the role of the arts in civic life would increase and residents would have access to resources and information through the media, a website, conference, and arts events.

THE *COMMON THREADS* PROJECT
Early Planning for Theater, Dialogue, and Project Leadership
Rohd and Romney came to the project as newcomers to Lima but as experts in their respective fields. Rohd, experienced in engaging the community in theater-making, intended to interview local residents and create and perform an original theater piece

that used movement and personal narrative to explore many perspectives and complicated questions around issues of leadership and diversity. Romney, skilled in a variety of dialogic approaches, would conduct pre- and post-performance dialogues herself and would also train local facilitators in order to build the community's capacity to continue arts-based civic dialogue. Romney would emphasize "listening with a sense of wonder," in order to suspend judgment and foster understanding that could lead to individual or collective action.

Because Rohd and Romney were outsiders, integrating them into the local leadership team was both challenging and stimulating. Early planning sessions in MacDonell's family room with Rohd, Romney, MacDonell, Mills, Gilbert, project coordinator Chris Rodabaugh, and Theresa Henry, Bluffton College multicultural director, were lively, provocative discussions as the insiders and outsiders negotiated their various understandings of potent topics such as race, leadership, power, and city/county tensions. The insiders were living in the environment in which incidents and tensions erupted regularly. The outsiders came with experiences and understandings from a broader perspective, and were often able to see clearly and name directly what was a tangled muddle for the Lima residents. This was true about the issue of race, which Romney and Rohd both saw clearly needed to be at the forefront. It was clear to Rohd, Romney, and the local leadership team that they needed to seek more diversity—farmers, African Americans—on the planning team, and Rohd and Romney came to realize that the project was originally framed as an Allen County project so as not to be seen as tilted toward the city's agenda.

Ready to Launch: *Common Threads* Conference and Animating Democracy Learning Exchange

Two significant convenings served as test ground and launch pad for the project. The first, the *Common Threads* Conference, was held at Bluffton College in October 2001. This conference was planned to bring together community members and civic leaders from the city and the county to learn about the *Common Threads* model as developed in Europe; view the six community arts projects; and examine the issues of *respecting differences* and *trust among leaders*, which had been identified earlier as impediments to economic development. In addition, MacDonell and Gilbert saw the convening as a transition to their Animating Democracy project, which would be called *Common Threads, Phase Two*. To that end, both Rohd and Romney presented at the conference to introduce themselves and their work to the community. Rohd developed four monologues about annexation, race, leadership, and trust based on his first 20 interviews; these were performed, reader's theater style, by four actors (two white Sojourn company members and two local African-American actors). The monologues were presented four times to audiences of 50 each. Following each monologue, audience members generated questions raised by the piece, and these were recorded for future reference. Meanwhile Romney presented her own session on dialogue where she modeled her techniques and approach, eliciting thoughts and images about Allen County from the group and emphasizing the importance of "curiosity" and "perseverance" during difficult moments. In terms of numbers, this conference was a highly successful event, drawing almost 450 people from Lima, Allen County, and the Bluffton College population. At the same time, the planning team became aware of some problems. In the minds of some participants, there were suddenly large expectations for what the project could achieve, while others expressed confusion

Early planning sessions in MacDonell's family room...were lively, provocative discussions as the insiders and outsiders negotiated their various understandings of potent topics such as race, leadership, power, and city/county tensions.

about the project and its timeline. *Common Threads* organizers recognized that clarity of communication with the public would be a demanding and constant challenge.

By the time of the Animating Democracy Learning Exchange in Chicago in November 2001, and with the *Common Threads* conference behind them, MacDonell, Gilbert, and Mills were ready to do some solid planning about project goals, events, and public relations. With the help of Lima resident Cathy Eldridge, a recent addition to the team, they developed the beginnings of a project work plan at the conference. Animating Democracy evaluation consultants were on hand to assist in the creation of an outcomes model with activities, short-term goals and outcomes, and long-term impact based on current conditions and needs (the goals as stated in the previous section derive from this outcomes model). The process of developing these planning documents in the synergistic environment of a national conference proved clarifying and energizing for the Allen County team.

Expanding Participation and Framing the Issue

> *There's a feeling of mistrust. A sense that Lima and the county will act in a way that will help themselves—at the expense of anyone else. Human nature. Once you expect mistrust, you'll look for mistreatment. Add an actual history of mistreatment and you have the potential for a bona fide lens of anxiety.*
>
> —*Excerpt from* Passing Glances

Back in Allen County, MacDonell and her team had a work plan and an outcomes model in place, but they were facing some tensions. There were serious issues on the table, and decisions to be made. The Bluffton *Common Threads* conference had brought questions and dilemmas to light that would become the focus of intense conversation and problem-solving efforts in the months ahead. Key groups were underrepresented at the conference. The absence of rural and township residents was apparent. According to Mills in an e-mail to the leadership team on November 11, county residents knew that city residents were pushing annexation, and they didn't need a conference or an arts project to express their views on this topic. "Don't go sneaking around worrying about how you're going to get me to talk. Come out here and ask me what you want to know," said one.[2] Mills also reported hearing that city and county residents don't yet understand what *Common Threads* or this project is really about. He stated, "I think the urban/suburban issue is, at its core, about race." African-American participation in the conference was not as high as expected either. On the day of the conference, funeral services were scheduled for one of the revered members of the community of color, and many of the African Americans planning to attend the conference saw the funeral as a higher priority. The team needed to address how to get that population meaningfully engaged in future activities.

So MacDonell and the team set out to expand project leadership and participation. They wanted to be as inclusive as possible, and to recruit and get buy-in from groups that had not been well represented at the conference, including rural farmers, suburban residents, city and county officials, and African Americans. The leadership structure that finally evolved was a series of concentric circles. In the middle was the core team of 11 people, including those already involved, which expanded to bring in Martin Stephens, an African American employed at the Ford Motor Company, and Jay Beggs, a leader in the farming

[2] Unless otherwise noted, the quotes and comments that follow are drawn from a series of e-mail and phone conversations between team members from November 2001–January 2002.

community. The next circle was made of sector leaders, 20 people who were opinion leaders in various sectors in the county and who would function as advisors. MacDonell used her long-time connections to draw in people and get commitments to the project. Finally, in the outermost circle were the residents at large, who would be tapped by the various sector leaders to be interviewed by Rohd or to participate in dialogue activities conducted by Romney.

In addition to worries about inclusion and representation, the group also deliberated about the project's ultimate goal: was it action and change or knowledge and understanding? MacDonell wrote that a goal would be "...not to necessarily act, but to know. Wouldn't that alone be progress in Allen County?" But Romney told the team repeatedly that, based on her conversations at the conference and with African-American residents of Lima, including core team member Theresa Henry, she thought the black community wanted change (particularly in the areas of jobs and empowerment) and was tired of just talk. Could the project be considered a success if people's understanding and awareness increased but nothing really changed? This question would recur over and over throughout the duration of the project.

Meanwhile the core team continued to struggle with framing and naming the issue that would drive the work forward. Rohd and Romney asserted that *respecting differences* was a euphemism for *race,* and other team members worried that *trust among leaders* was a euphemism for *annexation.* MacDonell feared that to name the issue of race directly would keep rural people out; already some feedback from the conference monologues indicating that there was too much about race. MacDonell wrote to Romney, "This is not strictly a race relations project. If it becomes that we will lose the perspectives of several important sectors in Allen County." Romney argued that NOT to name it directly would cause blacks to withdraw in frustration. She advocated for naming racism as one important focus within the many differences the project addressed. The question of *trust among leaders* led to a discussion about power. The team asked itself: are we really talking about power? Rohd expressed his notion that whites always feel their inherent power is threatened when non-white voices are featured in a work of art. Mills wrote, "How can people currently in power promote dialogue about the power structure without drawing distrust from those who perceive themselves as powerless?"

Again, MacDonell was cautious. She believed she was speaking from experience, having been involved with race and diversity issues in Lima since the early 1960s. During the civil rights struggle in Lima, she served on the board of Mizpah Community Center, where African-American families rallied to protest inequity in the schools for their children, and confronted racist white parents and school administrators. She believed project success required broad participation from diverse constituencies, including some of those same conservative, racist populations that had remained unchanged over the 40 years since the civil rights days. And she worried: "...The power metaphor might not make it in this conservative, Midwestern environment—people would shy away... Trust/distrust is an easier concept..." At the same time, she was very aware that the result of a successful project might be a shift in power from her group (upper middle class white residents), where she believed new effective leadership was at an all-time low, to a new generation of leaders, probably African American. Of this possibility, she wrote, "Perhaps the answer is

for those people who are seen as the power structure to step aside and let the leadership arise from those unheard voices." This is an acknowledgment from the architect of this project that while its public success may hinge on a delicate dance of language, true success could indeed result in real power shifts within Allen County. So *respecting differences* and *trust among leaders* remained the named public issues, but behind the scenes and in small groups, talk of race, racism, power, city/county interdependence, and annexation came out into the light.

Theater and Dialogue Processes

Rohd and Sojourn company members conducted extensive research into Allen County. According to MacDonell, they were sent subscriptions to local newspapers, maps, demographic information charts of the political structure, videotapes of *Telling the African American Story in Lima,* and other documentaries. Then, in February 2002, Rohd and Romney both returned to Allen County for a series of kick-off activities leading toward the creation of the production and the design of dialogue training and events. Thirty-four people, including *Common Threads* conference participants and the newly constituted sector leader group, attended two theater and dialogue workshops conducted by Rohd and Romney. To model his process, Rohd led some role-playing and conducted an interview to demonstrate how he draws material for the play. Romney engaged the group in dialogue activities, emphasizing listening for understanding, and led some follow-up discussions with questions raised at the conference. In addition to the workshops, Rohd and Romney were both out in the community, with Rohd conducting interviews and Romney making contacts in the black community. The decision was made to introduce the broader community to the project at a Work-in-Progress event at the Fairgrounds in May, which would include both a theater performance and dialogue.

Several tension points emerged leading up to this May event. The first concerned broad participation. Although the sector leader group had good representation, there were only four blacks and two rural residents at the February workshops. Second, Romney continued to push for clarity: did the sector leaders know which sector they represented and was it clear to them what their jobs were? Who would fill the role of the local dialogue facilitators, and with whom would they facilitate dialogue?

In addition, tension between MacDonell and Mills emerged. Although Mills was now executive director of CFA, it was MacDonell, as project director, who had the vision and also made the day-to-day decisions. Mills expressed concern that MacDonell would try to exert control, even over the final content of the script. MacDonell felt that Mills could not remain "neutral enough" to be effective with all constituencies. For the most part, these points were all aired and discussed by the core team, including the perception on the part of many that "three white girls are running the show" (a reference to MacDonell, Gilbert, and Eldridge).

Michael Rohd performing excerpts from Passing Glances *at the Lima City Council Chambers. Photo © Todd Campbell/ The Lima News.*

Artistic issues also came forward. Working in the form he has called "poetic documentary," Rohd expressed repeated caution about the potential for exploitation of people's stories. At the same time, it was becoming apparent that as he conducted more and more interviews across city/county boundaries, more and more people became interested in and invested in the project. As Rohd proceeded with interviews, he took care to ensure that voices that were not normally part of public conversation on civic issues were present, strong and, varied. He told the team that while the final piece would not advocate politically for a particular point of view, neither would it be neutral: "If half the voices are from non-dominant culture, dominant culture sees a surprising shift from majority to shared status."

In that vein, Rohd began to express concern about his hosts' comfort level and reaction to the theater piece he was creating. He worried that MacDonell wanted balance and neutrality in the piece that could not be present when all voices were brought forward. In March, he reported on a conversation with Brian Miller of the NAACP: "The black community is being squeezed economically in Lima and their cries for change must be addressed if Lima is to be 'saved' and if the city and rural residents are ever to reach a mutual understanding." Martin Stephens agreed: "These (racial and economic) issues have to come to light if any progress is to be made. If one group does not know what the other thinks or is feeling, [then] an assumption is being made that all is well." Rohd believed that if the piece were to catalyze authentic dialogue, this point of view must be expressed, even if it would be hard for some to hear. At the same time, Rohd was also making inroads in the rural and farming communities through his interview process. Rohd knew some of the material he had was challenging for both the rural and urban sides. People were speaking frankly about racial fears and stereotypes, about economic decline and poverty.

While Rohd hoped that continued open communication during the rehearsal process would lead to gradual buy-in from all parties, he worried that MacDonell or someone else might find some material too challenging and press him to tone it down. Also, there was the question of who ultimately owned the artistic product. For these reasons, Rohd and

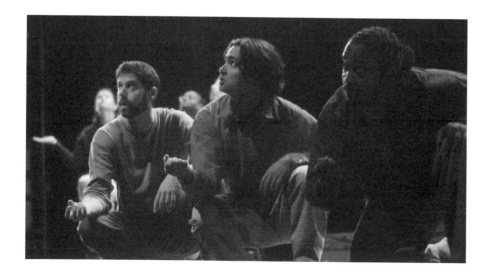

Michael Rohd and company members from Sojourn Theatre in Passing Glances. *Photo © Todd Campbell/* The Lima News.

MacDonell agreed to draw up a letter of agreement that would spell out roles, responsibilities, authority, and ownership. Through a series of communications over time, they worked through the critical element—that of Rohd's artistic freedom. The following excerpted exchange exemplifies their struggle:

MacDonell: I understand the new work will be your property, but that you will give us permission to use it for educational purposes.

Rohd: This is right…

MacDonell: I know we will be communicating almost daily about the script…

Rohd: It won't be everyday… I will need some space and time… I will be having conversations with you on the other side of creation rather than in every moment of creating…

MacDonell: Yes, I understand and respect the creative process… The question I can't answer in my mind is what if someone in the core leader group objects strongly to something in the script…?

Rohd: There is a huge chance that it will happen if we are truly working with diverse people with differing perspectives and opinions…

MacDonell: …Yes, and the hope is that everyone does learn from one another…

Rohd: It comes down to partnership and trust… In the end, I have to have the final say… You will have a voice, but not the final one.

In the end, the letter of agreement formalized agreements and understandings that developed over exchanges such as this one. Again, the team's ability to directly probe issues and concerns emerged as its strongest asset. Project leaders were consistently courageous about persevering through these periods of confusion and discomfort.

Rohd knew some of the material he had was challenging for both the rural and urban sides. People were speaking frankly about racial fears and stereotypes, about economic decline and poverty.

Leading up to the Work-in-Progress presentation, Rohd continued interviews and script development. Sojourn Theatre was in residence for eight days leading up to the event, engaging with community members in interview and workshop formats. Concurrently, Romney developed a training curriculum and worked with 44 local dialogue facilitators over two eight-hour days. Some facilitators were new to dialogue work, while others had come through the Study Circles process. In addition to conducting formal, public training, Romney was a force behind the scenes in the community for dialogue-in-action. She had illuminating conversations with Reverend Fails about the black community's need for jobs and empowerment, which she passed on to the team. She coached MacDonell through a tense incident with Brian Miller, head of the local NAACP, concerning some potentially offensive images in a school mural. She helped clarify and solidify the roles of the two African Americans on the core team, Theresa Henry and Martin Stephens. Stephens, who had his own story to contribute to the play, also felt he could be objective about the black experience in Lima, and recognized the importance of listening and dialogue before planning for change and resolution.

Partly because of their unique skills and partly because as outsiders they were viewed as objective, Rohd and Romney were each highly effective in engaging with community members on a deep level. These community connections surely contributed to the success of the Work-in-Progress event in May. One hundred people attended an evening of supper, dialogue, and theater. Before the performance, people sat at round tables and were

guided by the newly trained facilitators to respond, round-robin style, to questions such as: "When I think about Lima and Allen County, I hope---- I worry----." The 45-minute choreographed performance took place on platforms in the fairground's open warehouse. Audience response was positive. People clearly saw and heard themselves and the voices of their neighbors. Post-performance table dialogue included questions such as: "What did you find most intriguing?" "How would you like to see the performance and dialogue work move forward?" Elements identified as needing attention were the uneven skills of the facilitators, lack of time to pursue all questions, and the challenge of capturing the table talk. Overall, the Work in Progress event succeeded as a "dress rehearsal" for the culminating theater and dialogue events coming in October.

Bringing it All Together
By early fall 2002, gear-up for the October events was intense. Three public performances were scheduled for the Civic Center on October 11, 12, and 13—the first to be part of a day-long *Common Threads* conference, and the others public performances. Dialogue would occur at the conference and in conjunction with all performances. Tickets to performances were modestly priced at $5, and, to ensure access to the broad community, a complimentary ticket system was developed, utilizing the sector leaders.

Dialogue training
Romney was in town for three days before the culminating activities to conduct dialogue facilitation training for the core team and the sector leaders, as well as other interested residents. This training consisted of a variety of dialogue exercises for conducting arts-based dialogue with small groups, including practice with both the Public Conversations model for dialogue on difficult issues and Liz Lerman's Critical Response approach to dialogue about a work of art. Beyond the actual training events themselves, Romney's approach was "...to carefully and fully as possible 'co-construct' the dialogue methodology and practice with the people on the ground in Lima." Romney worked closely with Judy Gilbert and Cathy Eldridge and credits them with much of the success of the dialogues.

Script development
Rohd and the Sojourn Theatre company were in residence continually from mid-September on, and they had benefit of a large, fully equipped home owned by MacDonell to live and work in. Altogether, they were in Allen County a total of 50 days over 14 months, and they reached 400 people in 290 different contact events. Script development continued, giving way to selection and shaping. (Rohd had far more material than he needed or could use). Rehearsals ensued; design and technical decisions were made. (Sojourn brought designers and technicians to Allen County as well). *Passing Glances: Mirrors and Windows in Allen County* evolved as a collage of monologues, scenes, tableaux, and movement. By creating composites, cross-cutting and juxtaposing words and images, Rohd's script deftly gathered the many threads in the complicated Allen County tapestry. Audience members would see and hear themselves in the piece ("mirrors") and would get glimpses into the lives of their fellow citizens ("windows").

Not surprisingly, water also became a powerful metaphor. MacDonell states that Rohd was inspired to pursue the water metaphor by the sight of a farmer drinking and washing from a trough of clear water while looking to the sky for rain. "Water would be a motif in

Rohd's script deftly gathered the many threads in the complicated Allen County tapestry. Audience members would see and hear themselves in the piece ("mirrors") and would get glimpses into the lives of their fellow citizens ("windows").

this work," she said: "no rain, too much rain, water as a political issue, water as a symbol of cleansing oneself…water as a religious symbol." At one point during the performance, instead of using umbrellas to protect from rain, actors turned them upside down to catch the water. At another point, actors stepped out from the protective circle of the umbrella and into the falling water.

> We weep water, we sweat water, we bleed water, and in Allen County we argue water… the quality of water—not great. The quantity of water—not enough. Wondering about water—still here… Water has been an issue for 15 years…water—water—water—one day at a time, one drop at a time.
>
> —Excerpt from Passing Glances

The abstract set consisted of modular units augmented by projections on the upstage wall of words and images, including photographs of Allen County. Music underscored and commented on the action and images. The company of nine actors (including Rohd) wore neutral street clothes so as to portray a variety of Allen County residents. The layering of non-verbal passages and "poeticized" language with technical elements such as lighting, projections, and sound contributed to the work's artistic power.

Dr. Patricia Romney leads members of the community in one of the dialogue facilitation trainings.

Barnstorming

In order to promote awareness of the project and attendance at the Civic Center performances, a series of 12 "barnstorming" performances took place in eight rural and urban settings across the county over a period of two weeks in late September and early October. In keeping with the barnstorming tradition of traveling from place to place, making brief stops to do promotions or presentations, small groups of cast members visited locations ranging from churches to Lima city council chambers to a VFW hall and the Allen County farm bureau. The church barnstormings were unique in that they happened during the regular Sunday morning services, reaching whole congregations. Performances at four Catholic masses reached 2,500, and one, during intermission at a gospel concert in a black church, reached 800.

At each stop, a selection of three or four monologues tailored to the specific audience was read, followed by brief dialogue conducted by Rohd or trained local dialogue facilitators. In all, over 3,800 residents were exposed to the project through the barnstorming. The barnstorming was a strategic opportunity that afforded participants the chance to engage in an "intragroup" conversation about these difficult issues with people like themselves. While it is impossible to know how many of these people attended a full performance at the Civic Center, it did create "buzz" about the project in the community.

A dialogue table at the Common Threads *conference, 2002.*

All the little mom-and-pop operations in the 50s are pretty much gone. In the 50s, we had mom-and pop, we had chickens, pigs, and cows. We don't have that anymore. We have specialized operations…There's a very small number I would classify as full-time farmers. Others…have a real 40-hour job, then they come home and farm.

—*Excerpt from* Passing Glances

Dialogue in action

Just prior to the culminating activities of October 11–13, issues emerged about the marriage of art and dialogue. Because Romney was not part of script development and rehearsals, she had not been in Allen County as the piece evolved. Now, three days out, she was here and she needed to settle on a format for the dialogue in conjunction with the public performances. There were two issues brewing. Rohd wanted the dialogue to happen in a space other than the theater, which he felt would be intimidating. Furthermore, he discovered during the development and rehearsal process that the 90-minute running time he had originally envisioned would probably be insufficient. A longer running time, intermission, and the need to move people to a different space could render the audience's time commitment to between three and four hours, which several people on the core team (including Romney and MacDonell) thought was too long.

With so much at stake, and in the heat of technical rehearsals, tensions bubbled up. Romney, Rohd, and MacDonell approached the problem from their different vantage points. Through some tense conversations, they worked for resolution. Rohd understood Romney's concern that the dialogue could be pushed back too late in the evening, detracting from its effectiveness. Romney understood Rohd's reluctance to make last-minute cuts to the show, thereby eliminating key viewpoints contained in the piece. In the end, the team compromised. Rohd did some trimming; Romney and MacDonell decided the post-performance dialogues would be optional, and people who wanted to end the evening after the performance would be able to do so. The core team also decided to hold the dialogue sessions in spaces adjacent to the performance hall rather than in

the performance hall. They agreed on a short transition period so audience members who chose to stay for dialogue could have a snack and a drink and get situated. Rohd, MacDonell, and Romney now agree that had budgets and schedules permitted Romney to be in town more frequently, a fuller collaboration between artist and dialogue specialist could have resulted in easier and earlier resolution to this dilemma. Romney still wonders how much more they would have collaborated if there had been more time. "The work evolved so separately," she says. "In one sense it was so big it needed to."

Culminating conference, performances, and dialogue

With the pieces finally in place, the *Allen County Common Threads Theater Project* arrived at Friday, October 11, 2002, with the day-long *Common Threads* conference at the Civic Center, attended by more than 200 Allen County residents. Conference attendees came from 22 employment groups and 11 geographic areas, including Bluffton College students and faculty, social service providers, representatives of the media, and local officials. There was good representation from the African-American community, but the farming community was underrepresented. MacDonell, Gilbert, and Eldridge co-facilitated the event, with Romney leading the dialogue activities. With attendees seated at round tables, MacDonell and Gilbert provided background and project history. Romney introduced the World Café model, which was chosen upon the recommendation of Judy Gilbert. The World Café structure and process was a good fit because it accommodates large numbers of people

The thing that really got
my attention, though
Happened about six months ago

I was pulling into
the company parking lot
And just behind me
On the road
There was an accident
Not a huge one,
but folks were hurt
It was serious

I was the first person
on the scene

I helped someone out of a car
I called for help
I went into the road and

directed traffic around the wreck
The cars
In the middle of the road

I took control of the scene
I did what needed to be done

All this in a couple minutes
So, pretty quick,
there's another guy
A co-worker of mine
Who comes out to help
A white co-worker
We're both directing traffic

Police start showing up
Company folks start
showing up
Paramedics

Every person that comes
They go to my co-worker
Not one person asks me
what happened
Even after he told them
I was here first
Not one person comes to me

They all go to him
Like he's in charge

Like I'm not there

—*Excerpt from* Passing Glances

while also permitting them to mix. It also includes acceptance of stated agreements on process and procedures, prepared questions for participants to respond to in round-robin fashion, a timekeeper, and a recorder. For this event, tables were covered in newsprint and markers were provided, encouraging participants to make notes, drawings or doodles about what they were hearing. These would become records as participants moved from table to table throughout the day. The first round of questions included: What has been discussed on city/county issues? How has this project affected the community?

Mid-morning, the entire conference moved into the theater to view the first full performance of *Passing Glances: Mirrors and Windows in Allen County*. Excitement about the performance was palpable in the audience.

Participants returned to the conference space, joined by Rohd and cast members and guided by Romney. Dialogue was framed using the central metaphors in the play and issues *Common Threads* intended to address. Romney and Gilbert asked participants: What in the performance you have just seen most *mirrors* your life in Allen County? What opened a new *window* into someone else's experience? What are the connections to the themes of trust and respect? What connections do you find among us and our observations and discussions? What potential actions are emerging? Tables were asked to reach consensus on one or two issues raised in the performance they considered most important. Guided now by Eldridge, people reported on their findings, which included the following topics: race, diversity, breaking down stereotypes, government leaders talking to each other, black entrepreneurship, and using arts in schools with youth.

There is a lot of satisfaction
to be gained from burying
something in the ground,
watching
it grow, taking care of it—
But the real gamble
A farmer's friend or foe
Weather
Weather, and time
Cause when you're planting
If that soil is too wet
Or too hard
You lose
And if it doesn't rain
when you need

You lose
We do not control the
circumstances of making
our product
In a world that is all about
delivering a product
But when it's time to plant
Time to harvest
It doesn't matter what else
is going on
My world can't wait
When it rains, it pours

—*Excerpt from* Passing Glances

Each table was then assigned one issue, the tables were labeled and attendees moved to the table housing the issue they felt most passionate about. Discussion about each group's chosen topic ensued. In these new groupings, 16 issue/action teams were formed and named by the end of the day:

Romney and Gilbert asked participants: What in the performance you have just seen most mirrors your life in Allen County? What opened a new window into someone else's experience?

1. Breaking Down Negative Racism, Sexism, and Classism
2. Bringing Diverse Peoples Together
3. Collaboration of Faith Institutions Toward Social Change
4. Community Development and Metropolitan Government
5. Early Childhood Education in Schools Regarding Non-Violence
6. Education/New Job Opportunities
7. Elected Officials Dialogue
8. Empowerment through Sustaining *Common Threads*
9. Housing and Homes
10. How to Get the Public to the Decision-Making Table
11. Next Generation Friendly Community
12. Return of Black Entrepreneurship
13. Sister Neighbors (like Sister Cities Program)
14. Using the Arts to Teach Respect
15. Widen Diversity
16. Youth Rehabilitation and Activities

At the end of the conference, there was a surge of energy about the creation of the Action Teams as vehicles for community organizing and communication. Although the Action Teams would be refined and combined over the next several months, their actual creation was an extremely positive outcome that was reinforced by the written surveys conference attendees filled out: 97 percent of the survey respondents indicated elected officials need to take part in more conversations like these; 73 percent indicated they felt more likely to get involved in civic issues. Organizers were pleased that 96 percent indicated they had a better understanding of how the arts could be a catalyst for public conversation.

The two public performances and dialogues were also highly successful, and very different from one another. In each case, the core team and sector leaders planned pre-performance events hosted by key constituencies designed to attract their friends and neighbors. Saturday night, October 12, Alpha Kappa Alpha (AKA), a black sorority, hosted a reception prior to the show. Orchestrated by core team member Theresa Henry, this reception was critical to spreading word about the performance in the black community. In fact, Saturday's lively and appreciative audience of 550 people included about 150 African Americans, who were particularly responsive to the pieces on race and class. MacDonell reported that a middle-aged black woman sitting in front of her told her companion, "This is exactly like it is for black folks here—just exactly." Martin Stephens concurred: "The performance reflected the voices of the black community. What is, is." About 100 people stayed for the post-performance dialogue, which was guided by Romney and her locally trained facilitators and utilized a format and questions similar to the ones used at the conference. After some initial reluctance to move from the drinks and snacks to the dialogue, people were engaged at their tables.

Because farmers don't work on Sundays, the matinee on Sunday, October 13, was geared to the farming and rural Allen County residents and township officials. Through the connections in the sector leader group, the president of the Township Trustees and Farm Bureau officials issued invitations to Sunday "dinner." Ninety farmers, elected officials, and township trustees, and their spouses attended the noon meal. During "dinner" Romney guided the tables to engage in conversation about prepared topics. While some tables seemed confused and hesitant about addressing the questions, other tables had lively discussions. At the 2 p.m. performance, attendance swelled to 400. The audience was somewhat more subdued than the night before, but response was positive, and 84 people chose to remain for the post-performance dialogue. In fact, both post-performance dialogues exceeded attendance expectations; clearly a significant percentage of the audience chose to extend their experience by participating in the dialogue.

Ultimately the questions became: how do we draw people into a project if they perceive, rightly or wrongly, that it is not relevant to their lives? Whose stories get told? And who decides?

Media involvement

Media involvement in this project was very strong, and contributed to public awareness and a sense of momentum and excitement. *The Lima News* was a model media sponsor. It had just completed a feature series on race relations and wanted to extend its reach in this area of community life. The editor was impressed with the goals of the project and saw it as a link to the paper's work. The editor also wanted to train the newspaper staff in the dialogue process in order to assure that all perspectives would be heard in roundtable sessions they regularly host on community issues, so that they might write balanced feature series. *The Lima News* published 37 feature, editorial, and news articles from October 2001 through December 2002. They also published monologues from the script, and kept a photographic record of the project. Further, *The Lima News* editor became an advisor to the project, and two employees received dialogue facilitation training. The depth of the paper's involvement was a surprise to project leaders, as the *News* was not known for community involvement or civic journalism, and is a politically conservative institution. MacDonell credits Judy Gilbert's mutually beneficial approach to partnership development as key to the success of *The Lima News'* involvement. Television and radio were also involved. Clear Channel Radio Lima and Fox TV Lima collaborated to produce and air excerpts from six monologues on the subjects of race and class, farming, and political leadership.

Each monologue opened and closed with a description of the *Common Threads Project*, and they were aired to coincide with the publication dates of *The Lima News* print stories. In this way, awareness about the project extended to Allen County residents who did not attend barnstorming events, dialogue activities, or performances.

ISSUES AND LESSONS LEARNED
Naming and Framing the Civic Issue

The process of naming and framing the project's civic issue was difficult because embedded in that naming were all the nuances and complications of community life in Allen County, where *respecting differences* and *trust among leaders* were seen by many as euphemisms for race and annexation. Ultimately the questions became: how do we draw people into a project if they perceive, rightly or wrongly, that it is not relevant to their lives? Whose stories get told? And who decides? While MacDonell and other core team members were concerned that rural residents would not engage in a project about race, African

Americans insisted it had to be addressed directly. At the same time, county residents challenged city residents to be up front about using water as leverage for Lima's need to annex the townships in order to increase its tax base. In the end, the decision to retain the milder themes of *respecting differences* and *trust among leaders* probably did result in more participation from rural and county residents. Some on the core team believed African Americans would participate no matter how the issue was framed because the fate of the city so directly affects their lives. Ultimately, consensus among core team leaders is that although African-American participation in the project was strong, their involvement and the depth and retention of that involvement was not always satisfactory.

There is no question that the way the issue was framed and who extended the invitations affected broad participation across sectors at public events. Exceptions were the barnstorming performances, which were presented to captive audiences. In fact, these mini-performances and dialogues enabled blacks, city dwellers, civic leaders, suburbanites, and farmers to enter the project in the company of people like themselves, no doubt helping people to feel honored and safe. In the end, this was a factor in the success of the subsequent heterogeneous groups.

Insider/Outsider Project Leadership

Among the core leaders, the dynamics between the insiders (MacDonell's team) and the outsiders (Romney and Sojourn) was sometimes uncomfortable on both sides. The insiders worried that the visitors didn't understand their community ethos. In describing the evolution of her relationship with Rohd, MacDonell stated: "...we both started out a little wary about where we might have big differences. I saw myself as the advocate...(for) the community, and worried about putting Allen County in his hands, knowing that we would be left with the results of his work after his departure." The visitors viewed relationships and issues through objective eyes, and were sometimes able to see dynamics that residents didn't or couldn't acknowledge. MacDonell was concerned about balance in the final piece; Rohd expected it to have a point of view and wanted control over its artistic evolution. Soon, it became clear to MacDonell that "...*Passing Glances* would indeed center on racism as the pervasive thread that runs through all the issues of leadership, trust, history..." She also stated: "...the artist's point of view pointed to the elephant in the room." In the end, the insiders, both audience and project leaders, grew to trust the outsiders. This trust was also expressed by the people whose stories were told onstage. One rural resident said, "If someone *local* was up there on stage saying true but painful things that were hard for me to hear, I would always wonder what he had against me."

Outsiders' sensitivity was demonstrated continually, particularly about the relationship between MacDonell and her on-site team ("the three white girls"). Rohd and Romney made efforts to include them in ways that would support the authenticity and success of the work. Romney, in particular, found ways to respectfully utilize the skills and experience that Eldridge and Gilbert brought to the project, most publicly in her design of the co-facilitation model for the culminating *Common Threads* conference. Theresa Henry and Martin Stephens agree that as an outsider, Romney was especially effective bringing forward the voices of black leaders and in clarifying their roles. She also played a critical role as "coach" and "mediator," with community members and core team leaders.

Aesthetic Issues

It was clear from the beginning that Rohd's aesthetic and his approach to artistic creation would have a huge impact on the project's outcomes. His signature form of "poetic documentary," in which real people's stories and experiences are "lifted" into the realm of poetry, connected powerfully with many who encountered it. This was true in workshop settings where he modeled the interview process in a role-play as well as at barnstorming events and staged readings and in the full performances. When people see and hear their own words and experiences presented "poetically," they are moved to open themselves to the different experiences and perspectives of neighbors and strangers. Part of the power of poeticizing language and experiences is in the selection and use of metaphor. Rohd's use of artistic metaphor, such as water, drew people in, enabling them to experience and confront difficult topics with a sense of wonder. At the same time, metaphor had a distancing effect: because it is symbolic and often non-literal, people could imaginatively entertain an idea they might resist in the everyday world.

A related artistic learning occurred around the question of whether or not a work of art could be "neutral." In the beginning, MacDonell and others hoped for a balanced piece that would represent all viewpoints even though some of these viewpoints could offend some audience members. They saw this as crucial to enlisting broad participation. Rohd quickly realized he could *not* be neutral, and that while he would not take a side on any issue, his approach would be "voicing that which is usually unvoiced." He was bolstered in this discovery by Romney, who maintained that one could be "multi-partial;" that is, on all sides at the same time.

In the end, Rohd's piece achieved a finely tuned nuance of multiple viewpoints that was the truth of Allen County. Audience members often expressed surprise as they experienced a reality for blacks or for farmers that was unknown to them, but only a few were disturbed or insulted, and many came away enlightened.

Finally, discoveries in the artistic realm were also revealed through the process of crafting the letter of agreement between Common Threads and Sojourn Theatre. Eventually, the agreement codified the understandings at which Rohd and MacDonell arrived after the arduous process of written and face-to-face communication. In addition to delineating details about payments, schedules, roles, and responsibilities, the agreement also examined the notion of artistic responsibility and ownership. As its creator, Rohd would own the final product, but Common Threads retained rights to future uses of the script, royalty free, for educational purposes. Rohd would ultimately make all artistic decisions about the content of the piece. The mutual understanding and agreement to which these partners arrived is testimony to the trust that developed over the months of the project.

Artist and Dialogue Specialist Collaboration

Romney's and Rohd's project roles vis-à-vis one another were not always clear. In the beginning, Romney expressed her hope to be involved in the interviewing, and even in the script development. Rohd does not recall a conversation about that level of collaboration, and he believes they had a miscommunication on the issue of her role.

Also, there were points during the project when Romney questioned her role—why was a dialogue specialist needed when Rohd himself often facilitated dialogue about his work?

For his part, Rohd expressed concern that Romney, coming from a non-arts background, might inadvertently neglect aesthetic issues when crafting dialogue questions. At the same time, each was playing a significant role in the community during the development phase. While Rohd conducted interviews for script development, Romney met with civic leaders and coached MacDonell through relationship-building on the core team and in the black community. But the collaboration *between* Rohd and Romney was not as obvious as the one between Romney and MacDonell or between MacDonell and Rohd, and was probably an underlying cause for the tensions that emerged over the show's running time and the impact on the dialogue format. From MacDonell's perspective, "Michael was challenged by the fact that someone other than himself would be developing and leading the dialogue…[but] as they became familiar with each other's work, the trust between them grew." Ultimately, the lesson is that clarity about roles requires continuous and careful attention and honest communication as problems emerge and unforeseen situations develop. An additional lesson is that collaboration necessitates that people work in time and space together. Due to budget and various schedule constraints, Rohd and Romney were not often in Allen County together.

Sustaining Arts-based Civic Dialogue

This project also holds lessons about the issue of the institutional capacity of under-resourced cultural organizations to conduct and sustain the work of arts-based civic dialogue. The capacity of CFA to manage the *Common Threads* activities was always in question. MacDonell stated: "I have learned that, from my experience…arts organizations with long-standing community development missions are the best organizations to do arts-based civic dialogue, but the paradox is…[they] seldom have the financial resources and the human capital to fully pursue this work." In fact, according to Mills, CFA succeeded in managing the original *Common Threads* project because MacDonell had the vision and devoted herself as its volunteer project director, providing essential leadership, a tremendous amount of time, and even personal financial and in-kind resources.

Absent the infusion of outside grant funds and the skills and tireless dedication of a volunteer project director, a project of this scope and complexity is going to be difficult for the struggling arts council to sustain. MacDonell, Mills, and the *Common Threads* team addressed this issue as they searched for ways to sustain *Common Threads* as an affiliate of CFA, but not dependent on the Council indefinitely for human and financial resources. There was much discussion during the course of the project on where *Common Threads* would "live" after October 2002, when MacDonell, Gilbert, and Eldridge would step away from the forefront. Although Mills believes that CFA now has greater access to more sectors of the community, the council may not have the human and financial resources to pursue future projects, let alone to administer *Common Threads* on an ongoing basis. As he now states, "…[*Common Threads*] grew in scope well past our ability as an organization to manage it… *Common Threads* continues, but largely outside the mission of the arts council." At the same time, MacDonell reports that CFA is having money problems, and Mills is now functioning as a volunteer. She also mentions, "We have started conversations with Artspace Lima (a visual arts center) on an affiliation—either complete merger (with CFA) or something else. The reason is we cannot financially support two big arts agencies in a town with diminishing resources." Talks are also underway with United Way of Greater Lima about taking on the *Common Threads* project work.

Rohd's use of artistic metaphor, such as water, drew people in, enabling them to experience and confront difficult topics with a sense of wonder. At the same time, metaphor had a distancing effect…people could imaginatively entertain an idea they might resist in the everyday world.

OUTCOMES AND IMPACT

Arts-based dialogue in Allen County, Ohio, was clearly an experiment that took major effort from all parties involved. Martie MacDonell believes the ongoing issues the project took on will take years to resolve. Her view is that the intent of this project was "to simply take a few more steps along a continuum of action toward a more democratic community." She saw four major gains:

- Several thousand diverse citizens came together to think and talk about the issues of race and trust among leaders.
- The *Common Threads* dialogue process continues to be used in school and community settings.
- *Common Threads* action teams are at work to improve relationships among city and county elected officials and have linked with the Chamber of Commerce to propose a citizen's long-range community plan.
- The arts are perceived as a way to address community issues.

Seven thousand people from 15 of the 16 villages, cities, and townships in Allen County were represented in the *Common Threads* project. Following the October 2002 events, there was a shared feeling that Allen County was poised for forward motion on a variety of issues. The degree to which this would happen, according to core team members, would depend on establishing and maintaining key relationships across barriers (city, county; black, white), and people's willingness to work for greater understanding.

What follows are outcomes and impact for which there is demonstrated evidence:

City and county elected officials participated in the project and are now talking to one another. New civic leadership has emerged. Each of the Action Teams has a chair or

Members of the community participate in dialogue after seeing Passing Glances. *Photo © David Massey/ The Lima News.*

co-chair who stepped up to the challenge. MacDonell reports: "The term 'civic dialogue' has entered into the community's vocabulary, now used by public officials, NAACP leaders, economic development professionals, arts groups, and educators…" She also reports that the NAACP president recently sought dialogue in a meeting with a white sheriff over the alleged beating of a black man, and the two men have developed a productive relationship. Martin Stephens and his wife have taken on expanded community roles. He writes: "In addition to what I was already involved in, the county commissioners invited me to be on the board of the Veterans Civic and Convention Center… Cleo is now involved with the Ms. Bronze Pageant (scholarship competition) and is co-chair of Diversity Council where she works." And Brenda Ellis, an African-American woman who was a key participant in *Common Threads*, was one of three finalists for the prestigious ATHENA Award from the Lima/Allen County Chamber of Commerce for her work to help women reach their full potential through the Alpha Kappa Alpha sorority and other significant work with women in the community of color.

"The term 'civic dialogue' has entered into the community's vocabulary, now used by public officials, NAACP leaders, economic development professionals, arts groups, and educators…"

Greater understanding of differences did occur, although this was difficult to achieve and hard to measure. MacDonell writes, "We assumed this project would be far easier than it was… Another assumption was that the majority of residents of Allen County would take an interest in civic discourse about compelling issues that affect us all. We now have experience with the fact that many turn away from confronting deep questions, content to have unexamined perspectives." Still, over 90 percent of project participants who completed a survey said that multiple perspectives that came forward in dialogues added to their understanding of each other and the issues. There is also evidence of attitude shifts among some community members as—through performances, dialogues, and Action Team activities—residents began to view their problems and issues from multiple perspectives. Examples are the white farmer who said after a barnstorming performance at the farm bureau, "You got us right so I have to trust you got the others right also," and the rural white woman who said, "To be perfectly honest, my husband and I and our friends thought there was too much about blacks in the play. Where do these blacks come from? We have never heard of these dissatisfactions, and we worry that blacks in the audience will get wrong ideas… Maybe we feel this way because it is the first time we have heard this… Maybe the next time it won't be so hard." Theresa Henry states, "For those involved… I think they are more aware of race issues and concerns now."

Citizens are taking action through the 16 Action Teams created at the Common Threads conference. By May 2003, several teams were fleshed out and functioning:

Bringing Diverse Peoples Together chose to return to the Study Circles model to continue to examine race relations.
Collaboration of Faith Institutions for Social Change fosters collaboration among youth groups of various faith institutions.
Community Development is researching effective economic development in other cities like Lima.
Elected Officials Dialogue meets monthly for breakfast.
Housing and Homes has created modules on the theme of "shelter" that were displayed in the Lima Town Square.

Next Generation Friendly Community wants to create a *Common Threads* Youth Conference.

Widen Diversity strives to extend cross-cultural understanding to Muslim and Jewish communities.

Youth Rehabilitation and Activities completed a pilot project to increase at-risk youth awareness of public services available to them.

As of May 2004, three action teams have demonstrated the most positive results for Allen County. In fall 2003, the Housing and Homes Action Team completed the *Shelter Project*, which was a school-based initiative that partnered Lima City Schools, a women's crisis center, and other social service agencies to create 12 house modules expressing multiple perspectives on the concept of "shelter." These artworks were on exhibit in Lima's Town Square and were auctioned off, with proceeds going to the participating social service agencies. A second action team, Elected Officials Dialogue, hosts monthly breakfast meetings for elected officials in Lima and Allen County to build relationships through informal conversation. The most significant success is the Community Development Action Team, which has tackled economic development in Allen County, and completed a research phase and brought a community planner from the Ohio State University Extension Service on board to do planning and make recommendations. The Chamber of Commerce is interested in this work, and the team has successfully solicited participation from both city and county officials. A summit meeting was held for all elected officials in June 2004, and *The Lima News* is giving the effort extensive coverage. Most importantly, government officials have agreed to *consider* implementing the recommendations growing out of this planning. As MacDonell put it, "*Common Threads* has finally been legitimized."

In the short term, the greatest impact on race was among those directly involved in the project, but key issues for African Americans were not affected by the project. There are differing views on the project's impact on race relations and in the black community. Some core team members perceived it to be minimal. According to Mills, "...I don't think the issue of race was affected in any way, positive or negative. If anything, we suffered some from an 'enough talk already' kickback." Romney concurs in part with this assessment, and she questions the depth of the involvement of African Americans. She clearly recalls that for blacks, the main issues were jobs and empowerment, which, in her view, were not sufficiently addressed during the project. Henry agrees with this assessment and says she thinks race relations are "about the same."

On the other hand, Rohd asserts, "I've never done a show that was so embraced by a non-dominant culture community, specifically the black community... Remember some in the white community felt the show was way too much about black people and their problems." MacDonell points to a small but positive development in interracial collaboration when she writes, "Our [*Common Threads*] database is so good that the president of the local chapter of Alpha Kappa Alpha...has asked for a copy of the *Common Threads* 'community of color' list. She tells us it is better than the AKA list." Stephens asserts, "Overall, I think there was a slight improvement, but only for those who were involved in or attended some of the performances. Current economic conditions continue to be a roadblock for improvement in race relations."

I'm a young Black man who, you know, is positive, I come to work every day. I opened up my own business. I'm not out there shootin' and killin' and whatnot and people need to see that cuz it's not fair when I go to Wal-Mart and you got these women who are lookin' at me, or avoidin' me and whatnot cuz I'm a young Black man with braids. When you see me out there and you see my braids—don't be scared of me cuz I'm just as scared of you as you are of me, you know what I'm sayin'? I just think we're misunderstood. And I just wish people could see on a broader scale, you know what I'm sayin'…the more positive side?

—*Excerpt from* Passing Glances

Arts and non-arts people gained an appreciation for using arts as a catalyst for dialogue and social change. One elected official said, "Theater gave us a way in where we didn't have one before." MacDonell reports surprise at the continuing "…power and resonance of *Passing Glances.* Almost every day I hear someone refer to a phrase or an insight in the work they are still thinking about…" Mike Huffman, fine arts coordinator for Lima City Schools, was inspired by the project to focus on issue-based arts in classrooms. In tribute to the power and effectiveness of the poetic documentary form, Huffman engaged Rohd and Sojourn Theatre Company to return to Lima in May 2004 for teacher training and school residencies.

Common Threads' goal of building *local* artists' capacity for civically engaged art proved more difficult to realize. It was disappointing that only one local actor participated in *Passing Glances.* Auditions were well-publicized and held for two nights, but no local actors showed up. Rohd believes this reflects some resentment at the outside artists within the local theater community. People felt excluded by the commission of an outside playwright and professional company. And, for some local university theater people, the poetic documentary form was unfamiliar. MacDonell cites one conversation where a retired theater

25

director found the work "sociologically interesting…but not theater in the sense of the well-made play, so why call it theater?" These dynamics between mainstream, traditional forms of theater and community-based, civically engaged work will be challenging for *Common Threads* and CFA if this work continues.

"All this gave us a real gift—depth, collaboration with partners who treated us well, and whom we respect… Our work since is deeper, and builds on successes and lessons from Allen County."

Citizens trained in civic dialogue facilitation are at the ready to lead future events. Scaffolding for civic dialogue in the future was built by this project. Forty-four Allen County citizens are now trained in dialogue facilitation from a variety of sectors including former Study Circles facilitators, social service agencies, schools, universities, churches, African-American service groups, and the Allen County Leadership group. Trainees set up practice sessions and attended refresher training. Currently, several of these local facilitators are working with Action Teams or in schools on *Common Threads*-related projects. Unfortunately, Lima's mayor's plans to revive the interracial Study Circles have not materialized due to lack of funding.

The artist and dialogue practitioner experienced growth and insights in their work. For Rohd and Sojourn, the project had a huge effect on company morale and company bonding. Rohd also cites the following impact on him and his company: "…learning and growing with our process and methodology; having the opportunity to explore this style of new work development; community engagement, and production away from our home base, and over such a length of time. All this gave us a real gift—depth, collaboration with partners who treated us well, and whom we respect… Our work since is deeper, and builds on successes and lessons from Allen County."

What can poetry offer us in times of challenge? Can it help us solve an argument? Can it help us see each other in a new light? Can it find a word that rhymes with annexation, and in so doing, remove the tension of an issue forever. Maybe…Maybe not. But can it give us a sense of things larger than ourselves? Larger than our own perspective? Can it make us consider why things are as they are?

Faith. Memory. History. We all swim in a sea of our own experience. Poetry like tonight's puts the seas of many into one ocean… Up here. What does poetry mean to us? Images. Movement. Music. Words… the words of a white farmer performed by a black man… the story of a black woman told by a white man. Poetry is permission to let daily life and identity have surprising meaning. To change… Even water…

—*Excerpt from* Passing Glances

Romney learned first-hand how powerful art can inspire and affect conversation and dialogue. Mills and the CFA were challenged to examine not only the institution's internal capacity for the work, but how the civic nature of *Common Threads* going forward was in alignment with the council's core mission. Those questions are still being pondered.

CONCLUSION

In terms of the size, scope, and complexity of the *Allen County Common Threads Theater Project*, the impact on Allen County is impressive. There were over 20 formal performance and/or dialogue events over 12 months, and numerous other small, informal gatherings, interviews, and conversations. Thousands of people were affected directly, and many more through extensive media and public relations coverage. The project tackled some of the most intractable issues of our time: racial divisions, the decaying urban core, the challenges of farm life, and the dearth of effective political leadership.

With such high ambitions, the record on outcomes achieved is understandably mixed. Certainly people are talking to each other across sectors, and there is some observable shift in attitudes on these topics. The formation of Action Teams is a practical step in moving from shifts in understanding to change. Art is now seen as a powerful way to draw people together around difficult issues. Many more people in Allen County have experienced some form of civic dialogue, and a cadre of citizens has been trained to facilitate these conversations.

However the challenges that endure will make it difficult to maintain forward motion on both the civic and artistic fronts. Racial tensions and rural/urban strife are still in evidence in Allen County, and although many people have deeper understandings of these dynamics, these are national problems with deeply rooted histories and murky futures. Allen County is to be applauded for taking them on; in the face of such difficult dilemmas, it is what citizens and artists in a democracy can and must do.

WATERS

2

Los Angeles Poverty Department

::: *AGENTS & ASSETS*

JOHN MALPEDE

Founded 17 years ago in L.A., the Los Angeles Poverty Department has become one of the country's most outspoken and profound Theater troupes.[1]

—*Natalie Haddad*

[1] Natalie Haddad, *Real Detroit* (October 16, 2002).

A scene from the 2002 performance of Agents & Assets *in Detroit. Photo © Sjoerd Wagenaar.*

The Los Angeles Poverty Department theater group (LAPD) conducted a month-long residency project in Detroit, during which six members of LAPD worked with eight Detroit residents whose communities had been heavily impacted by drugs and drug policy. Together, they produced *Agents & Assets*, a play that investigates the advent of the United States crack epidemic. In 2002, LAPD Director John Malpede made two visits to Detroit to plan the project. The first was a three-day visit in April and the second was a month-long stay in August, during which arrangements for all aspects of the residency project (from housing and publicity strategy to casting and community partnerships) were finalized and implemented. The month-long residency culminated in four performances and post-show discussions in October 2002.

Each performance was followed by a discussion of drug policy and approaches to recovery from addiction, including different models and metaphors (the current prohibition and military models, as well as proposed public health models that emphasize treatment

rather than incarceration) for dealing with the ravages of drugs and drug addiction. Each post-show public forum started with presentations from scholars, recovery professionals, drug policy reform advocates, community leaders, and politicians. These forums led to general discussions with the input of audience members. The emphasis was to create an atmosphere in which all present could speak as citizens on an even footing.

Agents & Assets (which LAPD had originally developed and mounted in Los Angeles in 2001), was recast with a combination of LAPD members and Detroit residents from communities that had been heavily impacted by drugs and drug policy. The project was conceived in this way as a means of achieving significant local community involvement in the production and the post-show discussions, and of increasing community involvement in the issues raised. These goals were achieved by the project, which attracted a diverse audience that included significant involvement and representation from the recovery community, the Detroit theater and arts community, drug policy activists, students, community residents from the Cass Corridor area of Detroit, peace activists, and others concerned with the issues presented in the play and post-show discussions. The project galvanized relationships among people active in arts, drug policy reform advocates, drug recovery program participants, and professionals in Detroit.

COLLABORATORS AND PARTNERING ORGANIZATIONS

LAPD partnered with the Prison Creative Arts Program (PCAP); Urban Community Visionaries of the First Unitarian-Universalist Church of Detroit; and Mariner's Inn, a non-profit drug rehabilitation program in the heart of inner-city Detroit (the Cass corridor). Five of the eight Detroit cast members were program participants and staff members

(who were themselves program graduates) from Mariner's Inn. LAPD continued to work with Peter Sellars' producing group, Old Stories: New Lives, which had co-produced the public conversations and panels in the original LA production of *Agents & Assets*. Old Stories: New Lives provided administrative support and creative input into the construction of the public discussions, and Sellars was a panelist on the rhetoric of war panel. PCAP worked with LAPD in constructing the panels and involved Families Against Mandatory Minimums (FAMM) and Citizens Alliance on Prisons & Public Spending (CAPPS) in the planning process as well. LAPD Producer Ron Allen worked with Urban Community Visionaries to create an ongoing dialogue with Malpede in the discussions leading to the formulation and construction of the panels and public conversations. The result was a profound series of public conversations that convened speakers and topics for discussion that has particular resonance in the host community and provided audiences with a broad context for discussing current as well as alternative policies.

Speakers included:

- Jeff Edison, attorney, Detroit Lawyers Guild
- Felix Sirls, public health professional and Minority Aids Outreach Program coordinator, City of Detroit Health Department
- Jo Ann Watson, Michigan Drug Policy Reform
- Maureen Taylor, Detroit Welfare Rights
- Ed Gardin, staff counselor, Sobriety House
- Dawood Muhammad, minister, Nation of Islam
- Amanda Brazel, Students of Sane Drug Policy
- Chris Parks, University of Detroit, director of NRO, a nonresidential drug rehabilitation program, and specialist on arts in drug recovery

Panel moderators included:

- Ron Allen and Gwen Winston, Urban Community Visionaries
- Nkenge Zola, journalist and former Detroit NPR newscaster
- Alfred J. McCoy, professor of history at the University of Wisconsin and author of *The Politics of Heroin*
- Regina Schwartz, professor of Comparative Literature at Northwestern University and the author of *The Curse of Cain*
- Peter Sellars, theater and arts festival director and frequent critic of current drug and social policies

Partnering organizations provided enormous support in all aspects of the project, contributing to its success and its impact on the local Detroit community. PCAP provided in-kind housing during extensive organizational visits to Detroit to plan the residency, and its leaders—Buzz Alexander, Janie Paul, and Gillian Eaton—made numerous introductions that facilitated the production of the show and the public conversations. Eaton introduced LAPD to Allen, the community minister of the Unitarian-Universalist Church and a member of Urban Community Visionaries, which became our co-producers of the project. We rehearsed at the Unitarian Church and performed in the church's beautiful and imposing sanctuary. Eaton also introduced LAPD to Shawn Nethercott of Matrix

Theater, who provided in-kind set materials for the production as well as extensive assistance in promoting the production by e-mail. She also invited LAPD to speak at an anti-war convocation at her church. Eaton also provided assistance with the in-kind donation of props and a luncheon for one of our guest panelists through the theater department of Wayne State University. LAPD, in turn, was able to arrange for PCAP to use Zeitgeist Theater's mailing list, which Zeitgeist provided for us as an in-kind marketing contribution. Alexander made introductions to Penny Ryder of CAPPS and Laura Sager of FAMM, who advised us in determining the issues to be addressed in the public conversations, provided contacts and recommendations for speakers, and assisted us in gathering an audience for the events. We introduced Alexander and PCAP to Deborah Wright of Drug Policy Forum of Michigan, a sponsor of the treatment versus incarceration initiative that they were attempting to place on the November 5 ballot. PCAP and Michigan Drug Policy Reform intend to develop this new link in their ongoing work in Michigan for drug policy and penal reform. Allen worked closely with LAPD as the local producer of the event.

...Malpede told prospective cast members that from his point of view, "...everyone has a unique and valuable energy—and can be profound and beautiful in performance."

INCLUSION OF LOCAL PERFORMERS IMPACTED BY DRUG PROBLEMS AND POLICY

Poet and playwright Allen conducts art and self-esteem workshops regularly at two drug recovery centers—Mariner's Inn and Sobriety House. He immediately grasped the importance of our project to his community and mobilized his great variety of community contacts in producing the project. This included generating the partnership with Mariner's Inn. LAPD worked closely with Mariner's Inn in realizing the project, and its contributions were many. Five cast members were Mariner's Inn program participants and graduates (including two program graduates now on staff at Mariner's Inn). Mariner's Inn provided in-kind rehearsal time, staff time, use of copy machines, tables and chairs for the sets, some costume pieces for the cast, and transportation for other set pieces. They also provided a crew to run the show.

Malpede directed the performance project and Henriette Brouwers performed and worked as assistant director. LAPD core company members Rickey Mantley, Melina Bielefelt, Alexander Anderson, and Tony Parker also performed in the show. The LAPD company members worked one-on-one with the eight Detroit cast members in developing their parts in the show. Mantley and Anderson led performance workshops for members of drug recovery programs at Mariner's Inn and Sobriety House; Anderson led LAPD's extensive outreach to 12 recovery meetings and university groups in central Detroit; Mantley led outreach to the social justice community; and Parker led outreach to other community-based artists. In addition to the five members from Mariner's Inn recovery program, the cast included Therese Blanco, Elana Elyce, and Nelson Jones—all veteran performers who were themselves from communities significantly impacted by drugs and drug policy.

At Mariner's Inn, Malpede and Allen conducted auditions—invitations to people in the recovery program to get involved with the project as actors. At the auditions, Malpede told prospective cast members that from his point of view, "...everyone has a unique and valuable energy—and can be profound and beautiful in performance."

Arthur Doster came reluctantly to the interview. A former professional football player, he is a big man with an unusually gentle nature. He is also dyslexic. He had a very difficult time doing a cold reading from the script, but the energy that he brought to the reading was beautiful. He was ambivalent about being in the piece, but he did feel that once he'd learned his text he'd do okay. Malpede strongly encouraged him to continue, telling him how special he found Doster's energy to be. Malpede expressed total confidence that Doster would do a great job. And he did. At the end of the performances he was hugely proud of himself and was looking forward to future theatrical opportunities.

The project was a catalyst for new initiatives among our partners in Detroit, even among those who already were in contact with one another. One outcome was the beginning of a recovery theater, a group comprising people in recovery in Detroit who will work together to learn theater craft and develop and present theater within inner-city Detroit. Allen was inspired to start Artists in Recovery after the residency. He plans to work with people who have been in recovery for a year or more to create and produce theater projects. This involves taking the recovery workshops much more seriously, because he and the workshop members will be presenting their work to the public.

The LAPD residency also resulted in the Drug Policy Forum of Michigan initiating an ongoing series of community dinners at the Unitarian-Universalist Church, co-hosted by Urban Community Visionaries. Through these dinners, the Drug Policy Forum of Michigan intends to include and involve a greater number of community members from communities severely impacted by drugs and drug policy in their organizing efforts. In an evaluative discussion months after the event, Wright said, "We started our dinner and dialogue meetings. This happened as a result of coming to the play. We invited people from the community to come in and talk about the issues and get involved in our ongoing activities. *Agents & Assets* was a great way of getting beyond us policy people just talking to ourselves—the play was a great way to reach out to and involve community members."

"*Agents & Assets was a great way of getting beyond us policy people just talking to ourselves—the play was a great way to reach out to and involve community members.*"

ASSESSING IMPACT

LAPD developed a series of follow-up questions to assess the impact of *Agents & Assets*, including the performances, public discussions, and strategies employed in building these events.

1. **Was the event effective in reaching new people? Did it reach new people regarding the issues of the war on drug and drug policy reform?**

> *The residency succeeded in reaching a very wide range of people. I had discussion with various people in the audience and particularly Wayne State theater students, art students, and students from the engineering school. They hadn't been political and they found the evening to be truly eye opening.*
> —Gillian Eaton, PCAP and theater faculty at Wayne State University

> *People were informed in new ways—getting a greater context for what's in front of their faces every day and what their communities are confronting. The panel was really effective. We wanted to invite some of the panelists to speak at some of our events.*

It's something we intended to do and still want to do. The LAPD project definitely reinforced the sense of what a resource the Unitarian-Universalist Church is and Ron Allen also. Your project gave us new Detroit contacts and reinforced our previous Detroit contacts. It definitely added a Detroit dimension.

—Buzz Alexander, Director, PCAP

The whole notion of the draconian nature of the drug laws and the fact that Detroit residents have been the recipients of these highly punitive laws was important.

As I said in my one-line biography in the program for the performances, "I thought I didn't care but I do." When I entered into the project, I thought I was just doing a job. As I worked, I was really impressed and moved by the efforts and the accomplishments of the others in the piece—especially the cast members from Mariner's Inn, who had never acted before. They had so much heart. It became a beautiful opportunity for me to contribute to the community. These people were trying to pull themselves up, recover from drugs, and get jobs and apartments. They were sweet, sweet people. I discovered that I enjoyed working with them and helping them develop their parts. I discovered that we were doing something really important and that my character, Maxine Waters, had something really important to say.

—Elana Elyce, Detroit actress who played Representative Maxine Waters

We got more people involved in and informed about the issues—people who were unaware, or had only a vague idea of the rationale behind drug policy and the drug issue. We alerted them to a vast, deep, complex issue and how people of color, especially minorities, are affected. We brought home who these policies target and how much havoc they've wreaked in our communities. Some of these new people were in recovery, who came in large numbers from Mariner's Inn, Sobriety House, and

A scene from the 2002 performance of Agents & Assets *in Detroit. Photo © Sjoerd Wagenaar.*

Alexander's Outreach to Narcotics Anonymous meetings. Also, theater people and college theater students from Wayne State came—a whole new audience of people who were getting into the issues.

—Rickey Mantley, LAPD core member who played CIA Lawyer Fred Hitz

2. Did it get more people involved in the issues and mobilize them for change?

It gave myself and the other drug reform activists that I work with new ideas of how to engage people about the subject. Also, it was energizing, and a boost to our efforts, because there were people from LA also concerned about and working on the same issues. It was refreshing and gave us a tangible experience of being part of a national effort to reform drug policy—something we, of course, knew we were a part of. But, with the freshness of the LAPD approach, we felt supported, that's for sure. It was great to make links nationally.

—Deborah Wright, Drug Policy Forum of Michigan

In February 2003, I did one of the Lysistrata[2] project readings: 850 people in the audience and 70 actors onstage. At that moment there was an awareness of lies that were told by government. That was an important door that had been opened by LAPD.

—Gillian Eaton

[2] The readings were organized by The Lysistrata Project, which began in the wake of 9/11. It is dedicated to bridging the spiritual, social activist, and women's communities, and humanizing the global agenda. www.lysistrataproject.org

3. Did the strategy of the event succeed in bringing media attention to the issues? And in particular did it inject different points of view into the media coverage that it did generate?

I don't think there had been any media coverage of the issue—the CIA involvement issue and the direct link of the fallout for Detroit. The Metro Times article stimulated a lot of interest. There is a shift in consciousness in the community. The whole notion of the draconian nature of the drug laws and the fact that Detroit residents have been the recipients of these highly punitive laws was important. And the use of the word "war" that you brought to everybody's attention—how the war on drugs really is a war, not just rhetoric, but a war on whole communities—that really illuminated things and created much greater awareness, as well as how you made the links between wars—the drug war, the war on terror, and the impending war in Iraq.

—Gillian Eaton

"It did interject different points of view into the media, because they interviewed the cast, people who had been victimized by the drug war, and people from different parts of the county."

The Michigan Chronicle, Real Detroit, *the* Michigan Citizen, *public radio, Jo Ann Watson's show—the media coverage was substantial in the minority and alternative press, not so much in the mainstream media.*

*—Ron Allen, venue producer,
Urban Community Visionaries, First Unitarian Universalist Church of Detroit*

I think it did. There were many articles and they wrote significantly of the issues within these articles. It did interject different points of view into the media, because they interviewed the cast, people who had been victimized by the drug war, and people from different parts of the county.

—Henriette Brouwers, assistant director and cast member

4. Did the structure of the organizing process and the event succeed in convening people from different strata and perspectives? Did it succeed in creating a situation where they could talk on an even footing?

The place was very safe. There were very different people present on different nights.

—Gillian Eaton

The organizing process consisted of contacting people, attending events, and passing out flyers. We got a good response from progressive, liberal people. Going to peace demonstrations was very effective. Mariner's Inn also reached out to other rehabilitation centers—people impacted by the drug issue—and they responded. Buzz Alexander and I did workshops at Mariner's Inn and got a positive response. They were on the bottom end—we alerted them to bigger picture they didn't know about. We were very effective in outreach and organizing among those people. Yes, everyone could talk on equal footing: at forums and in the workshops we talked about why we were here, dramatizing the hearings. They said, "Ya, we knew there was some governmental complicity on some level. This play let it be known that there was some kind of access facilitated at the highest levels of government: gun dealing for Contras. It seeped into our community and I'm a victim of it." People there understood that there was something going on, a big social thing, that had effected them personally. Someone targeted our community. It wasn't an accident that minority communities were affected. We could have reached out in a more organized way to the downtown business community.

—Rickey Mantley

"The drug policies we have in place are wrong, wrong headed, discriminatory. Now that I'm informed, I have an obligation to speak out."

Theater people (Matrix Theater, college theater students); drug rehabilitation people; politicians and activists; other artists (Tyree Guyton, others); church people—Unitarian, Catholic, etc.—union people; peace activists—all were present. Even footing: yes, especially because the panels had so many known community people and important topics. People came because of what each panel subject might be and then the floor was open and there was a real discussion.

—Ron Allen

5. Did people involved leave feeling more like citizens—that there was a place for their voice to be heard and to make a difference in making social policy?

I think they definitely felt they could speak. I'm not sure they felt like they could make any change. They were informed. Unfortunately, it made them more angry. I'm skeptical that they feel empowered because of how overwhelming it all is. But being an informed person who feels impotent is different that being an uninformed person who feels impotent. Some of my students had an awakening to activism in art and this first happened as a result of their being present at Agents & Assets. For the first time, they could see a correlation between their business in theater, being an actor or director, and their activist life. I was thrilled about that.

—Gillian Eaton

Many people shared information and announced other actions and events—a network was being created during the public discussions. They used it as a platform for what they were working on.

—Henriette Brouwers

"…because it's theater, it's a different form for activism to take. It presents the issues in a fresh way and allows for everyone to reassess their views and strategies."

After the discussion, people were sort of galvanized, politicized. They were aware that there was more to the drug problem than met the eye. It became apparent that the government and current drug policy just focus on the arrest of users—the little guys— but don't go after the bigger players. They wreck lives of the little people, go after the easy targets, while maintaining a policy of covering up governmental involvement. The drug policies we have in place are wrong, wrong headed, discriminatory. Now that I'm informed, I have an obligation to speak out.

—Rickey Mantley

6. Did the participating community groups build new constituencies as a result of the LAPD residency work?

I've been doing my community change work and that includes teaching self esteem and poetry workshops at Mariner's Inn and Sobriety House. At the same time, I've been writing my plays and having them produced at Zeitgeist Theater and elsewhere. My plays are challenging, nonconventional, definitely cutting edge in Detroit. I was really impressed by what LAPD was able to accomplish with first-time actors from Mariner's Inn. It really made me see how I could expand my serious creative activities by bringing more of them to my community work. I saw what value it was for the people here who worked on the LAPD production, and I saw that quality work could be achieved. That's what I want to do by working to form a Recovery Theater so that the creative work I do in a recovery setting gets out into other parts of the recovery community and beyond.

—Ron Allen

It deepened the connections. There were existing connections, but LAPD's work deepened them in varying ways and they were all positive. LAPD's work created an awareness that there is a community that exists and it's not just you. Ron Allen and the church are doing their activism and community-building work; PCAP is doing our work; the peace activists are doing their work; the drug reform activists are doing theirs. LAPD brought all these people together—and people in recovery programs, community people from the Cass corridor, and Wayne State students. Suddenly, at the LAPD events it was as if all these people were rising up and being together. Because it's so very fragmented in Detroit, LAPD was really a catalyst here. That was enormously important! Validation, unity, is what came out of LAPD's residency work.

—Gillian Eaton

Activist groups all know about each other. There's past history and sometimes a history of competing for scarce resources within the community. It's good when people come in from outside and just relate to the issues. It's pure and can reunite people. And, because it's theater, it's a different form for activism to take. It presents the issues in a fresh way and allows for everyone to reassess their views and strategies.

—Henriette Brouwers

Dawood Muhammad, Mariner's Inn, Sobriety House, and faith-based organizations generally do a lot of recovery work but are disconnected from the policy advocates. The project brought together faith-based, student, recovery, and civil rights groups. The project brought home how through the targeting of minority populations, drug policy as it is now is a threat to the civil rights of minority groups. John Conyer's office, Jeff Edison—they've worked in the arena of civil rights.

—Ron Allen

7. Did the theatrical component work on its own artistically—bringing in new performers and creating an artistically compelling result?

Yes definitely. I'm sure that the actors from Detroit had never done anything like that before.

—Gillian Eaton

The show was very professionally done, and it was exciting to see such a variegated cast; people from LA and Detroit, actors and nonactors, working together seamlessly and at such a high level. You couldn't tell who were the experienced actors and who were the first timers—that showed what a strong ensemble sense had been achieved through the rehearsal process. One of the great inspirations of this work, as always, is to see what people are capable of.

—Buzz Alexander

> **"…it was exciting to see such a variegated cast; people from LA and Detroit, actors and nonactors, working together seamlessly and at such a high level."**

Definitely. I think the performance improved from the original LA version. Tighter, better timing. The LAPD actors had a deeper understanding of the characters they were performing and they understood more about acting. The Detroit people: three were more experienced actors. They had a real revelation that people not trained as actors could do such a great job, and the non-actors too were surprised that they could do such a good job and hold their own with pros.

For Elana, Nelson, and Teresa, it was a big discovery that what they expected to be bad community acting turned out to be very good. Also, because of the commitment of the whole group, they became dedicated to the group. And they were challenged by the text, just to deliver a performance on the par with the rest of the company. They also were educated by the subject of the performance and they began to understand what was happening in the country and to their communities. They realized they were working with victims of the war on drugs. They realized that everyone together were doing something important. And because they were more formally educated they started doing research, educating themselves, and bringing resource material to the group.

—Henriette Brouwers

I was going through a lot of difficulty at that time, and that made the show all the more important for me, because it was a good thing. People thought maybe I wasn't going to make it to the performances. The subject of the show, what the government has done to our communities, that's too important. And my character, Mr. Bishop, he had some important things to say about that, and I wasn't going to miss saying them. I knew I'd do a good job and I did.

—Michael Dabney, performer, Mariner's Inn

A scene from the 2002
performance of Agents &
Assets in Detroit.
Photo © Sjoerd Wagenaar.

GIBBONS

*...what we thought
to be strategic,
i.e., scheduling the
residency directly in
front of the vote on
the initiative, was
ultimately way beyond
our control.*

*I was really impressed that we were able to take dull conventional transcripts, add
elements of dramatic conflict, protagonists, and antagonists and make drama. Through
editing, staging, and selecting who are the heroes, we made it as compelling as the
Shakespearean drama hero, villain, and chorus. That's why it worked so well. A very
important social issue was dramatized in a way that it never had before. It was an
artistically compelling way to stimulate discussion and change social policy. It affects
many people adversely. Subtly, the play says look at what's here, what Maxine Waters
found out, what Gary Webb found out, how the CIA was nevertheless exonerated,
it all ties in to the larger social problem.*

*We should take it on the road, to as many communities as we can. The aim of the
Drug Policy Forum of Michigan and the other groups is to try to change the terrible
drug policies that exist in this country. The play is an important way to get people to
think about what's going on. It should stir up debate in as many communities as it can.
It's good theater that doesn't hurt. It's novel theater. With panel and wide-range
discussion you can talk about the issues after the play.*

—Rickey Mantley

Agents & Assets was a creative way to bring in normal people through the art. It was a very artistic and engaging way to present the issues—very concrete. Because it was from a government hearing, you really saw how the government functions. I learned things from the play about the policy issues, especially by combining it with the discussions. The two dimensions of the program worked very well together—each reinforced the other, the play made the discussion more important and the discussion amplified and brought home the issues raised in the play. The combination made each part more effective. It would be great to have LAPD return to Detroit.

—Deborah Wright

LESSONS LEARNED

Also, extending the themes of discussions beyond the immediate concerns of one community generates a conversation that opens people's minds and builds the links needed to broaden the movement for change.

We didn't foresee that the treatment versus the incarceration initiative would be knocked off the ballot. We timed the residency so that it would take place immediately before the November 5 election, so that our efforts could directly enter into the public discourse as people thought about how to exercise their vote. As it turned out, no one got to vote on the issue. This didn't make the issue go away, however, and all the machinations leading up to its not getting on the ballot (the elections board, the state court appeal) kept the issue in the public eye. Also, there were legislative initiatives sponsored by Representative Bill McConico in the legislature that also addressed the issue of mandatory minimums and these moved forward and were ultimately signed by Governor John Engler just before he left office in January. The passing of this legislation was helpful in returning sentencing discretion to the judiciary, but left untouched stacked sentences, life sentences, and many other areas in need of reform. Also, a similar ballot versus incarceration initiative in Florida was knocked off the ballot through bureaucratic foot dragging on the part of the state judiciary. In Ohio, the initiative was on the ballot but it was defeated due to an aggressive anti-initiative campaign led by the governor that involved dubious use of public funds and public office to unduly influence voters and the vote. What we learned from all of this is that, on the one hand, what we thought to be strategic, i.e., scheduling the residency directly in front of the vote on the initiative, was ultimately way beyond our control. On the other hand, it became clear that the issue of drug policy reform is a long, protracted struggle, involving pushing and shoving from those on both sides of the issue. But the issue is one that is building momentum in the public consciousness. This ultimately gives us more flexibility in thinking how we might contribute to the debate through our residencies. It gives us increased flexibility in thinking how we might formulate, locate, and time future residencies while still making relevant contributions to the public re-evaluation of these policy issues.

Agents & Assets, as a play, was effective in putting into context and making the link between foreign policy and domestic policy. It achieved this through the text itself and the incidents of which it speaks, dramatic in themselves. Both the show and the panels about drug policy reform make the point that if we privilege foreign policy objectives over concerns for the citizens and specific communities in this country, people suffer greatly. To summarize, *Agents & Assets*, effectively built momentum in the public consciousness because:

· **The message was built into the text of the play.**

· **The activist intent was built into LAPD's organizing efforts leading up to the play and panels.** LAPD did extensive outreach to and participated in anti-war organizing connected to the war on Iraq. Staff worked with drug reform activists and made presentations at drug reform events before their event. Jo Ann Watson, who interviewed Malpede on her radio program, was on one of the LAPD panels. She worked with the Michigan ballot reform people and also worked for Representative John Conyers. We met Representative Conyers at a peace rally in front of the Federal building and at the Michigan Drug Reform forum.

· **The message was amplified and expanded in the formulation of the post-performance panels and discussions.** In Detroit, LAPD worked extensively with people in the community to determine conversation topics and invite panelists who spoke to the concerns of the community. One panel was specifically formulated around the rhetoric of war and why the military metaphor "war" was used to show resolve, whether in war on terror, Iraq, drugs, or even good things like deter-mination to ameliorate poverty. By having one conversation on this topic, LAPD expanded its audience and linked issues that were very much on everyone's mind at the time. When LAPD did *Agents & Assets* in Los Angeles, it held one panel specifi-cally on Project Columbia. This, too, brought a somewhat different audience to the event. This discussion helped people in our community (in that case, downtown LA) understand how their suffering was linked to the suffering of others in other parts of the world. The important point to be made here is that it contributes significantly to the residency process to identify significant themes that extend the issues of the play and to structure public discussions around these themes. Also, extending the themes of discussions beyond the immediate concerns of one community generates a conversation that opens people's minds and builds the links needed to broaden the movement for change.

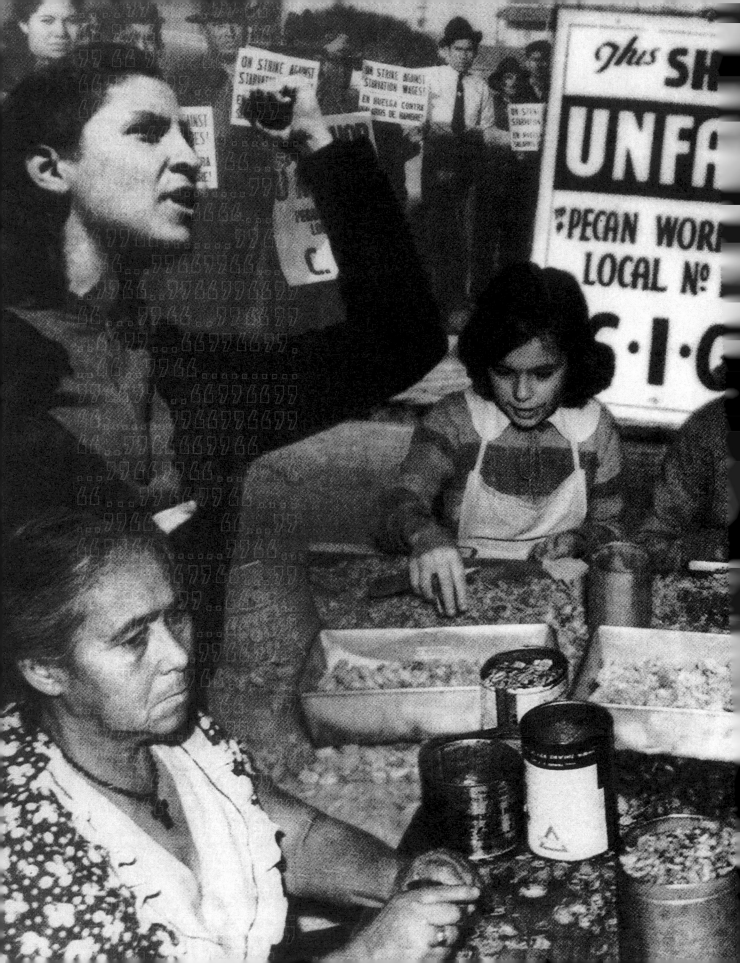

3 The Esperanza Peace and Justice Center

::: *ARTE ES VIDA*

We have learned that, in order to participate fully in democratic civil life, individuals must be culturally grounded, confident of their own voices, and certain of the value of their contributions. Art and culture give us this grounding.

—Graciela Sánchez, executive and artistic director

INTRODUCTION BY ANDREA ASSAF

Photo collage from the play An Altar for Emma *(2001), part of The Esperanza Peace and Justice Center's ongoing program,* Arte es Vida. *Photo courtesy of The Esperanza Peace and Justice Center.*

Arte es Vida is an ongoing program of The Esperanza Peace and Justice Center in San Antonio, Texas. Supported by Animating Democracy from 2001 to 2003, *Arte es Vida* addresses issues of cultural equity and democracy and examines "the role of artistic and cultural expression in a society that inherits the deep wounds, economic and political disparities, and continuing practices of injustice that are the legacy of cultural domination in the United States." It explores *cultural grounding*—the concept that a strong sense of selfhood and identity, rooted in creative expression and cultural practice, is necessary to empower marginalized communities and individuals to participate actively in public dialogue and civic life. To this end, *Arte es Vida* programming assists local Mexicano and Chicano communities in recovering their histories, art, culture, language, stories, and traditions, with a particular focus on the contributions of *sabias* (wise women elders). In addition to creating, facilitating, and presenting art and cultural events, the Esperanza hosts *pláticas* (community dialogues) facilitated by *animadoras* (trained Esperanza staff, artists, and community members).

In telling the story of *Arte es Vida*, Executive and Artistic Director Graciela Sánchez details four areas of activity within the larger project that reveal underlying cultural, political, and philosophical dimensions of the Esperanza's practice. These areas are: (1) community revisioning of labor leader Emma Tenayuca; (2) the effort to preserve La Gloria Building and other cultural landmarks in Chicano/Mexicano neighborhoods; (3) conflict of values within San Antonio's Westside community; and (4) historical conflicts between Chicanos and Mexicanos in San Antonio. She also articulates a clear statement on the significance of culture itself *as* a civic issue. This preface highlights some key points of the case study, particularly those that illuminate the role of arts-based civic dialogue work in a cultural organization oriented toward civic action and activism.

Cultural Grounding and the Concept of Art
The Esperanza takes the position that, as lesbian poet-activist Audre Lorde once declared, "Art is not a luxury!" This conviction, that art and culture are fundamental to the survival and health of communities and individuals, is reflected in the title of their project, *Arte es Vida*—"art is life." The Esperanza understands art as personally and culturally expressive activities, from cooking traditional foods, to enacting community rituals, to creating poems, performances, ceramics, or videos. They emphasize the importance of sharing and transmitting the stories and cultural practices of elders with the broader community, particularly the stories of women, whom they consider to be primary bearers of tradition and cultural memory. The Esperanza activities seek to increase leadership capacity within communities by recognizing otherwise marginalized individuals for their knowledge and contributions, and by encouraging community members to lead workshops, dialogues, organizing efforts, and projects.

The Esperanza supports the view that every person is a creative being capable of artistic expression. They emphasize the importance of community-defined cultural practice, and seek wide community involvement in all art making, performances, and events. In the following case study, Graciela Sánchez offers a critique of the artist residency model and asserts the importance of long-term, mission driven work. "Artists that work with *Arte es Vida*," youth facilitator and artist Vicki Grise explained, "must be community-based and must understand that they are not here to document our stories, but to empower a community to tell their own stories and document their own histories."

The Esperanza challenges assumptions about who defines art and culture, and how. They assert that these definitions are deeply political and relate to power, ownership, and the control of local resources. They reject the images of Mexicano or Chicano cultures projected by the tourist industry in San Antonio—made for easy consumption, depoliticized, and taken out of historical context (or revised to re-enforce a history of patriotic Texas identity). One example from the case study is the Esperanza's struggle to save La Gloria, a historic building that had once been an important social center for Mexicano and Chicano communities in San Antonio. The Esperanza saw La Gloria as an "elder" with stories to tell—a physical remnant of a thriving cultural past, a standing witness to the loss of local history.

The Esperanza asserts the importance of transference of cultural traditions and aesthetics from one generation to the next. Their emphasis on the cultural memory of elders, however, raises questions (or perhaps challenges) of cultural hybridity, which increasing

numbers of youth, and adults, face. Some consider hybridity not only a result of cultural loss but a complex experience and view of the world that, when lived with consciousness, creates its own cultural identity with progressive potential. In addition to recovering histories and cultural traditions, the Esperanza uses art to help communities envision alternatives and futures. Although the *Arte es Vida* project emphasizes the contributions of elders as a source of cultural grounding for the larger community, the work of the Esperanza as a whole includes the development of youth leadership and new aesthetics—such as spoken word, video, and performance art—rooted in appreciation and knowledge of traditional Mexican cultural forms.

Activism and Mission-driven Work
The Esperanza employs a philosophy of community cultural development that is grass roots, bottom-up, and empowerment and action focused. Characteristic of their work is the use of art and cultural practice toward social justice. The Esperanza Center takes multiple approaches to activism, including cultural grounding as a means of empowerment; cultural practice as a mode of community building; advocacy for the arts and culture as a civic issue (of representation, acknowledgement, equity, etc.); and use of art in demonstrations and performances of resistance. One particularly interesting aspect of the Esperanza's activism is the use of art and cultural practices to interface with public policy, in public spaces, and during governmental processes, such as hearings.

In addition, the Esperanza seeks to engage policymakers in community cultural activities, as well as advocacy projects. In some cases, the Esperanza has succeeded in building alliances and partnerships with civic leaders. A challenge the Esperanza has encountered, however, is the difficulty of engaging those with power in activities that critique established power structures. They began the *Arte es Vida* project with the goal of facilitating intergroup dialogue, including participants from opposing sides of political and economic conflicts, such as corporate leaders and environmental advocates. Instead, they discovered the long-term need for intragroup dialogue within Chicano and Mexicano communities, and rediscovered that who comes to the table still depends on (the perception of) who does the inviting.

Fundamental concepts and practices inherent in their process and approach to programming include multi-issue organizing; drawing connections among multiple forms of oppression; responsive programming that engages communities in pressing, current issues; youth development and mentoring; and long-term work toward sustainability and systemic change. In addition to developing long-term partnerships and coalition building, Sánchez asserts in this report the importance of working with community organizers as integral to arts-based civic dialogue work.

Dialogue Practice and Culture
The Esperanza sees dialogue as a means of raising consciousness, sharing knowledge, recovering history, raising appreciation for the life experiences of others, reviving cultural practices, building community, informing people of current issues, and mobilizing community members toward action. Formats used by the Esperanza Center range from large-scale public dialogues to interpersonal dialogue on civic issues in public space, to ongoing small group community dialogues, to consensus building among coalition partners,

to widespread community engagement in civic discourse. Many of these formats are art-based or incorporate various art and cultural activities to empower community voice or stimulate discussion.

Sánchez articulates cultural, theoretical, and practical elements unique to the Esperanza's dialogue practice. Instead of "dialogue," the Esperanza uses the Spanish word "*plática*." *Plática* translates most directly as "chat" or informal conversation, and connotes a comfortable and familiar tone, though the Esperanza employs intentional facilitation and dialogue techniques during these events. Sánchez emphasizes cultural values that contribute to successful dialogue, such as respect, the acceptance of emotional expression in public space, and a cultural willingness to spend long periods of time in conversation. She also offers reflections on the role of ritual, spirituality, and moral values in arts-based civic dialogue.

The Chicano and Mexicano community encounters other challenges, however, that the Esperanza addresses consciously in facilitation, such as overcoming barriers of who feels safe in public space and empowering participants to feel they have something valuable to contribute, whether or not they have formal education, are poor or working class, or are accustomed to being silenced (especially women). The issue of language is key in this context. Inadequate public education, the assumption that public speaking is for experts, language limitations (in English, Spanish, or both), and embarrassment or prejudice about the way people speak can create obstacles to participation and divisions within the Chicano and Mexicano community. Bilingualism both adds dimension and accessibility to dialogue for some, and creates tensions or inaccessibility for others.

The case study looks especially at intragroup dialogue within the context of Chicano and Mexicano communities in San Antonio. One finding from the *Arte es Vida* project is that there are always complex layers of dialogue that occur *within* any group. Community members have multiple, overlapping identities and internal conflicts that divide them, such as internalized racism, homophobia, misogyny within the community, or conflicts between recent immigrants and Chicanas/os who have been in Texas for generations. The Esperanza has come to consider work of intragroup dialogue—work *within* the community—a prerequisite for effective intergroup dialogue with other communities. As Sánchez states in her report, communities need to "develop their creative skills, and to recover skills of storytelling and conversation, that are essential to mutual understanding and alliance building."

Arte es Vida

CASE STUDY BY GRACIELA SÁNCHEZ

The people of the Esperanza dream of a world where everyone has civil rights and economic justice, where the environment is cared for, where cultures are honored and communities are safe. The Esperanza advocates for those wounded by domination and inequality—women, people of color, lesbians and gay men, the working class and poor. We believe in creating bridges between people by exchanging ideas and educating and empowering each other.

We have learned that in order to participate fully in democratic civil life, individuals must be culturally grounded, confident of their own voices, and certain of the value of their contributions. Art and culture give us this grounding. From our parents, grandparents, sisters, and brothers throughout the world, from our teachers and children, we have learned that social and political divisions cannot be bridged without accurate and respectful cultural understanding.

We believe it is vital to share our visions of hope…we are esperanza.

OUR OVERALL WORK

Toward a more holistic movement for social change, the Esperanza hosts *pláticas* (community discussions), workshops, and conferences; facilitates activist networks, coalition work, leadership training, and technical assistance; produces and presents justice-oriented art exhibits, concerts, plays, and performances; creates opportunities for personal development, community-building, and mutual understanding among groups; and much more.[1] In all of our work, we seek to erase borders, build bridges, and create alliances between people, while providing a space for disenfranchised groups and individuals to express themselves fully and creatively, and to develop skills as members and creators of a just, progressive, and diverse community.

Our work is rooted in three insights, derived from our daily experiences and lifelong theorizing. The first is that long-term progressive work must address multiple forms of systemic oppression—including race, class, gender, sexuality, language, and ethnicity—and must advocate for those wounded by domination and inequality—women, people of color, lesbians and gay men, the working class and poor. The second formative insight is that empowerment requires cultural grounding: in order to engage in productive social justice work, we must come to know and value ourselves, to challenge and celebrate our cultural histories and practices. The third basic insight of the Esperanza is that there can be no separation of goals and process—we must do our work with a habit of self-examination and a commitment to justice, and our process must include the development of lasting alliances among a community of shared values—a *comunidad de alma* (community of soul/heart). We have found that cultural organizing enables the formation of such a community—bound together by values of human dignity and shared learning.

Multi-issue Organizing

Since its inception, the Esperanza has organized local social, economic, and environmental justice activism through education, technical assistance, direct actions, media advocacy, marches and rallies, and political education campaigns. In order to challenge the many abuses of institutionalized power—especially power based on subordination by race, class, gender, and sexuality—our communities must learn to understand not only their own issues but also the relationship between all forms of oppression. We work to promote an integrated understanding that examines the dominant culture of violence and sees the interconnections of gender, race, and class oppression within that culture.

Overall, the Esperanza's goal is to transform the conditions of conflict among different communities in San Antonio. Our shared history is one of violence and disrespect, in which communities of color have been subjected to economic exploitation and cultural domination. It is also a history in which women and girls, lesbians, and gay men have been subjected to extreme and routine violence.

Throughout our work, and the work of our mothers and fathers, we have come to understand the devastation that our communities have suffered through this history of violence. In particular, we have come to see the continuing harm that individuals and communities suffer through loss and devaluation of our cultural histories, traditions, and practices. We have come to see how the devaluation of our diverse cultures happens through the routine, even unconscious, practices of governmental, educational, social,

[1] The Esperanza has been hosting *pláticas*, or community dialogues, since 1989.

A critical element in culturally grounding our communities centers on acknowledging our women elders, nuestras sabias...

[2] Emma Nelly Garcia (May Day, 2001), Lydia Mendoza (Homenaje a Lydia Mendoza, May 2001, and at the Casa de Cuentos), Rita Vidaurri (Homenaje a Lydia Mendoza and Casa de Cuentos, May 2004). *An Altar for Emma* (November 2000, May, 2001 and Casa de Cuentos), and La Gloria (2002–present). Other participating *sabias* have included Maria Berriozabal (2001–present), Doña Panchita (2000–present), and Doña Inez (November 2002–present).

and religious institutions. And we have come to understand that it is through maintenance of our cultural traditions, through careful passing on of our language and practices that our communities, our grandmothers and grandfathers, our mothers and fathers, have been able to survive.

Our general strategy, then, is twofold. First, we assist community members in recovering their histories and cultural traditions and in understanding the practices of domination that continue to injure individuals and undermine our communities. Second, we work to empower communities and community members to envision alternative choices for themselves and their communities, and to develop cultural practices that can resist and replace the cultures of violence and consumption that we inherit.

A critical element in culturally grounding our communities centers on acknowledging our women elders, *nuestras sabias*, recognizing that: (1) mainstream culture has never honored or valued their work and, consequently, most people of color do not know or remember these great *mujeres*; (2) these *sabias* were/are amazing pioneers and heroines in San Antonio political and cultural life; (3) these women's lives and history illuminate the racist and sexist history of our world; and (4) their strength, intelligence, and ultimate survival are valuable insights for everyone. During the Animating Democracy project of *Arte es Vida*, we worked with many *sabias*, including Emma Nelly Garcia, Lydia Mendoza, and Rita Vidaurri. We also highlighted the life of Emma Tenayuca, after her death, in *An Altar for Emma,* and the cultural memory of a historic building, La Gloria. Many other women elders have also participated in telling their stories or guiding discussions or workshops.[2]

We came to Animating Democracy with this orientation. As we have worked with Animating Democracy, we have become more conscious of and reflective about the methodologies of arts-based civic dialogue. In this report, we review some of the insights, approaches, questions, and tentative plans we have developed.

Our proposed civic goal was "to examine the role of artistic and cultural expression in a society that inherits the deep wounds, economic and political disparities, and continuing practices of injustice that are the legacy of cultural domination in the United States."

ARTE ES VIDA: GOALS, CIVIC ISSUES, ARTS/HUMANITIES, AND DIALOGIC COMPONENTS

Our proposed civic goal was "to examine the role of artistic and cultural expression in a society that inherits the deep wounds, economic and political disparities, and continuing practices of injustice that are the legacy of cultural domination in the United States." Although this remains our overall concern, through working with the arts-based civic dialogue frame, we have come to examine more closely the particular points of conflict in which we have worked, seeking to illuminate the cultural aspects and conflicts underlying particular disputes.

Among the particular conflicts we have worked on are four that we will describe in detail in this report. These are: (1) conflicts in our community's view and understanding of labor leader Emma Tenayuca; (2) controversy over the demolition of cultural landmarks in Chicano/Mexicano neighborhoods; (3) a conflict of values within San Antonio's Westside Chicano community; and (4) historical conflicts between Chicanos and Mexicanos in San Antonio. Consistent throughout our work on these conflicts has

been our focus on the importance of cultural grounding and on the need for participants to develop their creative skills, and to recover skills of storytelling and conversation that are essential to mutual understanding and alliance building.

Conflicts in Our Community's View and Understanding of Labor Leader Emma Tenayuca

During the 1930s and 1940s, labor activist Emma Tenayuca played a major leadership role in organizing low-paid Chicana/o and Mexicana/o workers in San Antonio and South Texas. Affectionately known as "La Pasionaria de Texas," she was a brave and passionate leader of Mexican workers in Depression-era Texas. Beginning at the age of 17, she helped to organize local chapters of the Ladies' Garment Workers Union and led a strike by Mexican women workers at the Finck Cigar factory. She led protests against the beatings of immigrants by the Border Patrol and fought for equal rights for all citizen and noncitizen workers, for a minimum wage, and for the right to strike.

In 1938, Emma Tenayuca led the largest strike of workers in the history of San Antonio. Pecan workers in San Antonio, most of whom were Chicana/Mexicana women, earned five cents a day, working in overpacked work spaces, with dangerous shelling tools and toxic dust. In late 1937, the pecan companies lowered the daily wage to three cents a day. Emma Tenayuca led 12,000 of the Mexican women pecan shellers out on strike on January 31, 1938. The strike lasted for several months, despite violent attacks by San Antonio Police and private guards. Over a thousand striking workers were arrested and jailed, including Emma Tenayuca. Union meeting places were ransacked and many strikers were beaten.

Some of the Altar for Emma pláticas went on for hours.

In 1939, Emma Tenayuca was scheduled to speak at a Communist Party meeting at the Municipal Auditorium in San Antonio. As she began speaking, approximately 5,000 white men stormed into the auditorium, throwing rocks and bricks. Many attendants were injured. Although Emma Tenayuca escaped safely, she was targeted by numerous acts of violence and was unable to find work in San Antonio. Emma Tenayuca died in San Antonio on July 23, 1999.

Sadly, even as Emma Tenayuca came to be recognized nationally as a Chicana leader, the Chicano/Mexicano community in San Antonio has been hesitant to embrace her, for various reasons. White leaders in San Antonio have been outspoken in denouncing Emma Tenayuca and clear in their disapproval of any show of support for her in the Latino community. Like the history of Chicano/Mexicano resistance in general, the history of labor organizing, including Emma Tenayuca and the strike by 12,000 pecan shellers, has been erased from public memory. Schools do not teach the history, and Emma Tenayuca has been treated as a source of shame or scandal, as a shadowy Communist who is somehow un-American, even within the Chicano/Mexicano community. This erasure has been particularly hurtful for women because Chicana leaders have been demonized repeatedly in San Antonio.

The Esperanza sought to encourage discussion of these conflicting ideas about Emma Tenayuca and the history of Chicano/Mexicano labor organizing by focusing an issue of our news journal, *La Voz de Esperanza,* on Emma Tenayuca and the pecan strike and by producing the play *An Altar for Emma,* by Beva Sánchez Padilla, in November 2000. *An Altar for Emma* explores the erasure of Emma Tenayuca and illuminates her vision and work

for social justice. Multigenerational cast members were drawn from the community, and the role of Emma Tenayuca was played by Chicana activists (Maria Berriozábal, Norma Cantu, Josie Mendez Negrete, and Graciela Sánchez) with a different woman in the role each night of the performance run. Musician Juan Tejeda composed an original *corrido* on Emma Tenayuca for the play (*corridos* form part of an oral tradition in Mexican culture of documenting histories, especially of heroes, famous people, and important events). Cristal Riojas directed an original movement piece to the *corrido*. The play included audience participation, including a segment in which audience members join a picket line as active participants. The production also involved recovery of photographs of the strike and Municipal Auditorium assault, tapes of interviews with Emma Tenayuca, and video of the Emma Tenayuca funeral.

As part of the outreach accompanying production of the play, we invited Tenayuca family members, community activists who had known and participated with Tenayuca in labor organizing, public school teachers and administrators, and other community leaders. Each showing played to a standing-room-only crowd. And as word spread about the production, we set up an overflow room with simultaneous video screening. Over 1,500 people saw the production, and thousands more read about it in *La Voz* and the *San Antonio Express-News*.

After each showing, there was a *plática* with cast and audience members. Since these performances occurred prior to the facilitation training of staff, these discussions followed the Esperanza model where a performer or staff person invites the community to stay and participate in a community conversation regarding the performance and the issues raised by it. Beva Sánchez Padilla, the author/director, and the three-member cast facilitated the *pláticas* by sitting informally on the stage or walking among the audience. Some members of the audience asked questions of Beva or the cast members, but most reflected on what they knew or had experienced about the time and events represented in the play.

Community members shared their memories of the labor struggles and the effect those efforts have had on their families and communities.

Performers, drawn from the community, shell pecans in a scene from An Altar for Emma, *2001. Photo © The Esperanza Peace and Justice Center.*

Some of the *Altar for Emma pláticas* went on for hours. The facilitators encouraged an informal, kitchen table atmosphere. They expressed genuine, heartfelt interest in learning from audience members, and this encouraged people to speak. There was a feeling that we were all very lucky to be in this space, hearing the stories of those who could remember those times. The older people responded eagerly, sharing memories both happy and sad. Because each person's story was recognized and valued, people felt appreciated. Each evening was different, yet every audience included some people whom we knew had interesting stories to tell, so each evening the facilitators addressed the audience with the desire to hear their stories.

Community members shared their memories of the labor struggles and the effect those efforts have had on their families and communities. A former pecan sheller brought the tools used to shell pecans and demonstrated the process of breaking and removing the

pecan from the shell. She talked about cuts to her hands and arms and the exhaustion that came from breathing pecan dust. Another pecan sheller strike participant recalled how the strikers began every morning by singing traditional Mexican songs. Neighbors of Emma Tenayuca came to share memories and the fear that seized the community after the Municipal Auditorium assaults.

Perhaps the most influential contribution to resolving the issues that had led to the erasure of this history within our own communities came from members of the Tenayuca family. The family had been torn apart. (Because Emma was a member of the Communist Party in San Antonio, she was denounced and demonized by the media, local businessmen, and politicians, and shadowed by the FBI. Add to this the fact that she was also young, and a woman of Mexican descent, and the hatred for this organizer in the 1930s was overwhelming.) Many family members saw each other at the Esperanza performance for the first time since the Municipal Auditorium assault over 60 years ago. Younger family members met for the first time. A cousin of Emma Tenayuca told about how Emma would sneak in by the dark of night to see her mother and to share whatever food she had. Family members told of the shame that they had experienced knowing that they were related to Emma Tenayuca, who was denounced by teachers, priests, and city leaders. People cried to recall their pain and to hear that of others.

Among our goals in the May Day event was to encourage active exchange in the city's public spaces.

As part of the theater production, we hung an exhibit of six (three by four foot) photographs of the pecan shellers' strike and an altar installation at the Esperanza. On May Day 2001, as part of the International Workers' Day Celebration, we created a mobile exhibit at the Plaza de las Islas in downtown San Antonio. Among our goals in the May Day event was to encourage active exchange in the city's public spaces. In the traditional way,

THE CHILI QUEENS OF SAN ANTONIO

A National Public Radio show, *Kitchen Sisters*, came to the Esperanza in January 2004 to interview Isabel and Graciela Sánchez for a segment dealing with Chili Queens of San Antonio. The Chili Queens were a group of Mexican women of San Antonio who had *puestos* or *fondas* (kitchen stalls with tables and chairs) in downtown San Antonio during the late 19th and early 20th centuries. They were so popular that white restaurant owners organized to shut down the Chili Queens in the 1920s, claiming that these women were spreading disease by selling their food. The Chili Queens were made nationally famous when San Antonio sent a group of them to the Worlds Fair of 1890.

one of our *sabias*, Emma Nellie, and several performance artists moved around in this small community park, which is one of the oldest parks in the city. We provided *aguas frescas* (flavored water) so that community members could drink and enjoy themselves in the park while listening to songs and engaging in the performances and conversation.

The enthusiasm Emma Nellie had for this work was infectious. Emma Nellie was a *trovadora* (a community singer) in the 1950s and 60s. She now lives in public housing for the elderly, near the Esperanza, and came to us one day when she saw our sign, saying she needed hope. We asked her to sing and to teach some of the songs she knows to young people, and she responded with incredible energy and joy. Although people in the public plaza on May Day were at first hesitant (as it is usually expected that people pay a fee for a song), some soon began to sing along with her and to share songs of their own.

> ...community members performed teatro *around issues of workers' rights.*

In addition, community members performed *teatro* around issues of workers' rights. Performance artist María Elena Gaitán and other *animadoras* ("animators" or facilitators)[2] engaged individuals and small groups of people in conversation about their own experiences as immigrants and workers. The performers created *actos* about the hotel/tourist industry and sweatshop/maquila labor.

[2] Prior to the course of her work with the Esperanza, dialogue trainer Luz Guerra suggested the term *"animadora"* rather than facilitator. She explained that this term is used frequently in Latin America, in community organizing efforts in El Salvador, and it fit more closely with our goals and cultural context.

One of the community actors laid a piece of white linoleum on the floor and handed markers to *gente* passing by. The actor was mute, voiceless. She gestured to others to write a message on the linoleum. One young woman, a hotel worker, was in the plaza with her daughter on her day off. She wrote, "Living wage for me and my children." She and her daughter stayed in the plaza for over an hour talking to *animadoras* about the hierarchy in the chain of workers, about the lack of benefits and health care, and about hiring practices. Another man showed us and others the needles of cactus embedded in his hands, narrating the story of how he crossed the border only days earlier. Others spoke directly about the unions in the 1930s and the pecan shellers' strike.

Though there were facilitators on hand, the most exciting part of May Day in the park was the conversation that happened amongst community members as they viewed the images and performances, shared memories, made connections, and claimed their own creativity. The plaza in its traditional design is meant to be a meeting place for people, a place to take families, to meet lovers, to join friends, and even though many gather in the plaza during lunchtime, something has changed the traditional intention of the plaza structure. Many of these changes have occurred over time as businesspeople have worked with city officials to limit the use of parks, especially if these activities were perceived as impeding their businesses. In time, street vendors—such as the Chili Queens, musicians, and artists—were kicked out of all parks and streets in the downtown area.

[3] One man eating lunch in the plaza greeted us by saying, "I'm glad you're back." When asked what he meant he said, "I'm glad you're back, that you came back to sing, to perform, like in the old days," making a direct connection between us and the tradition of the *carpas* and musicians that played in the open air markets in the 30s and 40s.

People continue to claim their space within the plaza. The elders on one corner feed the pigeons. The workers on another side eat their lunch. The mothers sit by the *raspa* stand. But when we brought the elements of music, performance, free *aguas frescas*, and *pláctica*, people began talking to each other. These elements that were once a part of the plaza scene were brought back, and this allowed people to exchange words, songs, and memories in much the same way they were accustomed to doing in the past.[3]

Because the Esperanza paid to rent the plaza for a few hours, the park police did not interfere with these exchanges. Consequently, the Mexican immigrant shared his story of illegal border crossing with the hotel worker, who learned about unions and union organizing from the elders. People resting in a corner sang with one another. Total strangers exchanged many stories of the pecan shellers, not just women who they had heard or read about, but their family members, moms, grandmothers, aunts, and sisters who were sent to jail, called communist, lost their jobs, and/or marched in the largest marches ever held in San Antonio. Over 150 people viewed the exhibit that day and many more joined other activities while in the plaza.

The recovery projects begun by *An Altar for Emma* have continued. Various community members have worked to recover and retell the history of the labor struggles of the Chicano/Mexicano community and of the leadership of Emma Tenayuca, Manuela Solis Sager, and others through film, video, murals, and photo archives.

Controversy Over the Demolition of Cultural Landmarks in Chicano/Mexicano Neighborhoods

La Gloria was a building in the near Westside[4] of San Antonio. Built on April 4, 1928, it served as a gas station, grocery store, and important gathering center for Chicanos and Mexicanos. During the depression, owner Matilde Elizondo converted the rooftop to a dance floor and La Gloria became the focus for generations of young Westsiders.

In late 2001, the city announced its decision not to protect La Gloria as a historical landmark and to issue a permit for its destruction. The current owner planned to replace La Gloria with an auto parts store. The controversy spurred by this announcement touched thousands of people. The Chicano community itself was divided as the city council representative supported the demolition in the name of economic development, and other community leaders denounced the city's callous disregard for the cultural heritage of the Chicano community.

The Esperanza helped to organize community members in support of the historic preservation of La Gloria and other culturally significant landmarks in the near Westside. Volunteer lawyers from the Esperanza and other community groups filed a court action that resulted in an injunction against the planned demolition. This gave the community almost a month in which to try to reverse the city's decision. The Esperanza worked quickly to engage community members in public discussion of the history and cultural significance of La Gloria. We recovered video of original footage of the building and rooftop dance floor from the 1930s. We organized public discussions focused on La Gloria, the original footage, and the memories shared by elders. We invited community members to envision possible uses for the building that would allow its preservation.

In the original footage, community members were able to see La Gloria in its heyday. By seeing Mexicanas/os dancing the Charleston, dressed in clothing of that era, younger generations acquired a vigorous image of their grandparents and great-grandparents. We showed the video wherever we could so that people would remember or learn of the significance of the building. When we marched through the streets demonstrating against the demolition, we made sure to screen the video at the end of the march in a much traveled

[4] The near Westside is a predominantly Chicano area of San Antonio.

These elements that were once a part of the plaza scene were brought back, and this allowed people to exchange words, songs, and memories in much the same way they were accustomed to doing in the past.

intersection so that anyone driving or walking past would be able to see the images of this building and its connection to the Westside community. We also screened the video outside City Hall (after being denied access to City Hall Chambers during the Citizens to Be Heard section) and during a hearing in front of a state judge who heard the case to save La Gloria (March 2002).

Throughout, we encouraged the community to recover the deeper significance associated with La Gloria and to express these deeper thoughts through images, music, and poetry. Community members went door to door speaking to their neighbors, hearing their memories of La Gloria and the depression days. Another group created a short video with poetry and visual narration about the tearing down of La Gloria. Still others used the video as a backdrop for a performance piece that was performed at a Youth Action conference opening (April 5, 2002).

The Esperanza had to rethink itself and consider how to include community in its introduction. We wanted to make sure young and old would speak. We wanted to perform, not just speak.

This performance, presented by a cast that included three generations of community members, was a creative and collective expression of memory and loss. To create the piece, we invited discussion with young activists on how to introduce the Esperanza to more than 200 youth from throughout the country who were participating in the con ference. The Esperanza had to rethink itself and consider how to include community in its introduction. We wanted to make sure young and old would speak. We wanted to perform, not just speak. But our time was limited to 15 minutes. We invited three elders in their late 70s and 80s to dance with us, as well as help us collect music of the depression days. Youth in school and drop-outs, as well, performed with us. Young and old danced together while images of La Gloria served as a backdrop. Straight and gay couples emerged. Vicki Grise read from a poem she created the day La Gloria came down. Finally, a poem was created by the spontaneous responses participants had to questions we posed to them. Through this performance, community members worked to produce an image of ourselves as connected to our history, sharing joy and pain in the struggle to maintain our cultures.

During the public dialogues on the demolition of La Gloria, participants articulated the importance of history, culture, and community responsibility. Cruz Piña Sellars said, "*Hubo una persona que empezó asi, como nosotros, a revivir el barrio…*" When asked why historical sites need to be saved, Sellars replied, "*¿Si no tenemos historia, madre, que hacemos?*" Guadalupe Segura described La Gloria as "*una cancha para bailar como en Mexico.*" She lamented the plans for demolition and explored the possibilities that such a sturdy structure had for the neighborhood. "*Se podría exponer arte de nuestra gente.*" She explained: "*Arte es todo lo que somos nosotros. Si no tenemos eso, no tenemos nada. Esa, pasado, cultura, arte, leyenda, devociones y todo lo que hacemos nosotros, los Mexicanos, se uniera en este punto clave para la juventud.*"

> [Translation: Señora Sellars: "It takes only one person, like us, to begin the process of reviving a barrio… If we don't have our history, mother, what can we do?" Guadelupe Segura: "A dance floor like in Mexico… The art of our people could be exhibited… Art is all we are. If we don't have this, we have nothing. This, the past, culture, art, legend, devotion, and all that we make, as Mexicans, could unite us at this key time for our youth."]

History, culture, art, legends, and politics were, and are, all part of La Gloria, and it was one of few buildings remaining from the 1920s, 30s, 40s, and 50s when the dance *salóns* (social clubs, radio clubs, patios, etc.) reflected the changes occurring within the city of San Antonio and, indeed, the world. One man recalled, "I grew up in *este barrio. Mi papá jugaba pelota, beisbol*, across the street. *Bonito* stadium. I went overseas to Vietnam, *Alemania. Lo tumbaron.* It broke my heart. *Estamos perdiendo mucha, mucha* history—*duele pa' nosotros que* went through it." He went on to name various buildings with historical significance for Chicanas/os that have been knocked down. Like other community participants, he noted the disparity in restoration of historical sites in the city.

[Translation: "I grew up in this neighborhood. My father played ball, baseball, across the street. Pretty stadium. I went overseas to Vietnam, Germany. They tore it down. It broke my heart. We are losing much, much of our history—it hurts those of us who went through it."]

Sadly, and despite an outpouring of concern from thousands of community members, La Gloria was demolished early in the morning following Easter Sunday, April 1, 2002.

Saving La Gloria was not a project that the Esperanza had planned. However, because the Esperanza is connected to a community, and because the issues surrounding the demolition of La Gloria—cultural grounding, history of our community, Westside community development, racist policies against the Mexicano/Chicano community, economic development at the expense of preservation of culturally significant buildings in our community—are integral to our vision, the Esperanza placed saving La Gloria at the top of our list of cultural organizing work that we had to do. Within a four-week period, the Esperanza worked with local community organizations and individuals including West Side residents, artists, activists, conservation activists, architects, and lawyers. The only goal everyone agreed to was saving La Gloria. But many had different reasons for the same goal. Some wanted to save La Gloria because they had once danced on the rooftop, or bought food when it was a market during the 1920s. La Gloria was their history. Others wanted to save it for its future potential use as a cultural arts space, a grocery store, or a museum.

The Esperanza supported community organizing by helping to facilitate meetings amongst community. We also taught these skills to each other. Too often, when groups organize around a specific issue, they do not take the time or have the skills to define specific parameters of how to run meetings, make decisions, speak within these meetings, etc. Most do not discuss the power dynamics that play out in dialogues or meetings. Consequently, discussions and decisions are dominated by men, while women, youth, and other groups who tend to be less assertive are silenced or disregarded. We were able to help community members become conscious of who was participating and to make deliberate efforts to allow everyone to speak. We helped the group achieve consensus decision-making. And most importantly, we helped participants to see that this crisis was connected to a larger context and that these discussions would have to continue beyond this critical moment.

Public policy cannot be transformed over a short period of time. The Westside community did not have more than a month to try to resolve a major problem. Although we spent hundreds of hours working and strategizing to save La Gloria, there were other

...most importantly, we helped participants to see that this crisis was connected to a larger context and that these discussions would have to continue beyond this critical moment.

forces working against us to demolish the building. Yet, the public dialogues surrounding the conflict over La Gloria resulted in lasting changes. Perhaps most importantly, the predominantly white and middle-class conservation/historical preservation community came to understand the commitment of many in the Chicano community to preservation of culturally significant landmarks.

Perhaps the most dramatic evidence of this shift was the public statement by Ann McGlone, director of the Office of Historic Preservation for the City of San Antonio, who spoke of her own recognition that Chicano neighborhoods had been largely ignored by the City preservation agencies and that this disparate treatment was racially motivated. Through these conversations, concerned members of both the white and Chicano communities came to a shared understanding of the history of cultural domination and the need for racial justice in the work of historic preservation, as in other areas of community life.

McGlone explained further that one of her own assumptions since the 1970s had been that the Chicano community did not care about historic preservation. This assumption was based in part on the actions of, and conversations with, some Chicano organizations that have pushed for new buildings rather than preservation. Because of the dialogues about La Gloria, McGlone is now actively working with the Esperanza and other Chicano organizations and individuals, and together we have been able to stop the demolition of other historic buildings in the Westside, including three homes on Guadalupe Street, during the fall of 2003 and January 2004.

[5] These groups include Centro Cultural Aztlan, National Association of Latino Arts and Culture, Avenida Guadalupe, Guadalupe Cultural Arts Center, Urban 15, San Anto, and Guadalupe.

The Esperanza's work on historic preservation continues. In the two years since La Gloria was torn down, numerous community members have become interested in having various buildings in the near Westside designated as cultural landmarks. We have helped community members to organize testimony to give to the Historic Preservation office regarding specific buildings. We are now in conversation with Councilperson Patti Radle, the Historic Preservation office, and several community groups[5] to develop a more holistic community development plan that incorporates a deeper and more complex vision of the community based on people's history, culture, and values. The Esperanza has helped to develop a strong coalition of community groups willing to carry on this work, acknowledging that we all don't come with the same understanding and values of community development, but that we will dialogue and better understand the complexities of our community. Decisions will be made collectively rather than from any one group, individual, or city agency. At the core of these discussions will be conversations centered on Chicano Westside history, the effects of classism, racism, sexism, homophobia, and ageism in our community, and how the effects of cultural genocide help to create divisions amongst groups.

Already the discussions are broader, more holistic and culturally based, and public policy has placed the voice of community at the center of its decision-making process.

The experience of organizing against the demolition of La Gloria, and the joining together images of cultural history and community solidarity, has transformed public discussion and decision-making regarding Westside community development. Already the discussions are broader, more holistic and culturally based, and public policy has placed the voice of community at the center of its decision-making process. We continue to promote dialogue among community members, economic development and housing agencies, and public officials to solve conflicts between perceptions of economic growth and the importance of

maintaining our cultural history. We have centered key dialogues on values of our community, beginning with trust. We acknowledge that our work will and must take time to build the trust amongst groups, in order for our work to move forward honestly and for the good of the entire community.

A Conflict of Values Within San Antonio's Westside Chicano Community

The near Westside is an area of approximately four square miles. Much of this area was part of the original township of San Antonio chartered in 1837. Under the Jim Crow legal regime, this was the area designated for Mexicans and blacks. In the 1940s, the first public housing in the nation, the Alazán-Apache Courts, was built in this area. By the 1950s, the near Westside had become the most densely populated and poorest area in the city. Census track 1105, where the Esperanza's *Arte Es Vida* project is located, has been ranked as the 11th poorest neighborhood in the United States based on per capita income, with 58.13 percent of the population living below the poverty line in 2000 (U.S. Census, 2000). The area continues to be predominantly Chicano, with the 2000 census reporting over 91 percent Hispanic.

This area, traditionally isolated by an expanse of railroad tracks, was subjected to massive destruction in the 1970s in the name of "urban renewal." The razing of neighborhoods caused the dislocation of large numbers of people and the separation of families, leading to isolation, increased crime, and loss of community identity. Today, the city is encouraging middle-class, upwardly mobile people to take over areas where poor and working-class families still make their homes. Although both the displaced and the newcomers are predominantly Latino, the shift in class represents an important shift in community values. Sadly, many second- and third-generation Mexican Americans who are moving back to the area in which their parents or grandparents were raised have internalized the "Anglo" population's disrespect for Mexican-American culture and community. Many have embraced the individualistic values and practices of the dominant culture.

One common theme in these conversations has been the idea of **buena gente**—*good people.*

Preserve community elders' lessons: La Casa de Cuentos meetings

The Esperanza has sought to address these conflicts through long-term dialogue among community members. One of the persistent complaints we have heard from community residents is that the near Westside has been periodically studied and "assisted" by numerous state and local agencies, who typically conduct one or two community meetings at the beginning of their projects and then never return to include community in developing the details of their programs. Hearing these concerns, we reaffirmed our commitment to long-term, community participation.

We have conducted monthly meetings at the Esperanza's Westside Casa de Cuentos (April 2002 to present). The design of these meetings has been to focus on elders in the community, encouraging them to share their knowledge of the community history and values. At some meetings we have asked participants to recall their interactions with neighbors, to tell of family illnesses or losses. In others, participants were invited to describe games that they played as children or to recall their memories of school. The meetings have attracted people of all ages to hear the stories and learn the lessons and the values taught by our elders.

In addition to community elders, participants in our youth program, Artescuela, and our women's cooperative, *MujerArtes*, attend all *Arte es Vida* meetings, which ensures intergenerational dialogue at each gathering. At Casa de Cuentos, we have used different strategies to promote dialogue, including story circles, sharing pictures, and cooking together. Our vision of dialogue in these meetings honors and acknowledges the importance of our individual experiences (outside of titles, degrees, etc.) and offers a space to see our interconnectedness so that we can better understand our struggles as systematic forms of oppression and not as individual failures/successes. Types of questions raised in these *pláticas* have included: What role do the arts play in people's lives? How have ethnic/racial communities been affected by pressure to assimilate into the mainstream U.S. culture? How did/do our cultural traditions survive? What does it mean for people to lose their mother language and traditions, and how does it affect people's sense of self?

Another theme focused on what we began to call actos de corazón *(acts/actions from the heart).*

One common theme in these conversations has been the idea of *buena gente*—good people. In Mexican culture there is a distinction between *bien educado* and *instrucción*. To be *bien educado* means that you have learned to be/live well with others, to be generous, respectful, and considerate of those around you. *Instrucción*, in contrast, refers to public or private schooling. One becomes *bien educado* through interaction with one's family and community elders. And to be *bien educado* is valued far more than mere *instrucción*. To be *bien educado* is to be *buena gente*.

Another theme focused on what we began to call *actos de corazón* (acts/actions from the heart). This term refers to the move from the values of *buena gente* to actions for community that *Arte es Vida* participants repeatedly emphasized. People can claim to believe in concepts of generosity, sharing, compassion, caring, humility, respect, and the like, but to live these values, to be *buena gente*, one must actively work to assist others, to serve community. One must commit to *actos de corazón*, acts from the heart. This work is lifelong, a matter of lasting commitment.

Various community activities have grown out of the Casa de Cuentos dialogues. Youth of Artescuela who have participated in the *pláticas* talked about their interest in learning to make altars and to cook traditional foods associated with some important celebrations. Because it is the Esperanza's interest to have people recognize that we are all artists, that we are all creative, we have asked community members to think of themselves as possible workshop leaders, as teachers of cultural practices and traditions. Some of these activities have included cultural projects focusing on the *Día de los Muertos* and the *Posadas de Navidad*.

Deepen the learning of community traditions: *Día de los Muertos* project
In some areas of Mexico, there are nine days of celebration of *Día de los Muertos*; in the United States, most of those celebrations have focused on November 1 and 2. Because of the strange complexity of cultural genocide and exploitation, many people in our communities have been taught that *Día de los Muertos* is a form of devil-worship, on the one hand, and on the other, an attraction for the tourist industry, a performance created by artists who may or may not be Chicana/o or Mexicana/o. The Esperanza was initially engaged in these celebrations, but stepped away after it became too commercialized.

Recently, because of our dialogues at the Casa de Cuentos, community members wanted to participate in some element of *Dia de los Muertos*. The Esperanza was also interested in developing more in-depth knowledge and history of this tradition.

In some of the gatherings before *Día de los Muertos*, community members learned about and composed *Calaveras*, stylized satirical poems dedicated to living people addressed as if they were dead. The subjects can be political figures, friends, or family members who are living. This tradition of popular poetry has been all but lost in San Antonio, and the Esperanza *Arte es Vida* dialogues have played a pivotal role in reviving the practice. As part of our *pláticas* on the cultural history of this tradition,[6] community participants wrote *Calaveras* that were read and then published in *La Voz de Esperanza*. Last year, for the first time, our daily newspaper, the *San Antonio Express-News*, invited its readership to write *Calaveras*.

On the day before *Día de los Muertos* in 2002, a 70-year-old *sabia*, Señora Inez Valdez, conducted a workshop on traditional foods made for the celebration. Doña Valdez has had no formal education and has worked all of her life as a cleaning woman. This workshop was the first time she was publicly acknowledged for her creative abilities and culinary skills. The workshop spurred dialogue about traditional Mexican cooking and gave Doña Valdez a sense that she could support the work in community beyond cleaning offices or houses.

[6] *La Voz* editor Gloria Ramirez, community elder Enrique Sánchez, professor Josie Mendez Negrete, and artist-in-residence Veronica Castillo helped facilitate several community dialogues/workshops during the last three years to teach the cultural history of Calaveras.

Community members participate in Las Posadas, *2003. Photo © The Esperanza Peace and Justice Center.*

In the weeks preceding *Día de los Muertos*, community members created altars at the Casa de Cuentos. These included traditional family altars and altars to important community members. Youth of Artescuela also created altars dedicated to their ancestors, as well as movie stars and other personalities that they honored. The women of the Esperanza's Westside ceramics *colectivo, MujerArtes*, also participated and created a communal altar. One family created an altar for their ancestor, Adela Navarro, and shared her story as a Mexicana who worked in the early twentieth century to preserve the original *campo santo* (cemetery) of the Mexican community, San Fernando Number 1.

On November 2, 2002, about 50 community participants (ages 9 to 80) revived the traditional practice of cleaning the graves in the community cemetery. San Fernando Number 1 is still an active cemetery, just two blocks from Casa de Cuentos, but because it is an older cemetery, there are few visitors. Many people in the neighborhood, especially some young people, had never visited their family's gravesites and have not experienced the complex relationship between the living and the dead that is celebrated in Mexican culture.

Community members walked in a procession to the cemetery, cleaned the gravesites of family members and others, and decorated the entrance to the cemetery. As part of the festivities, we hired a trio to serenade both the living and the dead. One community

member read a story she had written about *Día de los Muertos* in Mexico, and this inspired dialogue about the meaning of the celebration to the Chicano/Mexicano community.

Revive community values: *Posadas de Navidad* project
Another project inspired by the community dialogues was the revival of the *Posadas de Navidad*. In the 1930s and 40s, Christmas was a time of much community interaction and activity, and the Guadalupe Catholic Church paid a principal role in promoting these cultural activities. At the center were the *Posadas*, a reenactment of the holy family's search for shelter in Bethlehem. The *Posadas* involves processions of people, led usually by children dressed as Mary and Joseph, walking from house to house, singing and playing instruments. At each house, the travelers request shelter and are denied it in song. Finally, they are admitted to a home, and all participants enter to enjoy the warmth and generosity of this welcoming family.

One of the reasons that community participants chose to revive the *Posadas* is that it is a celebration that emphasizes the values of generosity, community interaction, and shared artistic expression that have come to be the focus of our community discussions. We have come to see the harm caused by isolation and consumerism. Older people long for social interactions, and young people relish the excitement of piñatas, fireworks, and rousing music and dance. *Posadas* involves everyone—old, young, and in-between—in community enactments and song.

In preparation for the *Posadas*, the Esperanza worked in partnership with Our Lady of Guadalupe Church and its members, City Council Representative Patti Radle and her staff, *MujerArtes*, and the San Jacinto Elderly Housing Community—organizations that are located within a single city block yet have not worked together before. For the elders of our *Arte es Vida* project, the importance of maintaining this tradition was critical. They were willing to design and develop their own *posada*. Women from *MujerArtes*, like Señora Lujan, commented, "*Ya era tiempo que hicieran algo que a mi me gustara.*" ("Finally, you're doing something I like.")

We at the Esperanza wanted to make sure we spoke to our neighbors to find out if: (1) anyone else was already organizing the *Posadas;* and (2) how to expand partnerships so that all neighborhood participants felt included. We were told that indeed the *Posadas* procession is performed for the Guadalupe Church. We made contact with the organizer and offered our idea of participating and bringing other community members to the *posada* as well. We offered the Esperanza's *MujerArtes* studio and called the city council representative to see if she and her staff would participate, since their Westside office is next door. The fact that the Guadalupe Church agreed to participate with the Esperanza was tremendous, as the Esperanza is known for its pro-choice, pro-LGBT, and out queer programming. For the Guadalupe Church to actively work with the Esperanza and promote the event to its constituency was a first.

At Casa de Cuentos, the Esperanza is continuing to offer opportunities for people to gather—elders, youth, women, men, gay, straight, Chicanas/os, Mexicanas/os, brown, black, and white. As people tell each other of their experiences, of their sorrows and their mothers' dreams, of lessons learned long ago and just yesterday—as community members gather to share stories, values and insights—they will create and recreate the Westside community of San Antonio.

Conflicts Between Chicanos and Mexicanos in San Antonio

In 1994, the Esperanza created *MujerArtes* as a long-term educational project in the Westside of San Antonio. Participants are poor and working-class Chicana and Mexicana women. Local and Mexican women artists—including Veronica Castillo, of the well-known Alfonso Castillo family of Puebla, Mexico—were invited to teach classes in hand-built ceramic art. Part of our understanding is that women tend to be the members of the family who carry culture and pass it down. We wanted to encourage their desires to be creative but also to offer them the opportunity to learn about their histories and traditions so that they could share that knowledge with their families and communities. In addition to artistic skills, participants learn and share their stories, working to piece together the history of their communities as Latinas, women, and working-class immigrants and/or colonized people. Central to the design of *MujerArtes* is a communal or cooperative allocation of authority and resources.

To encourage dialogue around these conflicts, the Esperanza has offered workshops with local Chicana activists and historians so that Chicanas/os and Mexicanas/os can explore their differences.

Over the years, the *MujerArtes cooperativa* has been challenged by conflicts between Chicanas—women born or raised in the United States—and Mexicanas—women raised in Mexico. These conflicts have arisen between the participants and in their work with Mexican women artists. This lack of understanding between Chicanas and Mexicanas is not limited to the experiences of the women of *MujerArtes*. It is complex and difficult to explain briefly. Some factors that lead to divisions amongst Chicanas/os and Mexicanas/os include the United States/Mexican history and the economic relationships created out of this history; the racist policies of the United States towards Mexico and its citizens; the racist policies of the United States towards people of color living here; the effect of internalized racism among Chicanas/os and Mexicanas/os living in the United States; the lack of understanding of this history by Mexicanas/os and Chicanas/os; class and educational differences between Mexicanas/os and Chicanas/os; and the inability of both communities to visit each other and experience each other's worlds.

It is both difficult and important for Chicanas to see the similarities and differences between their lives and the lives of Mexican women. There are many dimensions to the divisions. Chicanas typically do not have a strong sense of themselves and their abilities. The Chicanas of *MujerArtes* are working class and poor. The majority of them do not have a high school diploma, and if they do, the schools that they have attended have not been very good, so their mastery of basic knowledge is also limited. Throughout their lives, most Chicanas have had to suffer from racist policies in schools, work, and society in general which has penalized Chicano and Mexicano communities for speaking in Spanish. One participant at the Casa de Cuentos *pláticas* recalled having her mouth "washed with Joy" for speaking Spanish at school, and many have similar stories. People have learned to survive these racist assaults by (1) not speaking Spanish; (2) not teaching their children Spanish so they will not be targeted; and/or (3) making fun of others who speak Spanish.

Additionally, the public schools have not given bilingual students adequate instruction in either English or Spanish. During the 70s, bilingual education classes were developed to teach students to transfer from Spanish to English, rather than maintaining Spanish and learning English in addition. In the process, many students did not learn either language very well. Most feel shame in their limited mastery of both languages.

THE WOMEN OF JUAREZ

Between 1993 and 2003, in the city of Juarez, more than 450 women have disappeared and 284 women have been found murdered. The majority of the homicides began with kidnappings that were not investigated when reported. Later the missing women were found dead in vacant lots throughout the city. In addition, the victims all have the same physical appearance: they are thin, dark-skinned, and have long, dark hair.

Many of the murdered women traveled to Juarez from interior states of Mexico to work in the United States or other foreign-owned *maquiladoras* (factories) located in Juarez, on the international border. The *maquiladora* owners profit off the thousands of young women who come to Juarez in hopes of finding work. At the factories, they are subjected to low wages, demeaning working conditions, and ruthless sexual harassment.

According to Amnesty International, authorities have unjustifiably delayed their investigations, failed to follow up with witnesses, provided incorrect information to families, and falsified evidence. Observers conclude that the police either are involved in the murders or are actively protecting the perpetrators.

At first, authorities publicly blamed the murder victims, accusing them of dressing provocatively or being out too late at night (*maquila* workers are routinely left to wait for buses on unlit roadways and walk for miles from bus stops to their homes). More recently, authorities have blamed the families of the victims, claiming that the families had not properly supervised their daughters and that the families were attempting to benefit from international attention on the murders.

Exposure to racism in the United States has deeply injured many Chicana/o and Mexicana/o people. We have been taught to view our dark skin and indigenous features as ugly and our cultural traditions as silly or archaic. Mexicanas/os, on the other hand, tend not to be aware of these issues and to be frustrated with Chicanas/os, considering them weak or indecisive.

Many Chicanas/os cling to their status as United States citizens and work hard to distinguish themselves from immigrants, adopting an anti-immigrant stance. Chicana/o children make fun of Mexicana/o children's accents, calling them "mojados" or "wetbacks"[7] and other derogatory names. At the same time, many middle-class and upper-class Mexicanas/os come to San Antonio to shop in the lavish North Star Mall, where Chicanas/os usually go only to work or to look, seldom to buy. In interactions at the mall, wealthy Mexicanas/os often treat Chicanas/os as servants, expecting them to attend to their every wish. Mexicanas/os criticize Chicanas/os for their uncultured or nonfluent Spanish, or their ignorance of Mexican culture. Similarly, many of the Mexican artists who come in contact with Chicanas/os come from middle-class backgrounds and are better educated than the working-class or poor Chicanas/os they meet in San Antonio.

[7] "Mojado" or "wetback" is the slang term for a person who crosses the border illegally, from Mexico into the United States—a derogatory name for an undocumented worker or immigrant, especially from Mexico.

Even Chicanas/os who are well-rooted in Mexican culture are looked down on by many Mexicans because many Chicana/o families in San Antonio come from the northern states of Mexico (e.g., Tamaulipas, Coahuila, Chihuahua) and the *norteño* culture (flour tortillas, *norteño* music, ranching, rural life) is looked down on by Mexicanas/os from the coastal or interior Mexican states. When Chicanas/os visit Mexico, we are made fun of and called "Pochos" and "Gringos" by Mexicanas/os. Most Mexicanas/os don't know what a Chicana/o is and think that we, or our families, rejected Mexico. In fact, many of us never left Mexico but became United States citizens in 1848 after the signing of the Treaty of Guadalupe when the United States took Texas, New Mexico, Arizona, Colorado, and California from Mexico.

To encourage dialogue around these conflicts, the Esperanza has offered workshops with local Chicana activists and historians so that Chicanas/os and Mexicanas/os can explore their differences. In 2001–2002, as part of the Casa de Cuentos dialogues, members of *MujerArtes* began sharing stories and images of growing up in San Antonio and in Mexico. They then expressed these memories in relief tiles that have been exhibited at the Casa de Cuentos as part of the *Arte es Vida* dialogues. The women have created over 60 different images and have inspired others to tell their stories of their childhoods in San Antonio or elsewhere in South Texas and Mexico. In addition, we have brought Mexican women artists for long-term work with the women of *MujerArtes*.

MujerArtes Project of Sympathy and Support for Families of the Victims of Juárez Murders

As part of the Animating Democracy project, the Esperanza presented the film *Señorita Extraviada* by Lourdes Portillo in June 2002. The women of *MujerArtes* viewed the film and participated in *pláticas* about the tragic murders of young Mexican women in Juárez, depicted in the film. The *plática* was led by Lourdes Portillo; Elvia Arriola, law professor and director of the Center for Women on the Border; and Patricia Castillo, director of PEACE Initiative, a local organization addressing domestic violence. It was designed for all women to share a few ideas about the film, looking at their own work or personal experience to situate the conversation. The Chicanas were particularly moved to learn that the victims were poor, brown women like themselves and their daughters. The community, however, stayed for another two hours of very impassioned sharing of information and analysis which led to further community discussion.[8]

The Esperanza youth activists participated in PBS's P.O.V. Youth Views Talk Backs. They interviewed themselves and other youth who viewed film and sent these interviews to P.O.V. in New York. The comments of one young Chicana at the Esperanza was added to the opening segment of the national screening of *Señorita Extraviada*.

This experience led the women to learn more about the Juárez murders. Community members took the responsibility to organize more film screenings throughout the city that the Esperanza facilitated. Another group of community activists wanted to organize a demonstration, march, public performance, and a visit to the Mexican Consulate in San Antonio. The Esperanza helped facilitate and headquarter this, which coincided with a national day of action on the Juárez murders, in July 2002. Latino gay men and lesbians,

anti-domestic violence activists, anti-globalization activists, teachers, social workers, and others were moved to organize a local-to-the-global demonstration, many for the first time in their lives. Participants researched names of women who were murdered, and created banners, signs, and other creative art pieces for the demonstration and march. Women dressed in black performed a street theater piece created specifically for this gathering.

In the spring of 2003, the *MujerArtes cooperativa* undertook a project to raise money to support families of the victims of the Juárez murders. *MujerArtes* created an altar to the victims, consisting of 26 pieces of ceramic art depicting aspects of the Juárez tragedies. In a stunning clay assemblage of tribute and grief, mutilated women are strewn amidst 10 sequences of rural domestic life, dinner-like and shoe-shaped plates, nichos, plaques, mosaics, politicized crucifixes, and a majestic centerpiece: an *árbol de la muerte* (tree of death) entitled "*Maquilando Mujeres/Piecing Women.*"

"I knew of the story," said Rosie Zertuche, a *MujerArtes* member who created a trio of faceless women shrouded in Siqueiros-like grief.[9] Zertuche, a mother, grandmother, and great-grandmother, wanted to create something so memorable that people would be moved to find the killers. "See the dove with a heart in its beak?" she said. "It could happen to us."

Veronica Castillo describes the project:

> *Decidimos hacer un altar en conmemoración de las mujeres de Juárez. La idea era crear un pieza principal estilo 'árbol de la vida' que le queríamos llamar 'árbol de la muerte,' acompañada por varias otras piezas complementando el árbol con escenas hechas por las mujeres de la cooperativa.*

> *…Del video [Señorita Extraviada] sacamos algunas imágenes representativas de las víctimas, como los zapatos, las batas de las maquilas, los autobuses misteriosos, y las caras cínicas de la policía y de los sospechosos. Las lágrimas de las madres es lo que más nos calaba en el corazón, porque todas nosotras de MujerArtes. Somos madres y sabemos el dolor que puede llegar a sentir una madre al perder a su criatura.*

> *…Espero que este altar nos ayude a recordar a las vidas inocentes que han sido arrebatadas de nuestro vientre familiar, y sobre todo que comunique el apoyo que la coperativa de MujerArtes y el Centro Esperanza le queremos dar a las familias de las víctimas. Con respeto y dignidad.*

> [Translation: We decided to do an altar in commemoration of the women of Juárez. The idea was to create a central piece in the style of a 'tree of life' that we wanted to call a 'tree of death,' accompanied by several other pieces complementing the tree with scenes done by the women of the cooperative.

> …From the video [Señorita Extraviada] we pulled some images of the victims, such as the shoes, the clothes of the women workers, the buses, and the cynical faces of the police and the suspects. The tears of the mothers touched our hearts, because all of us of *MujerArtes*, we are mothers and we know the pain that a mother can feel on having lost a child.

[9] David Alfaro Siqueiros (1896–1974), a master of the Mexican school of mural painting, was very active in the organizing of México's labor forces. His political activism resulted in many deportations and years in jail, where he created most of his easel works. www.adanigallery.com/Siqueiros/main.html

From the video Señorita Extraviada *we pulled some images of the victims, such as the shoes, the clothes of the women workers, the buses, and the cynical faces of the police and the suspects.*

...I hope that this altar will help us to remember the innocent lives that have been taken from our womb, and overall to communicate the support that the co-operative of *MujerArtes* and the Esperanza has for the families of the victims. With respect and dignity.]

Over 400 people attended the opening, about half of whom stayed for a panel presentation and plática.

In June 2003, Alicia Gaspar de Alba, a professor of Chicano Studies at UCLA who had just completed a book about the Juárez murders, led a writing workshop for the women of *MujerArtes*. She asked the *mujeres* to think about the names of the victims in Juárez. She asked them to describe memories associated with the names, and to identify colors, sounds, and smells they associate with the names and with the murders. Participants described "*olor a sudor de miedo*"; "*aire que se oye muy lejano*"; "*fuerte de piedra*"; "*el olor de un hombre que no se ha bañado.*"

[Translations: The odor of sweat caused by fear; a breath that is heard very distantly; the strength of stone; the smell of a man who has not bathed.]

The *MujerArtes* participants told their memories and their reactions. They cried for the women of Juárez and for their own loved ones. The women later used these stories to create text to accompany the altar exhibit. Throughout the month-long showing in San Antonio, the community continued to visit the powerful altar. In all, almost a thousand people personally viewed the altar, and many thousands more heard or read about it. Alicia Gaspar de Alba invited the women to participate in a conference at UCLA in October 2003.

Outreach for the altar exhibit included Spanish-language radio, television, and print media. Over 400 people attended the opening, about half of whom stayed for a panel presentation and *plática*. The panel consisted of Señora Benita Monarrez, whose daughter Laura, a 17-year-old student, was found murdered in 2001; Verónica Castillo, lead artist on the project; Cecilia Ballí, a journalist who has written on the Juárez murders; and Alicia Gaspar de Alba. A 20-minute video of the writing workshop was also screened.

Carmen Lujan, a member of the MujerArtes *cooperativa, creates a work in clay about the murders of young women in Juarez, Mexico, 2003. Photo © The Esperanza Peace and Justice Center.*

The presentations were moving. Señora Monarrez spoke courageously of the horror that she and her family experienced—searching endlessly for Laura in the days after her disappearance; pleading hopelessly to police to do something to find and save Laura; finding Laura's dismembered body scattered in a vacant lot where three other murder victims had been found.

Yet the *plática* was disappointing in many ways. Professor Alicia Gaspar de Alba and journalist Cecilia Ballí seemed to disagree on the significance of some of the evidence that had come to light, yet they avoided any discussion of these differences. Perhaps they did not want to risk upsetting Señora Monarrez or perhaps they did not think that further discussion of these issues would be of interest to the audience. In either case, a question or comment from the audience could have widened the discussion, making it more comfortable for all. The audience included several people who were from Juárez and knew the community and others who had worked in *maquiladoras* and could speak about those experiences, yet those people did not speak. Although the panelists invited questions or comments from the audience, only a few people spoke, and their comments were hesitant and deferential. The discussion never moved from the panel to the audience as we hoped it would.

In the disappointment of that plática, *we saw clearly the need for community-based organizers to be part of facilitated discussion.*

Audience members may have been afraid of upsetting or offending Señora Monarrez or they may have been shocked by the horror of the crimes and the power of the altar that was on view downstairs. In addition, the audience may have been intimidated by the eloquence of the panelists and hesitant to express their own views to these experts who they did not know personally. For all of these reasons, we believe that discussion would have been better with a facilitator who knew the community and individual audience members. A community-based facilitator could have elicited comments from specific audience members who the facilitator knew had information or analysis to share. The facilitator could have reduced audience members' intimidation by modeling a question or comment herself and by inviting comments addressed to a more "practical level" of analysis.

As we reflected on the event, we recognized that we should not have expected the panelists, none of whom were familiar with San Antonio or well known to our audiences, to have been able to facilitate the discussion in this way. In the disappointment of that *plática*, we saw clearly the need for community-based organizers to be part of facilitated discussion.

The *MujerArtes* altar was exhibited for a month in San Antonio and then traveled to Los Angeles where all the works were made available for auction at the UCLA Fowler Museum of Cultural History. As part of this project, women of *MujerArtes* traveled to the conference, visiting various women's activist and artist-based community groups along the way. The first stop, and probably the most emotionally charged, was a visit to Juárez. We traveled past the *maquiladoras*, stopped and walked in the killing fields where bodies had been found, and met with mothers of disappeared and murdered women and girls. This experience was profoundly moving for both the women of *MujerArtes* and the women of Juárez, and lasting friendships have developed.

Additionally, *MujerArtes* visited indigenous communities like the Pueblo of New Mexico, the Navajo in Arizona, and the Hopi of First and Second Mesa in Arizona. Here, the

indigenous communities saw these Chicana women as indigenous people too. They asked the *MujerArtes* women what tribe they were from. The women responded, "We're from the Westside tribe."

Not having traveled much in their lives and not having ever exchanged with other indigenous women, *MujerArtes* participants met other women potters who looked like them, but who had different cultures and languages. They were excited to see the value of these indigenous artists. We met with *sabia*/elder Pablita Velarde, an 85-year-old elder who spent two hours telling Pueblo stories and her personal story. At the end, *MujerArtes* gave Pablita some artwork, and she exchanged with them some of her work that was now in postcards. The *MujerArtes* women continued this practice with the other indigenous people.

Although *MujerArtes* received no compensation for the Altar to the Women of Juárez, these impoverished women contributed all of the proceeds from the sale (over $5,000) of their work to the mothers of the disappeared and murdered women. In the understanding of being *buena gente*, they recognized the need to support the women of Juárez, as well as women in their own community and collective. Through this sustained dialogue, the women of *MujerArtes* have come to value themselves and their culture in new ways, and to seek a closer connection with their Mexican and Native sisters.

Dialogic Training and Methodology

Throughout the Animating Democracy project, the Esperanza experimented with different styles of dialogue facilitation. This section discusses some of our training, reflections, and tentative conclusions.

Teach the facilitators: New Bridges training with Luz Guerra and Hugh Vasquez.
At the beginning of the Animating Democracy *Arte es Vida* project, Luz Guerra was hired to train *animadoras/os*. We hired Guerra because she is a very experienced facilitator and trainer of facilitators, having worked almost a decade for the American Friends Service Committee, providing training and workshops on unlearning racism and other oppressions. In addition, because Guerra is a Latina, a Puertoriqueña from New York, a community organizer, and activist trainer, she brings a culturally appropriate perspective. Finally, throughout our history of attending conferences, workshops, and trainings, she is one of the few facilitators we've found who has broad experience with anti-oppression training (anti-racism, anti-sexism, anti-classism, anti-homophobia, etc.) and felt her work was most closely related to the vision and work of the Esperanza.

...many members of the audience resisted participating in dyads or small groups because they feared they would miss interesting stories told by other participants.

All artists, advisory group members, partners, and individuals interested in learning skills to become facilitators in the *Arte es Vida* project were required to attend a training session with Guerra. In January 2001, the Esperanza hosted a four-day intensive "train the trainers" workshop, conducted by Guerra and Hugh Vasquez. Hugh Vasquez is a nationally acclaimed anti-oppression trainer; cofounder of TODOS: Sherover-Simms Alliance Building Institute in Oakland, California; and cofounder of New Bridges (see sidebar), a multicultural youth program focused on eliminating racism, sexism, anti-Semitism, heterosexism, and ageism.

In the fall of 2001, Guerra trained approximately 35 additional people in smaller groups. These trainees included new Esperanza staff, board members, and *buena gente* (members

10 We did not survey every *Arte es Vida* event. The description in the text is drawn from the several formal and informal surveys we have conducted over the years. This is one element that we will strive to achieve in the next phase of our *Arte es Vida* project.

of the Esperanza community who are committed to our work and to social justice) who were not able to attend the January workshop. Guerra also worked closely with youth leader Vicki Grise to train her as an *animadora*. Following this initial training, *pláticas* at *Arte es Vida* events were organized by a variety of *animadoras* drawn from the Esperanza staff and *buena gente*. As we experimented with the New Bridges approach, we found that it did not work very well for audiences/groups drawn to the Esperanza events. Through formal and informal surveys,[10] we know that audiences at the Esperanza typically include 70 percent to 90 percent people of color and more than 50 percent women. Significant portions of our audiences are Spanish-dominant (meaning that they speak Spanish at home or work and that they feel most comfortable conversing in Spanish). A majority is or was raised poor or working class.

For numerous reasons, many of the people in our audiences do not feel comfortable speaking in a public gathering. They have been told they do not speak clearly or do not speak English or Spanish well. They hear others speak, and may feel they are not as smart or not as knowledgeable. They are afraid they will not be understood, that they will speak for too long, or they will say the wrong word. This hesitation or uncertainty is especially evident in women.

Beva Sánchez Padilla, author of An Altar for Emma, *facilitates a plática with audience members, 2000. Photo © The Esperanza Peace and Justice Center.*

The audience/participants in *Arte es Vida* events have included some people who can speak easily in public and many more who are hesitant to speak. Working with groups of this sort, we focus on ensuring full participation. We have found the initial "rule-setting" phase of the New Bridges approach conveyed the unintended message that people should not speak unless they can talk in a particular way, and frequently people did not understand what the rules required. The effect was that many people remained silent and those who spoke seemed hesitant and self-conscious. We also found that many members of the audience resisted participating in dyads or small groups because they feared they would miss interesting stories told by other participants.

Early on we realized that we would have to modify the New Bridges approach to encourage meaningful discussion in *Arte es Vida* events. There were, however, some very important skills we learned in the training process which we continue to practice.

As we learned and experimented with the New Bridges approach, we also reviewed our experiences with successful and unsuccessful *pláticas* in the past. We focused especially on the very successful *pláticas* that followed *An Altar for Emma* performances. Reflecting on those and other *pláticas*, we realized that several elements contributed to their success:

1. The audience included people who we knew would have important things to say. For example, we had identified and specifically invited family, friends, neighbors, and coworkers of Emma Tenayuca, people whom we knew she had affected deeply, to attend the performances.

2. Because of this, the facilitators approached the audience with deep respect and interest. We all wanted to learn from those in the audience who had known Emma Tenayuca, and the facilitators expressed that sincere interest.

3. The performances were preceded by several articles in the Esperanza news journal, *La Voz*. Community members learned many details of Emma Tenayuca's life and work from these articles, and they learned of the persistent controversy regarding her membership in the Communist Party. Many people in the audience therefore came with a knowledge base and an interest in learning more.

4. The play itself included significant audience participation, including a move downstairs, an invitation to sing, and some members joining the cast in a protest march. These physical and musical activities brought audience members into interaction with each other and into a more active frame of mind.

NEW BRIDGES APPROACH TO DIALOGUE FACILITATION

In this model, the facilitator attempts to create an atmosphere where everyone can express their thoughts and feelings, and can listen to and learn from other participants. The facilitator often will begin by suggesting (or asking the group to suggest) some "rules of safety" to which all participants can agree. These usually include listen to each other with respect; speak for yourself, not for others (use "I" statements); and do not question or argue against someone else's statements of experience or emotion (do not "cross-talk": respond directly to another speaker).

During the ensuing discussion, the facilitator ensures broad participation by having those who wish to speak silently raise their hands until the facilitator signals to them that she or he has put them on a "speaker list." In addition, the facilitator watches to make sure that the discussion is not dominated by those who are most used to speaking, including men, whites, class-privileged, etc. When this happens, the facilitator may encourage others to speak by asking if they would like to add anything to the discussion.

The New Bridges model also makes frequent use of the "dyad" or "triad" in which two or three people speak and listen to each other, or small group discussions in which each person is asked to speak in turn. These devices are used because some people find it easier to express themselves to a small group rather than speaking in a group.

Dyads usually last for a short time, perhaps two minutes or so; small groups last for 10 to 20 minutes.

To encourage discussion following a film, performance, or other presentation, the New Bridges facilitator may ask questions about specific aspects of the presentation, but the facilitator will also allow periods of silence to allow participants to reflect. If someone speaks to an issue that the facilitator thinks is important or fruitful, she may ask the speaker to say more or go deeper with their comment.

Towards the end of a discussion, the facilitator will direct discussion towards the questions of individual or group actions: "What is your/our next step on this issue? What will you take home from this discussion?"

5. There were several *animadoras*, with no one person taking on a "teacher" or "director" role. Beva Sánchez Padilla, the author/director, and the three-member cast facilitated the *pláticas* by sitting informally on the stage or walking among the audience. Because the cast had just performed, they appeared to the audience as familiar. The too-frequent sense that *animadoras* are smarter, better educated, more articulate, etc. seemed not to arise. The *animadoras'* familiarity and informality contributed to the atmosphere of nonjudgmental discussion.

We found that the best *pláticas* happened when the *animadoras* have and are willing to express a genuine eagerness to hear the stories and comments of the audience. It seemed that this attitude was essential to encouraging honest community engagement. We also found that it is very important for the *animadoras* to be sure that diverse voices are heard. *Animadoras* at the Esperanza are asked to watch for domination (by men, by white people) or self-censoring (by elders, by Spanish-dominant people) and to intervene when that happens. *Animadoras* have said: "We have been hearing mainly from men. I will ask that women speak and that the men wait for a while;" or "'We have been hearing mainly from teachers. I ask that others speak and that the teachers wait for a while," and the like.

Preserve the stories of community: story circle training with John O'Neal
In May 2001, we were able to bring John O'Neal to the Esperanza to teach a one-day workshop on the practice of Story Circles. In this method, as many people know, participants speak to a particular issue drawing on their memories as provoked by the topic, or by the stories or comments of other participants. Most of the people who were interested in facilitating *Arte es Vida* discussions attended at least parts of this workshop, and participants demonstrated the techniques to a larger group of *buena gente* (the Esperanza audience and community members) at an evening event. The training initiated a new series of discussions about different techniques of facilitation and the significance of storytelling.

The animadoras' familiarity and informality contributed to the atmosphere of nonjudgmental discussion.

We have found that the Story Circle is an effective technique that we have used in a slightly modified form in several of our smaller (15 to 25 people) *pláticas*. We have modified the technique to allow people to speak without time limitation, and we have kept the group together in one circle. The reason for these changes is that we found that the time limit (in the training with John O'Neal, speakers were limited to three or four minutes) was culturally inappropriate among predominantly Chicano groups, where stories are usually long and complex. We found that the time limits had to be long to accommodate that storytelling style, and even when we set long times, speakers would repeatedly check themselves. It seemed that even long time limits conveyed the message that the group really did not want to hear very much or did not have time to hear much, and so people were hesitant to take up even a modest time allotment.

We decided not to break up into smaller circles because again we found that people just did not like the feeling that they were missing what was being said in the other groups. We are so hungry to hear each other—we don't want to miss anything!

John O'Neal's training also inspired reflection about the role of storytelling in the *Arte es Vida* project and in other work of the Esperanza community. We have come to understand that storytelling has many functions for our communities. It is a way of conveying

71

knowledge, history, and information about ourselves and our pasts that is not recorded in any place. Consistent with this function, we find ourselves and our communities anxious to hear and record and preserve the stories of our elders. We know that we are losing our histories, that this is a part of the cultural genocide which has so devastated our communities.

A second function of storytelling is to create a bond between people and to enlarge the world that we see as individuals and together with others. This is an experiential, spiritual, intellectual, and political dimension of storytelling that our work with *Arte es Vida* has brought into focus for us. Because we are anxious to do what we can to recover and preserve our histories and because we ourselves have grown up with the storytelling of our elders, our families, and our friends, we have not been as aware of the power and value of the simple experience of hearing stories, of hearing bits of memory that others carry. The simple experience is a powerful experience in solidarity.

Paula Gunn Allen describes the power of storytelling among indigenous communities: "My mother told me stories all the time, though I often did not recognize them as that... And in all of those stories she told me who I was, who I was supposed to be, whom I came from, and who would follow me. In this way she taught me the meaning of the words she said, that all life is a circle and everything has a place within it. That's what she said and what she showed me in the things she did and the way she lives."[11]

Yolanda Broyles-González describes the storytelling practice of Lydia Mendoza, a beloved Chicana musician whose singing career spanned more than 60 years, from the 1920s to the 1980s: "[M]ost of her narrative does not describe glory but instead offers guidance and encouragement for overcoming multiple obstacles. She aims to provide inspiration, counsel, and guidance, ultimately empowering women like herself (perhaps others, as well). This is the typical trajectory of the cultural practices known collectively as *consejo* (genres of counsel giving and talking), which have always been deeply valued in the Americas."[12]

This recognition has clarified for us the reason why we seek moments, opportunities, *pláticas* in which people are invited to tell stories; are reminded of memories; are lovingly, respectfully being heard and hearing others. This is a powerful political experience that is an important part of grassroots organizing as we at the Esperanza want to do it.

The training in *animadora* techniques made possible by Animating Democracy encouraged Esperanza staff and community to reflect upon, develop, and refine our work as facilitators, as cultural programmers, and as political organizers. This was a very valuable part of the project.

Bring techniques of spiritual grounding to dialogue. Maria Antonietta Berriozábal is a widely respected community leader and former city council member. Señora Berriozábal has contributed to our skills in the facilitation of dialogue by teaching us the role of ceremony and spiritual awareness in respectful exchange and mutual understanding. Through her actions, her stories, her ceremonies, performed at political and cultural events, she has taught us to remember two things as foundational to any action. First, we must recognize that the struggle for justice is much larger and longer than any one of our lives. Señora

11 Paula Gunn Allen, *The Sacred Hoop: Recovering the Feminine in American Indian Tradition* (Boston: Beacon, 1986), 46.

12 Yolanda Broyles-González, *Lydia Mendoza's Life in Music: La historia de Lydia Mendoza* (New York: Oxford U. Press, 2001), 201.

We have modified the technique to allow people to speak without time limitation, and we have kept the group together in one circle.

A second function of storytelling is to create a bond between people and to enlarge the world that we see as individuals and together with others.

13 Antonia Castañeda, "Introduction," *Gender on the Borderlands*, Frontiers 24, nos. 2 and 3 (2004): xii.

Berriozábal speaks of a 200-year clock to be placed at the Esperanza so that we can all remember that we will experience only a few minutes out of the long struggle for justice, and that we will not live to see the consequences of our actions.

Second, and simultaneously, Señora Berriozábal teaches us to see each human being as important and vulnerable. The spiritual dimension is inherently inclusive: it is a way of treating each other and a way of situating our work within a larger context that has little to do with institutionalized religious practice. It is nondenominational and nonjudgmental. It is simply the habit of remembering both the strength of our shared commitment to justice and the precious fragility of each one of us. Through this grounding, we have learned techniques of active and passive listening that are crucial to long-term community dialogue.

Finally, and to us most importantly, we have carefully observed conversations and storytelling within our communities and our families. We have learned how people are welcomed, put at ease, listened to, and respected. We have seen how conflicts are resolved, how appropriate and inappropriate behaviors are identified—for children and for adults. We come to these studies with an assumption that these practices, which are guided and practiced particularly by women, are based on wisdom that has been passed down for generations and is constantly reinvented. As Chicana historian Antonia Castañeda explains: "Threaded within, between, underneath, around, inside, and outside of sanctioned colonial, national, and transnational histories, *historia*/story remembers and recodes the borderlands, bearing witness to the living past, the present, and the future, belying officialdom's visible and invisible technologies of power to silence, deny, and obliterate."[13] We hope that the practices we learn will enrich our work in the facilitation of arts-based civic dialogue, while honoring and empowering our communities.

LESSONS LEARNED
Principles, Practices, and Philosophical Underpinnings of Arts-based Civic Dialogue Work

Through our work on the Animating Democracy project, we have come to a clearer understanding of the capacity for artistic expression to illuminate conflicts, promote dialogue, and enrich civic engagement within communities that have been wounded by colonialism and cultural genocide. We also have developed our knowledge of various models for dialogue facilitation and our skills in enacting these various forms. We have learned from our successes, our frustrations, and our failures; and we have gained insight from comparing our experiences with those of other groups in this project.

First, we have found it necessary to expand the art/humanities component to feature community members rather than individual artists or groups of artists. Second, we have learned that significant arts-based civic dialogue must be long term. Third, these models need to be expanded to include community organizers as an integral part of the arts-based civic dialogue project. And, fourth, arts-based civic dialogue can and should include performance and other artistic expression in the places of formal governmental and corporate decision-making, as a part of democratic participation, protest, and resistance.

Expand the art/humanities component to feature community members rather than individual artists or groups of artists. We have come to believe that the focus on an individual artist, or group of artists, which characterizes some versions of arts-based civic dialogue, is not useful for work in communities of color. This focus tends to reinforce the idea that artists are people of special ability and genius and that non-artists lack these qualities. Every day, dominant culture sends the message to poor and working-class people of color that they are not smart, not creative, not talented. Work that presents artists in this way simply reinforces this hurtful message.

We have been disappointed at how often even artists of color and those with poor or working-class backgrounds are vested in this "special person" view of artistic expression. This view of the artist is historically and culturally limited—a phenomena of fairly recent European culture—yet it seems to inform artists' understanding of themselves throughout the United States. In contrast, indigenous Mexican cultures see all people as creative, as visionaries, and as bridge builders, as do many non-European cultures.

In our work with Animating Democracy, we experimented with artist-focused work, yet we repeatedly found that individual artists could not enable artistic expression by community members beyond a superficial level. The artist that we had initially employed for this project is a very talented, socially engaged, Chicana performance artist from Los Angeles. Unfortunately, this artist found it difficult to connect with Chicanas/os in San Antonio and was often impatient with the lack of "political sophistication" among community participants at the Esperanza events. We had similar experiences with other individual artists who initially read the grant and agreed to work with us with community, but who ultimately had specific needs and criteria that didn't allow them to go out into community venues as we had hoped, or who were not willing to work with anybody but self-proclaimed artists.

The training in animadora *techniques…encouraged Esperanza staff and community to reflect upon, develop, and refine our work as facilitators, as cultural programmers, and as political organizers.*

We were lucky to have one artist, Veronica Castillo, who is the rare exception. The artist, a Mexicana, was eager to teach the skills, history, and traditions that her family had taught her. At first she was frustrated by how little Chicanas knew of Mexican culture and by what she perceived to be a lack of confidence or maturity in the Chicana women she worked with in San Antonio. Yet after perceiving the tensions and differences, Veronica worked hard to understand the cultural and political experiences of Chicanas/Mexicanas in the United States and to support the women with whom she worked. Unfortunately, Veronica had to end her commitments to *MujerArtes* after seven years, in December 2003, in order to commit herself to community work in her home of Puebla, Mexico.

After several frustrating experiences, we decided to consciously expand the art and humanities component in our projects. We went to community members to discover traditional and contemporary artistic practices. The result was one of the best parts of our Animating Democracy project. We enabled people to share their passion for song, for dance, for performance, for installation artwork, for clothes-making, drawing, painting, cooking, poetry, and story writing.

We also found that a crucial part of cultural grounding and community empowerment is developing ways for community members to imagine that they have choices in their lives, to envision alternative ways of responding to the limitations imposed upon them, and to

act on these alternatives. We have found that engaging in a variety of actions, informed by reflection, analysis, and evaluation, encourages people to think more broadly and to allow ourselves to imagine alternatives. Coupled with this is the need to question authority, not to accept all that is said and done by people with power: this is the legacy of generations of control by priests, military forces, and *patrones*. Some ways that community members gained these skills were through actively participating in defining project goals and strategies, developing new ways to reach community, addressing city council and other policymakers, and learning new skills of public discussion and organizing.

Significant arts-based civic dialogue must be long-term. We have found that the capacity of art and arts-based civic dialogue to illuminate conflicts, promote dialogue, and enrich civic engagement comes from its potential to help people understand the perspective of those with whom they disagree. In addition, shared artistic experience and dialogue may allow participants to recognize that the "other side" is motivated by values that both sides recognize and to some extent share. This much may result from a short-term project. Yet, in our experience, such results are temporary, at best, and at worst reinforce the belief of poor and working-class communities that outside "experts" merely use their communities for their own interests.

We believe that to make a lasting and meaningful contribution, art and cultural groups must work with community for long-term periods. We must do the hard work of learning to see the manifold issues of domination that continue to reduce human lives. Five hundred years of cultural genocide require the long-term work that allows people to see themselves, their histories, language, traditions, and values. And once communities are able to see, they must empower themselves to act.

On an even deeper level, the problem with short-term work is that it does not reach the spiritual aspects of community solidarity or the deep long-term wounds in community life. Despite the good feelings, short-term projects inevitably leave the hard issues unresolved. Participants then feel used or abused by the experience. The result is further distrust and unwillingness to participate in civic life.

In order to engage actively in civic life, one must trust one's community and allies. This is particularly true for poor and working-class women of color, who must continue to fight for their voice, right, and dignity despite repeated failure, harsh retaliation, soul-murdering betrayal, and the recognition that they, as individuals, likely will not enjoy the results of their work. Without long-term support, it doesn't make sense to "dialogue" with council member(s) when they retaliate against you. Without committed help, it doesn't make sense to organize, to create, to work for alternatives, to vote, when your efforts are blocked by those with the power to silence, ignore, or refuse you.

We expected that, after eight months, we would be able to dialogue with communities on oppositional sides—people like the tourist industry, business owners, etc.—but we have spent most of our efforts in the cultural grounding of our own communities. The work of cultural grounding within our own communities brings up so many issues. The history of colonization in our communities is so entrenched that we have much work to do with and among ourselves. We need to forge new values, new bridges among our communities,

The spiritual dimension is inherently inclusive: it is a way of treating each other and a way of situating our work within a larger context...

new ways to respect our differences, new ways to cultivate understanding. We need to analyze and understand the multitude of issues that divide us and to both recover and create ways to grow within ourselves and within our communities. We are left with a critical question in respect to civic dialogue/stakeholders: what happens when there is no "coming together" of interests? What is the place of civic dialogue between oppositional sides in a colonial context?

...the focus on an individual artist, or group of artists, which characterizes some versions of arts-based civic dialogue, is not useful for work in communities of color.

In our work with *MujerArtes* and the larger Esperanza community, we have found that long-term cultural organizing can create the deeper spiritual solidity and trust that is necessary to enable community members to engage in active civic life. Shared artistic and cultural work, together with long-term dialogue and focused community action, can create a community of trust, a *comunidad de alma*. This must be, for us, the goal of arts-based civic dialogue.

Community organizers should be an integral part of arts-based civic dialogue. We have found that the involvement of a community organizer with long-term ties to the community is crucial to the success of *Arte es Vida pláticas*. The community organizer is crucial to doing successful outreach and to identifying people in the community who might be interested in participating in *pláticas*. Because of historic class and racial segregation in San Antonio, poor and working-class people, particularly people of color, have been taught to know that they do not "belong" in theaters, galleries, or other spaces in which dominant art is presented. (They also feel they don't belong in schools, libraries, and other community spaces that are supposed to be for the community). Moreover, many people of color experience a deep sense of isolation and alienation that prevent them from participating in events and activities that are nominally "open to all." To draw alienated communities to the table, there must be someone who is known and trusted by the community, and that person has to work hard before and during the event/project to connect people and to draw them into conversation.

We have seen over and over again that powerful groups are not willing to engage in dialogue that may question their actions and focus attention on the effects of those actions on community life. Even long-term community organizers often cannot successfully bring powerful groups to the table. This was our experience in the La Gloria project when the actual decision makers—city council members, the building owner, and auto shop investors—made deals behind closed doors and kept the community away behind police lines. For our efforts in asking for dialogue, the Esperanza was penalized with a reduction in city neighborhood arts funding.

Interestingly, powerful groups in San Antonio were unwilling to participate even in *An Altar for Emma*, which focused on historical events that occurred over 60 years ago. Although we were able to get some coverage from the *Express-News*, San Antonio's only English language daily newspaper, the television and radio stations did not cover it. When asked about Emma Tenayuca by students who had attended the performances, many teachers refused to discuss the history, because they had been taught that Emma Tenayuca was a communist and were unwilling to learn more.

Our observation is that who comes to the table to participate in dialogues usually depends on who calls or presents the opportunity for dialogue, and this in turn determines the

Artescuela *youth prepare a performance to present to officials regarding concerns about future development over the Edwards Aquifer, San Antonio's sole source of drinking water, 2002. Photo © The Esperanza Peace and Justice Center.*

...the problem with short-term work is that it does not reach the spiritual aspects of community solidarity or the deep long-term wounds in community life.

tenor of the conversation. In San Antonio, the European centered museums or middle-class arts organizations do program exhibits and programs on Latin-American art, for example, but the exhibits (often traveling shows) disclaim any connection between the poor and working class Mexicanas/os and Chicanas/os that are a majority of the population in San Antonio and the people of Latin America whose struggles are portrayed in art. San Antonians are constructed by these shows as happily postcultural, enjoying the riches of many cultures without actually identifying with any. Needless to say, this does not empower our communities or animate democratic participation.

In San Antonio, we have had some success bringing powerful individuals into sustained conversation. Ann McGlone, director of Historic Preservation for the City of San Antonio, for example, responded to an invitation to meet with community about La Gloria. She eagerly participated and has continued to engage with communities on issues of historic preservation. More often, however, our invitations are met with hostility or indifference.

We think that the resistance is a result of the very deep and rigid divisions within San Antonio and the dependence of San Antonio on the tourist industry. Against that background, powerful people have succeeded in avoiding public conversation about the injustice of a low-wage, racially segregated, and gender-segmented economy. Ambitious Chicana/o leaders are taught to avoid controversy because it will weaken San Antonio's image as a fun, harmonious, Mexico-without-the-bad-water tourist destination. Because we have challenged this approach for 17 years, the Esperanza has the reputation as a place where honest discussion will be encouraged and the illusion of comfortable harmony is not long maintained.

This has been our experience with the Cultural Alliance of San Antonio (CASA, an organization of executive directors of cultural organizations), which is led by white men and women who are executive directors of mainstream arts organizations. The CASA leadership never agreed to participate in *Arte es Vida* project dialogues. These leaders repeatedly

ignore questions raised by community-based people of color regarding the role that CASA is playing, as they define a cultural plan for San Antonio. The leadership has refused to discuss issues of cultural rights and racial equity in formulating the plan. Instead, they have joined eagerly with city and business leaders who are working to expand the "cultural tourism" industry in which commercialized versions of Chicano/Mexicano culture are marketed in the name of cultural diversity.

Finally, we have found that a community organizer can create partnerships with other community-based organizations and individuals even if the most powerful groups refuse to participate. In the *Arte es Vida* projects, for example, the dialogue has been enriched by the participation of Centro Cultural Aztlan, the Guadalupe Cultural Arts Center, and other community based organizations. We found that other organizations were excited about partnering with the Esperanza in culturally based projects. Yet, most folks don't have the time or resources to take on a major role. The Esperanza has acknowledged its leadership position and did most of the work of organizing and managing projects such as *Día de los Muertos,* the *Posadas de Navidad,* and the Save La Gloria campaign. However, the participation of partnering groups has contributed to the success of these projects.

Arts-based civic dialogue can and should include performance and other artistic expressions in the places of formal governmental and corporate decision-making. We have found and we continue to learn that there is no separation between cultural performance, civil dialogue, and political protest. Part of the work of community empowerment involves our learning to see our struggle within larger contexts and to see how decisions made by government and corporate officers profoundly affect the conditions of daily life. And so to change the conditions of our lives we must address and effect governmental and corporate decision-making. One of the many insights that Señora Berriozábal has shared with us is the way in which our physical space, the urban area called San Antonio, has been shaped by very specific decisions made by the city council. She has taken hundreds of the Esperanza participants on an economic tour of San Antonio. In rented buses or vans, Señora Berriozábal takes us to the Southside, Westside, Eastside, and Northside to show us how decisions have been made to place a hospital here, a university there, a stadium over there, a coal-burning electric genera- tor over there. And her lesson, learned from 10 years as a city council member, is that these decisions are dictated by "the 17 white men"—a sloganlike description referring to the small number of building contractors, developers, cement sellers, wealthy busi- nessmen, and news media outlet owners who exercise political and economic power in San Antonio.

So as part of the *Arte es Vida* project, community members have organized a citizens refer- endum against the multinational corporation Temple-Inland's plan to develop a PGA golf resort and surrounding affluent suburb on one of the most sensitive parts of the recharge zone over the Edwards Aquifer, the city's only source of water. We have participated in a federal lawsuit challenging the city's refusal to honor the anti-Temple-Inland referendum.

We have presented testimony to city council, have met with individual city officials, have shown video in a state court lawsuit challenging the denial of historic preservation status to La Gloria. Because people think visually as well as verbally, because stories (like

parables) enable people to ponder a complex truth in ways that lineal speech does not, we often find it effective to use multimedia, multigenre means to inform community and challenge oppressive and exploitative government and corporate actions.

Among various actions designed to inspire public discussion on the Temple-Inland/PGA golf development, the Esperanza organized communities (targeting people of color) to speak at city council and at public hearings and gatherings throughout the city. Based on the work of cultural grounding, it was our goal to speak from our place of knowledge, history, culture, and truth. Presentations included performances by the Artescuela youth program, song, poetry, *dichos*, *cuentos*, and videos. In a "citizens to be heard" session of city council on October 24, 2002, three actors from the Esperanza performed a piece about corporate domination. The actors walked to the podium with cloth gags, which they struggled to remove as the performance progressed.

During March and April 2003, as the Esperanza organized community to save La Gloria, we showed the recovered video of rooftop dancing at La Gloria to a public meeting of city council and in a state court hearing on a motion for temporary injunction filed by volunteer lawyers working with the Esperanza. In every public action, the Esperanza participants have considered ways to reach not only the minds but also the hearts and memories of those with whom we interact. Artistic programming can often connect people at this more complex level.

14 Augusto Boal, *Legislative Theater* (New York: Routledge, 1998).

Augusto Boal, founder of the international movement Theater of the Oppressed and disciple of Paulo Freire, discusses the use of community-based theater in promoting dialogue about public issues both outside and inside the formal institutions of government.[14] The *Arte es Vida* project came to this practice because community people wanted to find a way to reach decision makers, to have them stop and think, to have them listen to the complex lessons of community life.

4 Out North Contemporary Art House

LYNN E. STERN

*Understanding Neighbors
artist Peter Carpenter in
Clipped, a video performance
created for dialogue
groups by Peter Carpenter
and Stephan Mazurek.
Photo © Stephen Mazurek.*

PREFACE

In 2003, *Understanding Neighbors* brought together nearly 100 citizens in Anchorage, Alaska, in a month-long series of dialogue sessions to address one of the community's most contentious civic questions: what is the social, moral, and legal place of same-sex couples in our society? *Understanding Neighbors*, a collaborative project sponsored by Out North Contemporary Art House in partnership with the Interfaith Council of Anchorage and Alaska Common Ground, aimed to synthesize and test an art-inspired dialogue model that would foster respectful dialogue and mutual understanding among community members holding divergent views on a divisive civic issue. Artists Peter Carpenter, Sara Felder, and Stephan Mazurek created eight performance-based video works derived from interviews with nearly 70 community members to serve as the catalyst for small group dialogues. Using a customized dialogue approach based on the Public Conversations Project's Power of Dialogue model, the project trained 25 community volunteers to facilitate dialogue sessions. To engage a representative mix of Alaskans with socially conservative, moderate, and liberal viewpoints on this emotionally charged topic, the project implemented a broad-based recruitment plan and media strategy. The project also engaged a social research team to evaluate the impact of the arts-based dialogue experience on community members. *Understanding Neighbors* concluded with a multimedia

Understanding Neighbors artists Peter Carpenter and Sara Felder in Ambivalence, a video created for the dialogue groups, performed by Carpenter and Felder, filmed by Stephan Mazurek. Photo © Stephen Mazurek.

work-in-progress performance reflecting the artists' experiences of the community dialogues and lessons learned.

This case study reveals project organizers' discoveries about employing art with a "point of view" in dialogues, as well as about tensions between creative autonomy and civic intent in creating the artistic work. It chronicles attempts to establish neutrality and credibility in the eyes of the community, and describes the obstacles to gaining participation of the full spectrum of religious and political viewpoints on the topic of same-sex relationships. Finally, given Out North's activist-oriented leadership and previous work, this case study also examines the benefits and pitfalls of Out North's effort to position itself as a more neutral space in order to encourage diverse participation, and the key questions that this prompted about civic dialogue as a means to achieve Out North's vision for social change in its community.

WHAT IS THE PLACE OF SAME-SEX COUPLES IN OUR SOCIETY? OUT NORTH POSES THE QUESTION ALASKANS DIDN'T WISH TO ASK

After we first submitted our Intent to Apply to engage our community about same-sex relationships, we were asked by an [Animating Democracy] reviewer "if we were inspired or just crazy." We know it's a tough matter to discuss, but that's why we're doing this work.

—*Out North's proposal to Animating Democracy, 2000*

Out North: A Catalyst for Creating Art, Community, and Change

Out North Contemporary Art House in Anchorage, Alaska, is a multidisciplinary cultural center that commissions, produces, and presents a vibrant mix of contemporary visual, media, literary, and performing artworks by local and guest artists. Founded in 1985 as an all-volunteer group producing and touring plays concerned with gay and lesbian issues, Out North has evolved into a professional nonprofit arts, educational, and community development organization that seeks "to create art, community, and change." To realize its mission, Out North's programming frequently tackles social and cultural issues affecting local residents, particularly Anchorage's lower-income and ethnically diverse populations. Out North's critically acclaimed productions, which often explore community concerns around race, sexuality, and/or class, are always thought-provoking, and at times controversial. To connect theatergoers more meaningfully with artists' work and foster community among diverse Alaskans audiences, Out North hosts residencies with local and guest artists that engage Anchorage residents in community-based art experiences. Out North is also nationally recognized for its model arts and literacy programs for at-risk youth.

While Out North's unwavering commitment to presenting daring artistic endeavors that explore challenging, often contentious, societal concerns has on occasion put it at odds with certain audiences and public funding agencies, the organization has earned the respect and appreciation of artists and the broader Alaskan community. In 1996 the Alaska Legislature honored Out North with a citation recognizing "the leading role Out North continues to play in promoting the artistic, economic, educational, and cultural development of our communities." Performance artist and local resident Jill Bess Neimeyer describes Out North's singular place in the Anchorage community:

> We have many arts organizations in this city that provide high quality music, dance, and theater to Anchorage audiences and artists alike. But Out North is different; Out North is special. Out North has consistently been the organization willing to take risks not just with local artists, but with outside artists doing daring new works. Out North has been the organization willing to teach not just the youth of Anchorage, but at-risk youth whose families might not otherwise have the money for special theater programs. Out North has been willing to challenge not only their audiences but this community with their vision of tolerance and cultural diversity.[1]

[1] Jill Bess Neimeyer, "Out North Deserves Community Support: One artist reflects on the value of taking risks," *The Anchorage Press*, November 27–December 3, 1997.

From "Pancake Gatherings" to Communitywide Dialogues:
The Genesis of *Understanding Neighbors*

Out North's interest in engaging Anchorage residents in an exploration of same-sex relationships responds to the community's continuing struggles with this divisive civic issue, as well as the personal experience of co-directors Jay Brause and Gene Dugan. As Brause recalls, the *Understanding Neighbors* project emanated out of the "recurring, intense controversy in Anchorage" in the mid-1990s regarding the legal, moral, and cultural place of same-sex couples in the community.[2] That controversy was reignited in 1996 by a lawsuit filed by Brause and Dugan that sought equal legal rights for same-sex relationships. While the suit was successful in the lower court and was assigned for trial in the Alaskan Supreme Court, the Alaskan Legislature advanced a ballot measure for public vote in 1998 that called for a constitutional limitation of marriage to preclude recognition of same-sex couples. Leading up to the vote, both sides of the ballot issue waged vigorous, highly polarizing campaigns. In the final vote, the ballot measure was adopted 68 percent to 32 percent.

[2] Out North Final Report to Animating Democracy, 2003. Unless otherwise noted, quotes from key participants are drawn from Out North reports to Animating Democracy.

While deeply disappointed by the ballot's passage, Brause and Dugan were equally frustrated by the contentious, deleterious nature of public debate surrounding the ballot vote and, more broadly, the topic of same-sex couples. Recalls Brause, "In the entire time those issues were being discussed, no one was listening to each other. It was far too easy to see the other as the enemy. And I know from my work in arts and culture that unless people have a chance to experience each other firsthand there is no hope for understanding."[3]

[3] Pamela Cravez, "Art & Dialogue," *Art Matters* (February 2003): 13

In search of new ways to advance the issue of same-sex relationships through a more constructive public forum, Brause became involved in 1999 with the work of the Reverend Glen Groth, a family friend and retired Lutheran pastor, who organized informal gatherings of clergy and lay people, including gay men and lesbians, to talk about family life and same-sex issues. Believing that Alaskans holding diverse viewpoints would better understand

each other if given the opportunity to tell their personal stories, Groth hosted these informal gatherings at his home, often serving his guests pancakes, to inspire respectful conversation and listening. Says Shirley Mae Springer Staten, the project coordinator for *Understanding Neighbors*, "[Groth would] say 'Come over and let me make you some pancakes,' and around the pancakes they would have this discussion. People learned to listen to each other in a different kind of way."[4]

[4] Ibid., 13.

Brause and Dugan were moved by the power of Groth's "pancake gatherings" to foster thoughtful discussions among people of diverse opinions and values, and sought to build on these efforts by developing a project for Out North in which challenging art paired with structured, listening-focused dialogue would enhance community understanding about the lives and concerns of same-sex couples and contribute to greater insight and healing. Their vision formed the basis of *Understanding Neighbors*, an arts-based civic dialogue project aimed at encouraging a communitywide conversation about the place of same-sex couples in Alaskan society.

In response to Animating Democracy's call for proposals in 2000, Out North fleshed out *Understanding Neighbors*' complex architecture and implementation plan. The project would commission a team of artists to create performance and video works created from interviews with 60 to 70 community members. These new artworks would be used to stimulate facilitated discussions in small group dialogues that would convene regularly over several months. These dialogue groups, comprised of community members from all walks of life, would address the question: what is the social, moral, and legal place of same-sex couples in our society? The project would conclude with a multimedia work-in-progress performance based on the artists' perceptions of the community dialogue experience.

"[Groth would] say 'Come over and let me make you some pancakes,' and around the pancakes they would have this discussion. People learned to listen to each other in a different kind of way."

Establishing a neutral, credible foundation for *Understanding Neighbors* was a key consideration for the project's design. In view of the highly polarized and emotionally charged public debate that preceded Anchorage's 1998 ballot vote, Out North realized that providing participants with a "safe space" conducive to respectful discussion and non-judgmental listening was paramount to the project's success. Moreover, *Understanding Neighbors* was predicated on the participation of a diverse mix of "neighbors" representing the full spectrum of religious and political viewpoints on the topic of same-sex relationships. As the project's sole sponsor, Out North wisely acknowledged that some community members might be deterred from participating in *Understanding Neighbors* because they perceive Out North and, by extension, the project as having a particular point of view on the topic.

To establish a neutral base for *Understanding Neighbors*, Out North partnered with two respected Anchorage groups to share responsibility for the project's governance and implementation: the Interfaith Council of Anchorage, an ecumenical network of faith communities; and Alaska Common Ground, a nonpartisan, all-volunteer civic membership organization that serves as a forum for addressing public policy issues. The planners envisioned that this partnership would signal to community members—especially gay/lesbian people and religious conservatives—the project's genuine commitment to neutrality and inclusion of diverse opinions on the topic of same-sex relationships. While this carefully constructed collaboration enhanced the project's credibility in the eyes of the Anchorage

community, it also set the stage for unanticipated tensions about power sharing and concerns about visibility that Out North would wrestle with throughout the project.

Artistic and Dialogic Interests

Understanding Neighbors' primary artistic intent was to commission a team of artists to create multidisciplinary artworks that would serve as the stimulus for communitywide dialogue on the project's civic question. Specifically, the artistic team would create six to eight short performance-based video works to be used as catalysts for the project's small group dialogues. Incorporating interviews with Alaskans and the artists' own story-telling performances, these video works would explore and illuminate a range of issues around same-sex relationships. To close *Understanding Neighbors*, the artistic team would also create a multimedia work-in-progress performance reflecting the artists' experiences of the community dialogues, interviews and lessons learned.

Motivated by the desire to foster new understanding among the people of Anchorage at a scale that made a difference, Out North and partners set forth an ambitious dialogue agenda: to engage 200 to 250 Anchorage community members holding diverse viewpoints in constructive, respectful dialogue about the place of same-sex couples in Alaskan society. To accomplish that goal, the project would employ a customized dialogue approach based on the Power of Dialogue model developed by Public Conversations Project (PCP), a Massachusetts-based group promoting "constructive conversations among those who have differing values, world views, and positions about divisive public issues."[5] The Power of Dialogue process, which emphasizes dialogue leading to mutual understanding and relationship building rather than agreements or solutions, was well suited to the project's overall dialogue goal of building reciprocal bridges of understanding among community members.

To implement the dialogue component, the project would engage a professional dialogue consultant to train a team of 40 community volunteers who would facilitate 20 small group dialogues. Each dialogue group of 10 to 15 community members would convene once a week over six consecutive weeks.

Organizers placed great importance on an evaluation plan to test the project's hypothesis that through an arts-based civic dialogue process: (1) participants would be more comfortable discussing controversial issues with others holding different points of view; and (2) the art component of the dialogue process would contribute significantly to this increase in comfort. A social research team would be engaged to conduct focus groups and create surveys to measure changes in participants' pre- and post-meeting attitudes. The research team would analyze this data to determine the degree to which participants became more comfortable over time discussing same-sex relationships with those holding differing viewpoints. The research team would also assess the extent to which the artists' work impacted participants' shift in attitudes.

Understanding Neighbors also hoped to validate and gain greater insight into the role of art in the dialogic process and its capacity to inspire constructive dialogue and open listening among people whose differences have led to polarization and stereotyping. More broadly, the project sought to test whether art-inspired dialogue can help other communities like Anchorage better understand complex, emotion-charged issues and each other.

[5] Project organizers carefully considered a range of dialogue approaches for use by *Understanding Neighbors*, including the solution-oriented dialogue model developed by the Connecticut-based Study Circles Resource Center. The Study Circles approach places emphasis on engaging whole communities in productive dialogue around critical social and political issues leading to action and change. Given the focus on fostering tolerance and understanding rather than policy change, organizers viewed the Public Conversations model as better suited to this goal.

FINDING A WAY TOWARD CONVERSATION THROUGH STORY:
THE IMPLEMENTATION OF *UNDERSTANDING NEIGHBORS*

Although I will never know the depth of understanding that happened in these four Thursdays, I witnessed some profound moments... I saw 11 people making courageous efforts to understand each other and share their unique stories. Author Terry Tempest Williams asks, "How are we to find our way toward conversation? For me, the answer has always been through story. Story bypasses rhetoric and pierces the heart. Story... returns us to our highest and deepest selves, when we remember what it means to be human living in place with our neighbors." By witnessing the stories of 11 courageous "neighbors," I was returned to a place of hope, faith, and trust in the goodness and humanness of us all.

—*Frankie Barker, volunteer dialogue facilitator,* Understanding Neighbors

Support from Animating Democracy in 2001 provided the *Understanding Neighbors* project with the opportunity and initial resources to bring the vision of Groth and Brause to fruition. However, two weeks after receiving notification of Animating Democracy's award, *Understanding Neighbors* experienced an early setback when the project's visionary, Pastor Groth, unexpectedly died. The project owed much to Groth's inspired approach to dialogue, as well as his personal credibility and reputation as a "bridge-builder." The loss of Groth left many in Anchorage asking who would have the courage to pick up this work? With a renewed sense of purpose, the *Understanding Neighbors* partners answered that question by setting into motion a complex and dynamic artistic and dialogic process.

The planners envisioned that this partnership would signal to community members— especially gay/lesbian people and religious conservatives—the project's genuine commitment to neutrality and inclusion of diverse opinions...

Project Partners and Roles

To steer the project's two-year implementation, project partners Out North, Alaska Common Ground, and the Interfaith Council of Anchorage formed the Understanding Neighbors Coordinating Committee, a governing entity having at least two representatives from each organization.

The coordinating committee's responsibilities included hiring project staff and contract professionals, fundraising, and oversight of participant recruitment for dialogue groups. Out North continued to serve as the project's fiscal agent and to oversee the artists' work. To aid the coordinating committee in exercising centralized, collective leadership over *Understanding Neighbors*, Brause made the considered choice to step back from the project and continue his involvement through Out North's committee representatives.

To carry out its work, the coordinating committee hired Shirley Mae Springer Staten, an Anchorage-based community organizer and actor/storyteller, to serve as full-time project coordinator. Kim-Marie Walker joined Staten as part-time project assistant/outreach developer. To maintain the project's neutrality, the coordinating committee established a separate and independent office.

To advance the project's dialogue activities, the coordinating committee retained Ann McBroom, a Seattle-based consultant associated with Public Conversations Project (PCP), to devise and conduct dialogue training based on PCP's Power of Dialogue

methodology for the community volunteers, as well as for the artistic team and coordinating committee.

To conduct the project's research and evaluation component, the coordinating committee initially contracted Dr. Nancy Andes, director of the Center for Community Engagement & Learning at the University of Alaska Anchorage, to devise and implement an evaluation plan based on a participatory action research model. When Andes unexpectedly withdrew from the project three weeks before the start of the dialogue sessions, the Powers Action Research Group, an Alaska-based consortium of scholar practitioners specializing in research, assessment, and evaluation of educational programs, agreed to complete the evaluation based on Andes' original design.

Led by project curator Gene Dugan, the three-person artistic team included solo theater artist and professional juggler Sara Felder (San Francisco, CA); dance/movement artist Peter Carpenter (Los Angeles, CA); and filmmaker Stephan Mazurek (Chicago, IL). These highly regarded artists, all of whom have had their work presented by Out North, were chosen for their respective creative talents and the innovative artistic approaches they brought to the project. Carpenter and Mazurek had previously collaborated through their association with XSIGHT! Performance Group, a Chicago-based troupe that combines dance, theater, and performance art. Felder's acclaimed *June Bride*, an autobiographical solo performance about a traditional Jewish lesbian wedding, received its world premiere at Out North in 1995.

While all three artists collaborated on conceptualizing and shaping the final artistic products, Felder and Carpenter deployed their talents as performers and storytellers to create performance "vignettes" animating key themes drawn from the interviews with community members. Mazurek provided video and filmmaking skills for development of the artistic works; he also contributed to the video documentation of the project's dialogue activities.

Key Artistic and Dialogic Activities

Over the project's two-year trajectory, the artistic and dialogue components unfolded concurrently along independent, overlapping tracks. This bifurcated approach to implementation stemmed in part from the project's initial assumption that artistic production and dialogue facilitation were two distinct enterprises requiring specialized expertise; it was later reinforced by the project's organizational structure, in which the coordinating committee took responsibility for executing the dialogue component while Out North directed the artistic component.

Artists' development of video works

To realize *Understanding Neighbors'* artistic component, the artistic team pursued the following activities leading up to the launch of the project's Community Dialogue Sessions in February 2003: artists' dialogue training; videotaped interviews with community members; development and videotaping of performance vignettes; creation of eight catalyst videos; and development of a multimedia work-in-process performance.

In preparation for the interviewing process, the artistic team participated in fall 2001 in an introduction to the Power of Dialogue training conducted by dialogue consultant

Ann McBroom. To determine the tone and form the videos might take, the artists also discussed with McBroom the dialogue format and how the art would be used in the dialogues. Drawing on techniques from the dialogue training session, the artists crafted dialogue questions to guide the interview process. They conducted videotaped interviews with 68 community members throughout south central Alaska. The interviewees reflected a diverse mix of Alaskans from all walks of life: traditional conservatives, representatives of diverse ethnic groups, members of the LGBT community, clergy, seniors, and teens.

Following the interview process, the artists met in San Francisco, Los Angeles, and Anchorage for several working sessions to create and rehearse the performance pieces for videotaping. In between these face-to-face working sessions, members of the artistic team—based in different cities—corresponded and critiqued their original scripts via e-mail. Out of that work, the artistic team created 20 video clips containing performance presentations.

In spring 2002, the artists met with the coordinating committee on two occasions to share progress on the evolving videos and discuss initial ideas about how the art would be represented in a structured dialogue setting. At the first session, the artists screened selected interviews with Alaskan residents and described how they would be developing performances and splicing footage of selected video interviews to create video "vignettes" of eight to 15 minutes in length. At the second session, artists Carpenter and Felder performed for the coordinating committee several works-in-process that later became integral to the project in their final video forms: "Identity," "Being Different," "Ambivalence," and "Clipped." Reflecting on these sessions with the artists, coordinating committee member Taylor Brelsford describes his initial impressions of the video interviews and evolving artworks:

...the artists met with the coordinating committee on two occasions to share progress on the evolving videos and discuss initial ideas about how the art would be represented in a structured dialogue setting.

> We saw some segments from the recorded interviews in Anchorage (the "talking head art") and the first sketches of the performances named "Identity" and "Clipped." Seeing the "talking heads," what struck me was the eloquence, and even the "poetry," of the speakers as they talked about their lives, their families, their loves, their church experiences. The performance "Identity" moved me in gentleness and humor with which it addressed how identities are multifaceted, while society at large might tend to lock onto and judge just a single dimension of a person's being. The early sketch of the dance "Clipped" was actually quite confusing to me. It was, of course, a fairly abstract form of expression, in which the tension of the movement was clear, and I knew from Peter's introduction that it would be placed in a church.

In fall 2002, the coordinating committee organized pilot dialogues which used three of the videos: "Being Different," a video with excerpts from interviews with community members; "Identity," a piece with a juggling sequence that explored identity/being different; and "Clipped," a piece that incorporated modern dance within a church setting, overdubbed with music and oration by a preacher. Each video was followed by a dialogue session. The pilot dialogues yielded important insights about the potential of these videos to inspire meaningful discussion around the project's civic question. As Brelsford recalls:

During the pilot dialogues in fall 2002, I saw the final versions of the three pieces: "talking heads" on "Being Different;" the performance "Identity," now placed on stage and in Peter's apartment; and the dance, "Clipped," now placed in a church and accompanied by a wonderful musical line, with particularly resonant horns. As the pilot group on these three pieces proceeded, I was not at all surprised that "Being Different" and "Identity" has such a powerful effect in setting up very powerful sharing among participants… I was surprised, however, at how rich the dance "Clipped" turned out to be as a stimulus to dialogue. Of particular note, many of us in the pilot seemed unsure of the artist's message in the dance—some observed tension, I liked the power of the music, some were struck by the harshness of the voice-over preacher's comments, and others noted that the dancer seemed to struggle to escape, and yet was pulled back towards the sacristy. The discussion on this was quite probing, and I think it was clear that all of us gained important insights into the art through the comments of the group. It also stimulated much discussion of the church/religious dimension of the project question regarding the moral, legal, and cultural place of same-sex couples in our community.

"…I liked the power of the music, some were struck by the harshness of the voice-over preacher's comments, and others noted that the dancer seemed to struggle to escape, and yet was pulled back towards the sacristy. The discussion on this was quite probing…"

A couple of videos were screened but not followed by dialogue to get feedback on their usefulness for future dialogue sessions: "Dr. Verner Von Verner," in which artist Sara Felder plays a Freud-like figure who dispenses homophobic observations and engages doll-like characters to further advance stereotypic homophobia; and "Homosexuality and Religion," a "talking head" video of selected individuals interviewed by the artists. An important observation for the artistic team that emerged out of the post-pilot dialogue debriefing session was the need to create a "couples" video piece in order to generate dialogue more central to the project's question.

By early 2003, the artistic team completed eight videos for use in the community dialogues sessions: "Clipped," "Being Different," "The First Time," "Identity," "Legal Rights," "Ambivalence," "Vocabulary," and "Desire." The artists planned to incorporate unused footage from the artists' interviews with community members and performances into the multimedia work-in-progress.

Development and implementation of arts-based dialogue sessions

To realize *Understanding Neighbors'* dialogue component, project staff undertook a year-long development and implementation process that culminated in the project's Community Dialogue Sessions held in February and March 2003. Key activities included community "mapping;" implementation of a public relations plan; recruitment of volunteer facilitators and dialogue participants; pilot dialogue sessions; training of facilitators; dialogue design workshops; implementation of community dialogue sessions; and research/evaluation of the project's arts-based process.

In preparation for the dialogues, the coordinating committee and staff completed in spring 2002 PCP's two-day Power of Dialogue method training conducted by McBroom. The training grounded the committee members and staff in PCP's methodology, which stages dialogue to move from entry and explorative questions to Appreciative Inquiry.[6] The training helped the coordinating committee members and

[6] Appreciative Inquiry (AI) is an organization development methodology devised by David L. Cooperrider and Diana Whitney. AI is based on the assumption that inquiry into and dialogue about strengths, successes, values, hopes, and dreams is itself transformational.

staff to refine their collective understanding of "dialogue" and provided them with a fuller understanding of the project's scope and implementation in the community.

"Mapping" the Anchorage community

In spring 2002, the project undertook a four-month process of community "mapping." This PCP-based technique used a modified interview process to explore how individuals and organizations within the community perceive conflict related to the moral, legal, and cultural place of same-sex couples. Besides informing the design of the dialogues, the mapping also served to build a base for recruitment of volunteer facilitators and dialogue participants, as well as lay the groundwork for community outreach and public relations. The coordinating committee members and staff conducted one-on-one interviews with 24 individuals representing a broad swath of the community: gays and lesbians, politicians, pastors, laypersons of the church, religious conservatives, and liberals. (See sidebar for the questions used in mapping interviews.) Project staff compared earlier community canvassing, which queried people about their views on same-sex issues, with the PCP mapping strategy, which focused on perceptions about how conflict around same-sex issues manifests itself.

> In our initial canvassing of the community, we wanted to get a pulse on thoughts and feelings about the issues of same-sex couples. There are many suspicions about the topic. A variety of questions posed [by interviewees] included: "Who are the stakeholders for the project?; and "Why was the project posing this question?" Most often the questions were: "What's in it for me?" and "Are you going to lobby for same-sex marriage?" These questions were asked by a variety of members in our community including gays and lesbians.

An *Understanding Neighbors* test dialogue group held at Out North. Photo © Jay Brause.

MAPPING THE CONFLICTS

Understanding Neighbors conducted exploratory interviews using a process modified from the Public Conversations Project to inform the focus and design of the project's arts-based dialogue sessions. Interviews aimed to deepen understanding of how issues regarding same-sex couples were affecting the community; identify where conflicts existed; evaluate the costs of these conflicts; and understand what had worked and not worked in the past to address or transform these conflicts. A range of community members including pastors, politicians, state and local public agency heads, organization members, and others participated in one-hour interviews. Following is the central question for the interview followed by follow-up questions.

Are you aware of any conflicts within your (community, organization, congregation) related to the moral, legal, and cultural place of same-sex couples?

If the answer is NO:
- How do you account for the absence of conflict that is straining other organizations, communities, congregations?
- Have there been conflicts in the past?
- Are there conflicts about other sexually related matters? What are they about? Who is involved?
- Are there lessons in the experience of your (community, organization, faith community) for those who are struggling with these conflicts?
- Who could we talk to in order to learn more?

If the answer is FORMERLY BUT NOT NOW:
- What were the issues in the conflict?
- How did the conflicts manifest themselves? How did the conflict evolve?
- How polarized did the matters become? What voices were devalued or silenced? Who were the bridges?
- Were there deliberate attempts to transform the negative sides? If yes, who made these attempts? How effective were they? What limited their effectiveness?
- If no such attempts were made, what changed the course of the conflict?
- Are there lessons in what you did and didn't do that could be lessons for others?

If the answer is YES:
- What are the specific issues around which there is conflict? In what context does it surface (local, regional, national)?
- How divisive is the conflict compared to other conflicts? What issues are more divisive?
- How has the presence of conflict around same-sex couples expressed itself? What are the signs of its presence? Who is affected by it and how?
- How polarized have these matters become? How many "sides" are there? What voices have been devalued or silenced? Who are the bridges?
- What impact is the conflict having on your (community, organization, congregation)?
- How widespread is the concern about the costs of the conflict? Who is most concerned?

- What steps have been taken to transform/address/contain these conflicts? How effective have they been? What has limited their effectiveness?
- Have members been trained as facilitators/mediators/discussion leaders to bring people together? Who are they? How were they trained? What role do they play?
- Have you ever retained a "third party" practitioner to help with these conflicts?
- What are the lessons you have learned from what has and has not gone well that you can share with others in similar struggles?

Potential for participating in dialogue project (modified)
- What, if any, potential value do you see in members from your (organization, community, congregation) participating in a dialogue project on the role of same-sex couples? Who would you like to see involved? What role would they play?
- What would happen during the dialogue that would make participation worthwhile?
- What would be your interest level in participating in a dialogue project on the role of same-sex couples?
- What concerns would you have about participating or recommending participation, in a dialogue about the role of same-sex couples?
- What should dialogue planners keep in mind when planning the dialogue sessions?

A more constructive canvassing of the community was done by PCP's mapping process. More than 20 individuals from many sectors of the community were systematically asked, "Are you aware of any conflicts within your (community, organization, and congregation) related to the moral, legal, and cultural place of same-sex couples? Mapping supported the recruitment of individuals for the pilot dialogue. It also helped get the word out on a grassroots level.

Concurrent to community "mapping," project staff devised and launched a comprehensive, multi-pronged public relations plan to recruit community facilitators and dialogue participants, as well as to effectively position the project within the community. Recruitment efforts included radio broadcasts of public service announcements; publication of project brochure and newsletter; advertisements in church news bulletins and other community newsletters; placement of articles in local newspapers; and one-on-one outreach to personal friends and family members.

The project also established a diverse network of project stakeholders, which included community-based groups and state and national membership organizations, such as: Healing Racism of Anchorage, the local chapter of Parents and Families of Lesbians and Gays, National Association of Social Workers, ACLU, Alaska Association of Marriage and Family Therapy, Alaska Dispute Settlement Association, and several church groups. Project staff solicited the support of project stakeholders to disseminate information to their membership. The combined efforts of community "mapping" and public relations activities resulted in a core database of 195 persons indicating their interest in participating as facilitator or dialogue participant.

Restructuring the dialogue component

Summer 2002 marked a critical turning point in the project's development and implementation. In the face of an acute budget crisis, the coordinating committee and Out North's board, as the project's fiduciary authority, redirected project staff efforts from community outreach to fundraising. Staff researched and submitted grant proposals to potential funding agencies; committee members made appeals to their memberships. Several individuals from the coordinating committee and Out North's executive board made significant contributions to close the project's budget gap.

In addition to stepping up fundraising efforts, *Understanding Neighbors* project coordinator Shirley Mae Springer Staten presented to the coordinating committee a scaled-back version of the project's dialogue component and a streamlined budget. The coordinating committee approved a restructuring plan that cut back the number and duration of the Community Dialogue Sessions, reduced the number of dialogue groups from 20 to 12, and the number of dialogue facilitators from 40 to 24.

Piloting the arts-based dialogue process

The coordinating committee organized a pilot dialogue to test the arts-based dialogue process and revise it collaboratively with community participants, artists, and project staff. Convened over two days in October 2002, the pilot involved 18 community members divided into two separate focus groups. McBroom facilitated one group and coordinating committee member and professional mediator Mia Oxley facilitated the

other. Each focus group viewed one of the catalyst videos and then engaged in the dialogue process; this sequence was repeated three times over the course of the pilot session using three videos ("Being Different," Identity," and "Clipped"). Participants and facilitators then met for a two-hour debriefing to obtain participants' feedback on their experience, and to elicit responses to two additional videos ("Dr. Verner Von Verner" and "Homosexuality and Religion") under consideration for use in the community dialogue sessions. In addition to the debriefing session, participants and facilitators completed survey forms four weeks after the pilot dialogue sessions to capture individuals' reflections on the arts-based process.

A number of important observations emerged that informed the development and implementation of the dialogue component. First, feedback affirmed the project's overall arts-based dialogue structure was, in the words of project staff, "reliable, efficient, and, despite some suspicion about a hidden agenda, community members were willing to fully participate." Most pilot dialogue participants agreed that the videos were an essential and positive element in the dialogue, moving it to different levels of understanding about same-sex relationships. As one participant put it, "[the art] focused the discussions and allowed us to go deeper into personal stories." In addition, they noted that sharing of different viewpoints on the art enriched the overall dialogue experience.

Pilot participants suggested that the creation of a "couples"-focused video would help generate dialogue more central to the project's question about the place of same-sex couples in society. They also noted that the absence in the pilot dialogue groups of community members holding conservative Christian viewpoints, especially those individuals opposing same-sex relationships diminished the possibilities for a fuller discussion and deeper understanding. To ensure greater representation of conservative voices in the forthcoming Community Dialogue Sessions, project staff initiated a second round of recruitment activities in January 2003; those efforts placed special emphasis on targeting local churches through personal invitations to congregations and placement of project information in church bulletins and newsletters.

...the absence in the pilot dialogue groups of community members holding conservative Christian viewpoints, especially those individuals opposing same-sex relationships diminished the possibilities for a fuller discussion and deeper understanding.

Facilitator training and dialogue design workshops

In late January 2003, 22 community volunteers participated in an intensive three-day facilitator training led by McBroom and Oxley. With experience in conflict resolution, Brelsford assisted as facilitator coach. Community volunteers were identified and selected based on submission of a written application and interviews conducted by McBroom. Nearly all facilitators had professional backgrounds in conflict resolution, counseling, and/or mediation. The training grounded facilitators in the principles and elements of PCP's dialogue approach and introduced them to the project's intentions and design. In addition, facilitators participated in a mock dialogue session and learned techniques to conduct phone interviews with their assigned dialogue participants prior to dialogue sessions.

To finalize the design of the four community dialogue sessions, the dialogue team convened facilitators in mid-February. Key activities included discussion around neutrality issues; introduction to performance videos; practice mock dialogue sessions; and crafting appreciative inquiries based on facilitators' phone interviews with their participants. To plan for the dialogue sessions, trainers assigned co-facilitator pairs to design dialogue

STRUCTURE OF *UNDERSTANDING NEIGHBORS* DIALOGUE SESSION

Following is an abbreviated outline used by dialogue facilitators describing the structure of one *Understanding Neighbors* dialogue session.

Entry

· Prepare yourself energetically to co-facilitate, doing whatever works to center yourself to prepare for the meeting and to be fully present for participants.
· Develop a plan for a safe environment:
 · Arrange chairs in a circle and ensure comfort of the room; and
 · Greet people as they arrive and make informal introductions.
· Describe the process being used by *Understanding Neighbors* over the four dialogue sessions, using the following ideas: sessions are designed to deepen listening and curiosity about our own and others' experiences for more understanding; understanding, on its own, has merit; and this process is not about debate or discussion.

Here's how it works for each session:
 1. We set group agreements to be used or revised for all sessions.
 2. We view a short video related to the topic.

3. The facilitators guide the dialogue by posing pre-formed questions that everyone will get to answer.
4. You have a chance to ask questions and offer answers about your experience in this dialogue session.

Understanding Neighbors was formed around the question: what is the legal, moral, and cultural place of same-sex couples in society? Many of you may have an answer to this question. This dialogue will be an opportunity to reflect and we will be focusing on aspects of that question rather than answering it directly.

· Invite participants to introduce themselves using a different one of the following questions each session.
 · What are you setting aside to be here today?
 · Tell us something about yourself that most people know about you.
 · What book, movie, or television show would you most like to take a vacation in?
 · What if anything would you like the group to know about you?
 · Develop agreements within the group about confidentiality and ground rules for participation.

Opening

Introduce the video:
 · The art for this dialogue is in the form of video.
 · It has a point of view in order to stimulate dialogue. Its role is to stimulate dialogue and open conversation through a shared viewing experience.
 · This video today is called "Being Different." It's eight minutes long.

Show the video, then ask participants for the following:
 · What feelings or thoughts did the video stimulate? What memories or images did it evoke?
 · Jot down your immediate response. This will help you respond to specific questions about your own experiences.

Facilitate the dialogue around these two talking points:
 · We've just seen a video of men and women describing their personal stories. Please tell us about a time when you were uncomfortable because you felt different. Jot down a few words to describe the experience. You'll have a minute and a half to share your experience.
 · Is there anything you wish you or others had done differently in this experience? You'll have a minute and a half to share your experience.

Inquiry

Guide the participants in the following thinking:

- Shifting gears, we've heard some personal stories from the folks on the video and here in the group. The next 15 minutes will be a period of direct inquiry. This is a chance for you to pursue your curiosity, to follow up on something you've heard in order to deepen your understanding.
- During this time, we invite you to pose a certain kind of question. A lot of questions we usually ask are really statements in disguise. This isn't a time for commenting on what others have said. (The facilitator should be ready to model a question of curiosity, e.g. "What did it mean when you learned 'to deal with it'?")

Invite questions "popcorn style" (as people feel the urge to respond) and facilitate the conversation.

Closing

Close the session by asking participants the following:

- To end our session, please turn to your notes responding to the video. What if anything did you not have a chance to say? (Take a moment to reflect and you'll have a minute to respond.)
- If there is time, the facilitator may also ask: "What is something new that you will leave with as a result of participating in this dialogue tonight?"
- Thank the group for their participation, abiding by the agreements created as a group, and remind about the confidentiality agreement.
- Make announcements about next week's dialogue.

entry, opening, inquiry, and closing details. To assess challenges that might occur during actual facilitation, facilitators role-played potential conflicts and interventions as they might happen at different times in a dialogue session.

Implementation of community dialogue sessions

Ninety participants who self-identified as "conservatives," "moderates," and "liberals" were divided into 12 dialogue groups, each led by co-facilitators. McBroom and Oxley chose the performance videos shown in the first three dialogues and facilitators chose the video for the last session based on their sense of which would be most useful for their group. The dialogue groups met between February and March 2003 for four two-hour sessions scheduled by each group. The groups convened at a variety of host sites throughout Anchorage: churches, business offices, schools, and a community wellness center. Most of the groups met during weekday evenings but several met during the day and one convened on Sunday afternoons.

Following each of the dialogue sessions, the facilitators summarized dialogue group experiences in weekly reflections, documenting what worked or didn't work in the session and what were the areas of agreement and/or disagreement for their groups. A facilitators' debriefing on March 31, 2003, allowed people to discuss more fully their overall observations and impressions about the community dialogue process. Facilitators also provided individual written reflections on the role, value, and impact of the art in the dialogue process.

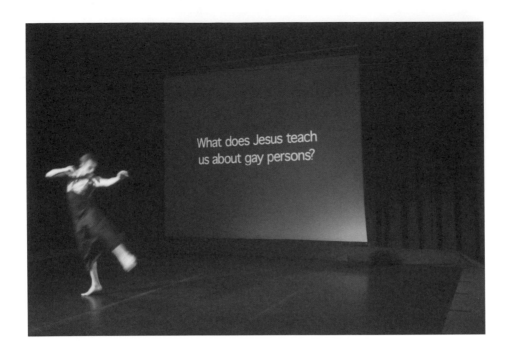

Measuring the impact of *Understanding Neighbors'* arts-based dialogue process
To assess the impact of the arts-based dialogue experience on community members,
the project's research team formulated and implemented a research/evaluation plan to
answer two central questions: Are the participants changed by the arts-based civic dia-
logue experience and, if so, how? And what role did art play in this change? In addition to
shedding light on these questions, the research and evaluation aimed to capture a broader,
more textured view of the participant experience.

Concurrent to, and following the implementation of, the Community Dialogue Sessions,
the research team deployed several evaluation tools—surveys, focus groups, and one-
to-one interviews with a representative sampling of participants. The participants
completed a pre-dialogue survey designed to ascertain their comfort level and familiarity
in the three key areas: topic of same-sex couples; controversial conversation; and art as
a medium for stimulating dialogue. A post-dialogue survey was distributed to all partici-
pants at the fourth and final dialogue session to measure shifts in those areas. In addition,
the research team recruited 32 dialogue participants to participate in two focus groups.
Finally, the research team conducted eight in-depth interviews to further understand and
validate the data gathered during the focus groups.

As outlined in its final report to the project partners, the research team had mixed
findings about the project's stated hypothesis, which was that through the arts-based
dialogue process participants would be more comfortable discussing controversial issues
with others holding different points of view, and the art component of the dialogue pro-
cess would contribute significantly to this increase in comfort. While the research data
amply documented that most participants experienced the arts-based dialogue process

as a useful tool for discussing controversial topics, the research team could not make definitive conclusions about the first part of the project hypothesis. This was due in part to the fact that the respondents—all of whom self-selected to be part of the project—already had from the outset a relatively high comfort level discussing controversial topics, including the topic of same-sex couples. Another mitigating factor was that the dialogue groups lacked the diversity of opinions regarding same-sex couples necessary to test the first part of the hypothesis. With regard to the second part of the project hypothesis, the research team concluded that the art served to provide context and focus discussions at the beginning of the dialogue process. Due to the lack of diversity of opinion among participants, however, it was unclear whether or not the art served to increase participants' comfort level in discussing controversial issues with others holding divergent viewpoints.

Understanding Neighbors' Coda: "A House with Many Rooms"

Understanding Neighbors concluded at Out North with the spring 2003 presentation of the artists' work-in-progress multimedia performance of "A House with Many Rooms." Many of the project's staff, facilitators, and dialogue participants attended. The 60-minute interactive performance interspersed video clips—excerpts from catalyst videos and new pieces—with moments of humor, dance, juggling, and monologues performed by Felder and Carpenter to reflect the artistic team's observations of the dialogue process and their personal reflections about the project.

The preparation of this work-in-progress and subsequent performance was cathartic for the artists, as it gave them a real chance to be seen and heard by both the public and facilitators in the project. The artists and Out North staff felt that this performance piece, if it had been deeply examined with the project staff and facilitators, would have led to many constructive insights for the future of this kind of arts-based dialogue work.

"As I consider next steps for Out North, I wonder whether civic dialogue is an appropriate tool for a minority people when their opponents haven't asked to sit down and talk."

OUTCOMES AND ANALYSIS

From the time Glen [Groth] and I started this project to pose a question others didn't wish to ask, Out North moved from the process of debate to dialogue; from governance that was unitary to shared; from organizational spotlight to footlight; from staffing that was internal to external; from art that was challenging to questioning—all to create a neutral base from which to welcome conservative participants to dialogue. Yet with all these changes made, we found that conservative people still participated in small numbers. As I consider next steps for Out North, I wonder whether civic dialogue is an appropriate tool for a minority people when their opponents haven't asked to sit down and talk.

—Jay Brause

Artistic Outcomes

Overall, the project's primary artistic intent—to create insightful, stimulating videos to catalyze dialogue on same-sex issues—was realized on many levels. From an artistic standpoint, the artists skillfully wove the voices of community members culled from the interview process with their own artistry as performers and storytellers to create eight

aesthetically compelling and thought-provoking videos. Furthermore, these artworks proved to be a potent tool in stimulating dialogue by triggering dialogue participants' personal experiences, stories, and opinions on the topic of same-sex issues. And, as facilitator Jackie Buckley describes, the artwork invited participants to contemplate viewpoints other than their own:

How important—or even possible—is "neutral" art for effecting "neutrality" in dialogue? Does art with "a point of view" diminish or enhance the possibility for "neutral" dialogue?

> The videos had the effect on participants that we anticipated they would have; namely, they provided a stimulus that inspired agreement, disagreement, contemplation, concern, and a wide range of emotions that were stirred. While the conversations rarely invoked the video images or sounds, except in passing references, they engaged the observers and invited reflection based on stories other than their own. The video had a voice in the group. Once that voice had been expressed the questions raised by participants seemed to frequently consider the video "character" point of view.

Was the artwork biased or a "participant" in dialogue?

While functioning as a powerful stimulus for dialogue, the videos also raised intriguing questions about the fundamental nature of art in relation to the project's concerns about neutrality. In carrying out their creative role in the project, the artists crafted videos reflective of their aesthetic interests as well as personal experiences and viewpoints about same-sex issues. Consequently a "point of view" was inherent in the artwork—one that tended to identify with and highlight gay and lesbian perspectives. That the artwork had a "point of view" was initially troubling for the project partners, staff, and facilitators, given their commitment to establish neutrality in the dialogue groups and create a nonjudgmental environment in which participants felt comfortable to tell their stories and listen to others' stories. Project staff and facilitators struggled with the dilemma of introducing into a "neutral" dialogue process artwork that many perceived as biased.

> [As] the facilitator training took place, some were troubled that the artwork plainly empathized with the struggles of lesbian and gay persons. Most facilitators grew comfortable framing the artwork as "having a point of view" and "representing a voice" in the dialogue process, but some continued to see the art as plainly biased. Understandably, the artists responded that as gay and lesbian people themselves, it would be inappropriate to try to speak from a point of view outside their own experience. Unlike a play, this was a work based on personal voice and that was a central factor for the creation of the work.

Many dialogue participants perceived the artwork as partial toward gay and lesbian perspectives, though they did not feel this bias detracted from the dialogue process. Surprisingly, dialogue participants holding conservative Christian viewpoints shared the same perspective. As a group of dialogue participants from the Abbot Loop Community Church commented, "We did feel the videos were slanted (encouraging acceptance of homosexuality), but not so much that the process was harmed." Other dialogue participants concurred that the artwork's slant toward one side of the same-sex issue was inconsequential in terms of the project's concerns for neutrality. However, they suggested that artwork representing a multiplicity of viewpoints would have made for a more stimulating discussion. Says facilitator Laura Bain:

The feedback from participants was that the "art" was too biased on one side and did not have equal dialogue on the topic. This was brought up by one of the gay participants. They felt that it would have been more stimulating for discussion if it [the art] had offered more viewpoints.

One of the project's most intriguing and unexpected discoveries was the way "biased" artwork, or art with a point of view on the topic, functioned positively in the dialogue process. As many of the facilitators observed, the artists' work was seen as another "person" in the room—a voice that invited dialogue participants to consider a perspective beyond their own personal experiences and opinions. And, as facilitator Jennifer Esterl observed, the artwork's role as "participant" in the dialogue process brought forth "minority" viewpoints underrepresented in the dialogue group's participant make-up.

> One of the things I noticed in our dialogue group is that the videos provided an outlet for the more marginalized voice. It worked well to use the suggestion that the videos be seen as "another participant," especially because they ended up serving as an ally for the one gay male in our group. I think they alleviated some of the burden and pressure on him to provide the viewpoints of the whole gay and lesbian community.

While the project unearthed fascinating insights into the interplay between art with a "point of view" and dialogue, it left many unresolved questions about the nature of art in effecting neutrality in dialogue. How important—or even possible—is "neutral" art for effecting "neutrality" in dialogue? Does art with "a point of view" diminish or enhance the possibility for "neutral" dialogue?

Finding balance in the project's art-dialogue equation

Fully integrating the art and dialogue components formed one of the project's greatest challenges. By virtue of the project's design, the artistic team operated with considerable autonomy in the creation of the catalyst videos. While this gave the artistic team free rein to create videos as they saw fit, it also unintentionally circumscribed the artists' role in design and implementation of the dialogue component. Consequently, the artistic team was challenged to insert its voice in the dialogue design process. More broadly, the artistic team struggled for equal footing and presence in a project that, as it unfolded, placed increasing emphasis on the dialogue process.

The "disconnect" between the art and dialogue components was reinforced by the absence of direct, ongoing communication between the artists and the coordinating committee and dialogue team. The artists felt largely "left out of the loop" about the project's core purpose and activities, especially about how the art would be used in the dialogue sessions—information that would have informed the creation of the videos. Carpenter describes the artistic team's frustration about the dialogue team's selection of the catalyst videos:

> After an informal training in the Public Conversations Project dialogue model by the project's dialogue consultant [Ann McBroom], the artistic team asked for her guidance and suggestions as to the tone and form the catalyst videos might take. She stressed that the videos should be artist-driven and that the artists should not worry about the principles of dialogue in their creation. Unfortunately, many

...the artists' work was seen as another "person" in the room—a voice that invited dialogue participants to consider a perspective beyond their own personal experiences and opinions.

of the videos were not chosen for use in the dialogue groups precisely because of an incompatibility between the tone and/or content of the art and the purpose of art in the dialogue sessions… I actually feel that [McBroom] was acting under the assumptions of the project: that experts should exercise control over their areas of knowledge. Unfortunately, (and as is often the case) this project placed the artistic team in a subordinate role to the role of dialogue.

Carpenter also points out that the videos could have been used to greater effect had the dialogue team received guidance from the artistic team about how art conveys meaning:

Another frustration of the artistic team came when we were sent questions that were asked during the dialogue groups. Based on the questions that we were sent, there seemed to be very little attention paid to the content of the videos and/or the questions seemed to be so vague as to remove the artwork from the conversation altogether. In retrospect I think the project would have benefited from the artistic team informally training the dialogue team as to how art operates to create meaning. Indeed, speaking with members of the dialogue team after our work-in-progress performance of "A House with Many Rooms," the desire was expressed for more inclusiveness across disciplines to be built into the structure of the project.

In *Understanding Neighbors'* final report to Animating Democracy, project members agreed with Carpenter's assertion that closer collaboration between the artists, dialogue team, and the coordinating committee would have fostered productive interplay between the art and dialogue components. They also recognized that incorporating an artists' orientation into the facilitator training sessions would have enhanced the dialogue facilitators' understanding about the artwork and their capacity to use it effectively in the dialogue process.

In many ways, the dialogue facilitators were indispensable to the project, not only for their skillful work with Community Dialogue Sessions, but as "evangelists" within the community for the kind of constructive dialogue the project sought to foster.

We now recognize that the project design did not thoroughly conceive, nor effectively implement, a training component to fully integrate the art into the dialogue process. The facilitators (along with the coordinating committee) had varying levels of sophistication with the art forms. Some among us were impatient and critical of certain art performances or questioned whether the documentary interviews represented art at all… As noted above, most on the coordinating committee now conclude that more direct involvement of the artists in the facilitator training sessions would have been a great help, perhaps by giving an orientation to the aesthetic choices used given its sometimes abstract nature; and to be briefed on the intentions of their work. This review could also have grounded the facilitators in the process of conducting their own group analysis of the art, when that was desired.

The project members also contemplated whether the integration of the art and dialogue components would have been better served had the dialogue method been determined in advance of the creation of the art.

Some felt it would have helped if the dialogue method was identified in advance, before the art was developed, so that the art could have been designed more specifically for the dialogue. Others felt this was precisely the problem, that the art

became too focused on dialogue rather than the artistic process and impact—that it was valid and critical in this project to "let the artists be artists"—to enable them to create work which was focused on what they needed to say.

Project members remained divided about how to bring balance to the project's art and dialogue equation. Should the artwork be shaped to serve dialogue? Or should the project "let artists be artists" in creation of their work? How can art and dialogue co-exist without one being overshadowed by the other? While *Understanding Neighbors* surfaced many more questions than answers about the pairing of art and dialogue in an arts-based civic dialogue project, Oxley considers that the most important lesson of the project was:

> …that dialogue and art can indeed be combined to encourage constructive conversation on a controversial topic. Art can enrich a dialogue process; it was so in this project even with the unfortunate decision to keep separate the artistic and dialogue design process, and even with the disproportionate emphasis—from inception though implementation—on dialogue. Like much learning, this project leaves me pondering. What magic could spring from more fully integrating the creation of art and dialogue?

Dialogue Outcomes

The project set forth a bold and challenging dialogue goal: to engage 200 to 250 Anchorage community members of diverse viewpoints in constructive, respectful dialogue about the question, "What is the social, moral, and legal place of same-sex couples in our society?" Taken as a whole, *Understanding Neighbors'* dialogue component succeeded on many levels. Through its carefully constructed and thoughtfully implemented dialogue framework, the project successfully renewed interest and raised awareness about the issue of same-sex relationships. It also engaged new circles of Anchorage residents, both as facilitators and dialogue participants. In view of several setbacks the project experienced along the way—the untimely death of its co-founder, acute financial stress, and the unexpected withdrawal of the project's original evaluator—these achievements are all the more remarkable.

The dialogue "evangelists": The critical role of the dialogue facilitators

The design and execution of the project's multidimensional dialogue component yielded a wealth of valuable techniques and methodologies. Among the most significant was the recruitment and training of 25 volunteer dialogue facilitators. This dedicated cadre fervently embraced the project's dialogue principles and goals and undertook their role with professionalism and commitment. In many ways, the dialogue facilitators were indispensable to the project, not only for their skillful work with Community Dialogue Sessions, but as "evangelists" within the community for the kind of constructive dialogue the project sought to foster. Project members concluded that the volunteer facilitators stood alongside community members as central participants in civic dialogue.

> We were fortunate to draw upon a very dedicated group of 25 facilitators, many with professional skills in mediation and group dynamics, willing to devote a great deal of time to this community project, and even to pay to help defray the costs of

"Art can enrich a dialogue process; it was so in this project even with the unfortunate decision to keep separate the artistic and dialogue design process, and even with the disproportionate emphasis—from inception though implementation—on dialogue."

training… Since the conclusion of the project, it has become apparent how critical this group is to considering an extension of this process—for without this trained group, there can be no Understanding Neighbors. How to keep them motivated has stepped up as a major question for continuation. This raises questions about who should be central to civic dialogue. In our case, the facilitators clearly became a critical participant, as important as the community participants themselves.

Netting media attention while defusing potential controversy

The project's lengthy, intensive recruitment efforts and public relations plan formed another critical dimension of the project's dialogue component. These activities resulted in the recruitment and participation of nearly 100 community members in the Community Dialogue Sessions, as well as forged critical alliances with a diverse mix of "stakeholder" organizations.

Given its potential for igniting controversy within the community about the emotionally charged topic of same-sex relationships, the project took a proactive stance in garnering media attention. Drawing on her previous experience working with local media outlets, Staten crafted and implemented a media strategy that carefully positioned *Understanding Neighbors* in the public eye, highlighting the project's commitment to welcoming community members representing both conservative and progressive viewpoints to dialogue on same-sex relationships. As Staten described it at Animating Democracy's 2003 National Exchange, this strategy was realized most effectively by bringing forward voices on both sides of the issue in editorial sections of the newspaper and in radio and TV interviews.

Understanding Neighbors artists Stephan Mazurek, Peter Carpenter, and Sara Felder hold a post-work-in-progress discussion with dialogue participants and facilitators at project end. Photo © Jay Brause.

Through the editorial sections we brought voices of people on opposite sides of the issue forward. This was important because that was the model for our project. We had to project that we welcomed conservative and progressive viewpoints. We used feature articles in the mainstream news and alterative newspapers. We had radio and TV interviews bringing together conservative and liberal points of view. A prominent Lutheran minister who was an early participant helped keep communities together. What would have been an inflammatory issue was not.

The project's proactive media strategy netted extensive press coverage and helped cast the project in a positive light within the community while simultaneously circumventing the potential for controversy. Ironically, *Understanding Neighbors'* challenges in bringing together participants representing a wide spectrum of perspectives may have been due to the project's success in averting controversy in the media. Says Brause, "Out North has wide experience with how controversy in the media results in higher participation in audiences... [T]hat our project staff was successful in keeping controversy out of the media is precisely one of the problems of gathering people to participate."

Did "understanding" happen?

In spite of *Understanding Neighbors'* proactive media and recruitment strategies and its conscious efforts to establish and evidence neutrality, the project was challenged to bring a range of voices to the dialogue groups. As the research/evaluation team's final report points out, the majority of dialogue participants, all of whom self-selected to be part of the project, were centrists on the topic of same-sex couples. Most participants expressed regret about the lack of diversity among group members; they were particularly disappointed by the relatively few conservative voices represented in the dialogue groups and the missed opportunity to hear and learn about this position. The lack of diverse viewpoints within the dialogue groups diminished opportunities for "understanding" to occur among community members who had hoped to learn about "the other side" of the same-sex issue.

The tepid response *Understanding Neighbors* received from both ends of religious and political spectrums raised a critical question for the project members: was the community ready to take on this civic issue? The project's community "mapping" and extensive outreach indicated that large segments of the Anchorage community were indeed ready for the general topic and supportive of the dialogue process. At the same time, the project leaders realized in retrospect that the gay/lesbian and the religious conservative communities were much less disposed at the time of the project to engage in dialogue on the topic of same-sex couples.

> ...[W]e are acutely aware that broad sectors of our community are not ready for a dialogue on the topic of same-sex couples. Some in the LGBT community expressed frustration that arts funds were being deflected to conversations with "people who will never accept us." Some church leaders who initially expressed support for the project curtailed their involvement during the developmental phase—a reflection of concerns over the project topic, sponsorship, lack of conservative presence, and other factors such as time required. In addition, many of the outreach meetings were met with a polite but cool reception.

The tepid response Understanding Neighbors received from both ends of religious and political spectrums raised a critical question for the project members: was the community ready to take on this civic issue?

Reflecting on the project's challenges in obtaining diverse viewpoints, McBroom suggests that conducting the community "mapping" process before designing the project (as opposed to using it to inform the dialogue design) might have yielded a more nuanced understanding of the community's overall level of readiness. Moreover, the project's design would have benefited from greater insight into how specific segments of the community have previously encountered the topic of same-sex relationships, and what factors might motivate or hinder them from re-engaging around this issue. Says McBroom:

> The biggest challenge was bringing a range of voices to the project. The most important lesson I learned was the need to spend substantial time and energy (up front) to understand the nature and impacts of controversy on the whole community, the old conversation, the potential value and motivation across different factions to engage in new conversation, etc. Although this preliminary "mapping" was attempted in the spring and summer, the project would have been more successful if this engagement had occurred prior to designing the project for the grant. The art, the dialogue design, and the outreach might have been more focused to meet the needs of the community as a whole, thus encouraging more participation from "conservatives" to allow for a richer, deeper dialogue.

Posing the project's civic question: Was it addressed or avoided?
From the outset, project members gave careful consideration to issues of neutrality in the formulation of *Understanding Neighbors'* central question—What is the social, moral, and legal place of same-sex couples in our society?—in order to provide a broad cross section of the community with multiple entry points into the topic. Toward that end, the phrase "same-sex marriage," which appeared in the original question, was changed to the more neutral "place of same-sex couples." The question in its final version formed the springboard for the artists' work and guided the development of the dialogue process.

...the indirect way in which the project question was addressed evoked meaningful conversation among group members about the general topic, but not a focused discussion on the legal/moral issues concerning same-sex couples.

One of the most interesting dialogue outcomes was the extent to which the project question was addressed. Many dialogue participants expressed disappointment that the dialogue groups did not delve directly enough into the question, particularly the legal and public policy aspects. From a structural standpoint, the reduced number of dialogue sessions did not provide adequate time for fuller discussion about other aspects of the project question. More importantly, the artwork and nonanalytic style of the dialogue design encouraged participants to respond to the project question by bringing forth and sharing their personal stories and experiences. As project members explain, the indirect way in which the project question was addressed evoked meaningful conversation among group members about the general topic, but not a focused discussion on the legal/moral issues concerning same-sex couples.

> ...[T]he project unfolded through the combined efforts of the artists, participants, facilitators and the coordinating committee, and there was certainly an evolution in the way the question was addressed, or in the eyes of some, avoided.
>
> The artists responded to the central question with an affirming, personal artistic vision, not always focused on couples. The design of the dialogue groups sought explicitly to avoid the analytic-debate style of conversation, and so directed

Understanding Neighbors
*Coordinating Committee
members Peg Tileston
and Mia Oxley in a final
project debriefing.*
Photo © Jay Brause.

attention to the variety of life experiences refracting from the central question. For example, dialogue questions asked participants to share their own experiences about being different, or being accepted in critical life choices. For most groups, the artwork, combined with questions of this sort, brought people to share their life experiences in a non-judgmental way, *and* to explore the many facets of experience for same-sex couples. However, there were no directed questions of the sort: do you agree with same-sex marriage? And the topic question was not posed by the facilitators.

Organizational Outcomes and Challenges

The coordinating committee structure: Did it work?

In addition to establishing a neutral and credible base for the project, the coordinating committee was charged with overall implementation of *Understanding Neighbors*. Drawing on the resources and expertise of the three partner organizations, the coordinating committee brought consistent and conscientious leadership to the project's execution. Individual members dedicated significant time and energy to serving on the committee.

Given the project's ambitious scope and complexity, the coordinating committee experienced many challenges, particularly in the areas of communication and decision-making. The coordinating committee struggled to build consensus within itself and among key project players around a shared understanding of the project concept, and to speak with a unified voice throughout the implementation phases. The structural separation between the coordinating committee and Out North leadership, namely Brause and Dugan, led to misunderstandings and strained communications.

Understanding Neighbors
artist Peter Carpenter in
Clipped, *a video perfor-*
mance created for dialogue
groups by Peter Carpenter
and Stephan Mazurek.
Photo © Stephen Mazurek.

While acknowledging the coordinating committee's value and critical contribution to the project, some project members suggest that a different type of governance structure, such as an advisory committee, might have proved as effective and more cost-efficient.

> …[T]he basic organizational structure of the three sponsors was a sound approach to concerns about credibility of an Out North solo effort, and brought some new instructional resources to the project. Various coordinating members contributed significant skill and effort to the implementation of the project. The separate office for Understanding Neighbors staff initially appeared to have been appropriate for clarity about the independence of the project. At the same time, the sheer labor of creating shared understandings and effective working relationships among the various entities was extremely demanding. While the collaborative governance approach was valuable, the coordinating committee has come to believe that a lower profile, advisory role for the coordinating committee, with greater reliance on the Out North staff would have reduced the costs of coordination, both financially and emotionally.

The efficacy of Out North's "distancing" strategy

Understanding Neighbors had profound organizational implications for its originator and co-sponsor, Out North. To address the project's neutrality issues, Out North made the crucial decision to distance itself from *Understanding Neighbors* by partnering with Alaska Common Ground and the Interfaith Council of Anchorage, and ceding its sole authority over the project to the coordinating committee. This was not only a structural strategy; Out North and the coordinating committee also agreed to establish a project office physically separate from, and independent of, Out North's headquarters.

From an organizational standpoint, Out North's "distancing" strategy had unforeseen and largely negative consequences. The physical separation of the *Understanding Neighbors* office strained communications and working relations between Out North and project staff. The arrangement also diminished opportunities for Out North staff to benefit from the experiential knowledge gained through the project. More importantly, the project's co-sponsorship model and shared governance structure reduced Out North's visibility and the centrality of its role as cultural organizer. In the end, Out North's "distancing" strategy, devised for the sake of the project's neutrality, effectively made this activist organization invisible.

In light of the weak response *Understanding Neighbors* received from the community's conservative sectors, these organizational consequences were all the more disheartening for Out North. Ironically, one of Out North's key findings was that the project organizer's "neutrality" was of lesser consequence to fostering meaningful community dialogue than active participation from all sides of a given issue. This also raised important questions for Out North about the efficacy of civic dialogue as a means to achieve its vision for social change in its community. How can dialogue foster understanding among "neighbors" when key segments of the community haven't asked to sit down and talk? And how can dialogue move a community from understanding to action around a critical civic concern?

That *Understanding Neighbors* would bring together Alaskans representing conservative and progressive views in meaningful dialogue on same-sex relationships was an expectation largely left unmet for Out North. Nevertheless, the project's carefully constructed pairing of thought-provoking art with structured dialogue broke new ground with regard to effective arts-based dialogue practices. More importantly, *Understanding Neighbors* stands as an inspiring arts-based dialogue model for Anchorage and for other communities seeking to engage their citizens in controversial civic issues. Says dialogue facilitator Jennifer Esterl, "…I am very excited about the [*Understanding Neighbors*] dialogue process and its potential application to other divisive issues in our community. I am particularly interested in seeing what it could do with issues of racism, and I think a similar type of artwork (i.e., videos) would be not only useful, but perhaps essential in helping to assure a diversity of viewpoints…"

Ironically, one of Out North's key findings was that the project organizer's "neutrality" was of lesser consequence to fostering meaningful community dialogue than active participation from all sides of a given issue.

Contributors

Andrea Assaf is the artistic director of New WORLD Theater (NWT) at the University of Massachusetts, Amherst. She is a performer, director, writer, educator, and activist. Before joining New WORLD Theater, Assaf was the program associate for Animating Democracy, and liaison to the *Arte es Vida* project. She has a master's degree in Performance Studies and a bachelor's in Acting, both from NYU. Her performance work ranges from Spoken Word to theater, from multidisciplinary solo work to collaborative ensemble productions. She has taught Meisner Technique, poetry/creative writing, and text and movement workshops for people of all ages. Her community arts experience ranges from youth work with NWT's *Project 2050*, to intergenerational work with Liz Lerman Dance Exchange, to original collaborative performances within the Filipino/a/American community in NYC, to performance-based conservation education in Tanzania, East Africa. In 2004, Assaf was awarded a grant from Cultural Contact (U.S.-Mexico Foundation for Culture) to collaborate on a new bi-national dance-theatre project, *Fronteras Desviadas / Deviant Borders*. Assaf's theory and practice interests include community-based arts, postcolonial studies, critical pedagogy, and cross-cultural performance. She speaks Kiswahili and Spanish, and is a member of the Writers Roundtable and Alternate ROOTS.

Grace Lee Boggs is an activist, writer, cultural worker, and philosopher based in Detroit, Michigan. Boggs' 60 years of political involvement encompass the major United States social movements of this century: Labor, Civil rights, Black Power, Asian American, and Women's and Environmental Justice. Born in Providence, Rhode Island of Chinese immigrant parents in 1915, Boggs received her bachelor's degree from Barnard College in 1935 and her doctorate in philosophy from Bryn Mawr College in 1940. In the 1940s and 1950s she worked with West Indian Marxist historian C.L.R. James and in 1953 she came to Detroit where she married James Boggs, an African-American labor activist, writer, and strategist. Working together in grassroots groups and projects, they were partners for more than 40 years until his death in July 1993. In 1992, with James Boggs and others, she founded Detroit Summer, a multi-cultural, intergenerational youth program to rebuild, redefine, and respirit Detroit from the ground up. Currently she is active in the Detroit Agricultural Network, the Committee for the Political Resurrection of Detroit, writes for the weekly *Michigan Citizen*, and does a monthly commentary on WORT (Madison, WI). Her autobiography, *Living for Change*, published by the University of Minnesota Press in March 1998, now in its second printing, is widely used in university classes on social movements and autobiography writing. In May 2000, she received a Discipleship Award from Groundwork for a Just World; in June the Distinguished Alumna Award from Barnard College; and in July the Chinese American Pioneers Award from the Organization of Chinese Americans.

Rha Goddess is a performing artist and social-political activist. Her work has been internationally featured in several compilations, anthologies, forums, and festivals. Goddess's debut project, *Soulah Vibe*, received rave industry reviews from *Ms. Magazine*, *The Source*, *XXL*, and *Interview*. *Time* magazine called it "...one of the year's coolest records." As founder and CEO of Divine Dime Entertainment, Ltd., she was one of the first women in Hip Hop to co-create, independently market, and commercially distribute her own music worldwide. In May 2000, *Essence Magazine* recognized Goddess as one of 30 Women to Watch in the new millennium. In 2002, Brooklyn Academy of Music's NextNext series, part of its prestigious Next Wave festival, chose her as one of six artists deemed to be influential in the next decade. Her activist work includes co-founding the Sista II Sista Freedom School for Young Women of Color, and being the former International Spokeswoman for the Universal Zulu Nation. Goddess has also been an encore featured keynote in the *Women & Power Summit at Omega Institute* along with Iyanla Vanzant, Eve Ensler, Anita Hill, Eileen Fisher, Jane Fonda, Alice Walker, and Marion Woodman. Goddess's current projects include *The Next Wave of Women & Power/"We Got Issues!"* and a modern trilogy entitled, *Meditations With The Goddess*. Goddess is based in New York where she lives with her husband attorney and author, Corey Kupfer.

John Malpede, artistic director of Los Angeles Poverty Department (LAPD), is an actor, activist, and writer. Founded in 1985, LAPD is the first performance group in the nation comprised primarily of homeless and formerly homeless people. LAPD's touring project, *Agents & Assets*, a performance concerning drug policy and the effects of the war on drugs on people and their communities, has been produced in Los Angeles, Detroit, and Cleveland. In 2004, Malpede's project *RFK in EKY*, a real-time documentary-style performance produced by Appalshop, sought to put a historical mirror up to present moment life in eastern Kentucky. Malpede has received New York's Dance Theater Workshop Bessie Creation Award, San Francisco Art Institute's Adeline Kent Award, Durfee Sabbatical Grant, Los Angeles Theater Alliance Ovation Award, and individual artist fellowships from New York State Council on the Arts, the National Endowment for the Arts, and the California Arts Council. He has recently been featured in five video works by artist Bill Viola and as Antonin Artaud in director Peter Sellars' production of *For An End to the Judgment of God*.

Graciela Sánchez is cofounder and director of The Esperanza Peace and Justice Center. A dedicated activist-cultural worker, Graciela Sánchez has worked throughout her lifetime to eliminate racism, sexism, homophobia, and class elitism. As director of the Esperanza, Sánchez does everything from programming; proofreading the monthly news magazine, *La Voz*; grantwriting; consulting with other grassroots groups; and major donor and capital campaign development; as well as cleaning toilets and mopping floors. Prior to the Esperanza, Sánchez worked with the Southwest Voter Registration Education Project and the Mexican American Legal Defense Fund. She was then selected to study film and video at the Escuela Internacional de Cine y Television in San Antonio de los Baños, Cuba. She began organizing in the queer community on the state and local levels in 1985 and was a founding board member of the San Antonio Lesbian Gay assembly, the San Antonio Lesbian/Gay Media Project, and ELLAS, a state and local Latina lesbian organization. In 1992, she was given the prestigious Stonewall Award, a yearly acknowledgement honoring achievement in the national Lesbian/Gay community. She has also

received several community awards from various community groups including a Lifetime Achievement Award from the Hispanic Research Center at the University of Texas/San Antonio, The LULAC Woman of the Year Award, and the Human Rights Campaign Fund Activist Award.

Lynn E. Stern is a New York-based writer and independent consultant with 15 years' experience in the nonprofit sector. She advises philanthropic organizations and nonprofit groups in strategic planning, program design, management, and evaluation. Fluent in Russian, Stern is a specialist in cultural exchange between the United States, Central and Eastern Europe, and Russia. She served as project specialist to the Ford Foundation's Media, Arts and Culture unit where she oversaw its capacity-building initiatives in the arts, international creative collaboration and arts-based civic dialogue. She currently serves as consultant to the Foundation's electronic media policy portfolio.

Susan Wood is an arts consultant based in Ann Arbor, Michigan. She was the Animating Democracy project liaison to the *Common Threads* project in Lima, Ohio. Formerly, she was executive director of Flint Youth Theatre (FYT) and fine arts coordinator for the Flint School District. Under her leadership, FYT was one of 35 cultural organizations included in Animating Democracy, a program of Americans for the Arts. FYT subsequently received the Governor's Arts Award for the state of Michigan. Wood was the recipient of the 2000 Arts Advocate of the Year Award from ArtServe Michigan, and was named Youth Theatre Director of the Year (with William Ward) by the American Alliance for Theatre and Education in 1999. After her tenure at FYT, Wood served as consultant in theater, arts education, and community cultural planning for the Charles Stewart Mott Foundation. In her work there, Wood facilitated the planning and development of the Flint Cultural Center, researched models of arts-based learning across the country, and examined the intersections of artistic processes and products and the foundation's civil society and civic engagement work. She was project director for the community cultural planning process in Flint and arts consultant to the Ruth Mott Foundation. She is an adjunct lecturer at the University of Michigan Flint in the theatre and education departments. Her most recent publication is *Creating a Future for At-Risk Youth in Michigan*.

About Americans for the Arts and Animating Democracy

Americans for the Arts is the nation's leading nonprofit organization for advancing the arts in America. With more than 40 years of service, it is dedicated to representing and serving local communities and creating opportunities for every American to participate in and appreciate all forms of the arts.

To learn more about programs, membership, and how you can support Americans for the Arts, call 202.371.2830 or visit www.AmericansForTheArts.org.

Animating Democracy, a program of Americans for the Arts' Institute for Community Development and the Arts, fosters arts and cultural activity that encourages and enhances civic engagement and dialogue. Animating Democracy is a resource for linking the arts and humanities to civic engagement initiatives. Animating Democracy helps to build the capacity of artists and cultural organizations involved in a wide sphere of civic engagement work through programs and services, including:

· A website providing practical and theoretical resources related to the arts as a form and forum for civic engagement and dialogue;

· Referrals of artists and cultural institutions experienced in designing creative civic engagement and dialogue programs on a wide array of contemporary issues;

· Learning exchanges and professional development programs that offer opportunities to learn and share practices and innovative methods in arts-based civic dialogue/engagement work;

· Technical assistance and consultation for museums, historic sites, and community groups seeking to develop arts- and humanities-based civic engagement initiatives; and

· Publications featuring books, essays, and reports exploring arts- and humanities-based civic engagement.

For more information about Animating Democracy, call 202.371.2830 or visit www.AmericansForTheArts.org/AnimatingDemocracy.

PUBLICATIONS FROM ANIMATING DEMOCRACY

Art, Dialogue, Action, Activism is a publication of Animating Democracy, a program of Americans for the Arts, which seeks to foster civic engagement through arts and culture. Other Animating Democracy publications include:

CIVIC DIALOGUE, ARTS & CULTURE: FINDINGS FROM ANIMATING DEMOCRACY (2005)

ART & CIVIC ENGAGEMENT SERIES (2005)
Dialogue in Artistic Practice: Case Studies from Animating Democracy
> *Hair Parties Project*, Urban Bush Women
> *Faith-Based Theater Cycle*, Cornerstone Theater Company
> *An Aesthetic of Inquiry, an Ethos of Dialogue*, Liz Lerman Dance Exchange

Cultural Perspectives in Civic Dialogue: Case Studies from Animating Democracy
> *King Kamehameha Statue Conservation Project*, Hawai'i Alliance for Arts Education
> *African in Maine*, Center for Cultural Exchange
> *Arte es Vida*, The Esperanza Peace and Justice Center

Museums and Civic Dialogue: Case Studies from Animating Democracy
> *Gene(sis):Contemporary Art Explores Human Genomics*, Henry Art Gallery
> *Mirroring Evil: Nazi Imagery/Recent Art*, The Jewish Museum
> *The Without Sanctuary Project*, The Andy Warhol Museum

History as Catalyst for Civic Dialogue: Case Studies from Animating Democracy
> *The Slave Galleries Restoration Project*, St. Augustine's Church and
> the Lower East Side Tenement Museum
> *Traces of the Trade*, Katrina Browne and the Rhode Island Committee for the Humanities
> *The Without Sanctuary Project*, The Andy Warhol Museum

Art, Dialogue, Action, Activism: Case Studies from Animating Democracy
> *Common Threads Theater Project*, Arts Council of Greater Lima
> *Agents and Assets*, Los Angeles Poverty Department
> *Arte es Vida*, The Esperanza Peace and Justice Center
> *Understanding Neighbors*, Out North Contemporary Art House

CRITICAL PERSPECTIVES: WRITINGS ON ART AND CIVIC DIALOGUE (2005)

ANIMATING DEMOCRACY: THE ARTISTIC IMAGINATION AS A FORCE IN CIVIC DIALOGUE (1999)

To order these publications, visit the Americans for the Arts online bookstore: www.AmericansForTheArts.org/bookstore

Visit the Animating Democracy website for other case studies and writings on art and civic dialogue. www.AmericansForTheArts.org/AnimatingDemocracy.